13-Digit ISBN: 978-1-60433-265-0
10-Digit ISBN: 1-60433-265-4

This book may be ordered by mail from the publisher. Please include $4.95 for postage and handling. Please support your local bookseller first!

Books published by Cider Mill Press Book Publishers are available at special discounts for bulk purchases in the United States by corporations, institutions, and other organizations. For more information, please contact the publisher.

Applesauce Press is an imprint of
Cider Mill Press Book Publishers
"Where good books are ready for press"
12 Port Farm Road
Kennebunkport, Maine 04046

Visit us on the Web!
www.cidermillpress.com

Design by Tilly Grassa, TGCreative Services
All illustrations courtesy of Anthony Owsley
Printed in U.S.A.

1 2 3 4 5 6 7 8 9 0
First Edition

CONTENTS

CHAPTER 1

CRAZY CHARACTERS

Why is the Frankenstein Monster always laughing?
His mad scientist keeps him in stitches.

What does Santa do before he takes off on his sled?
He buckles his sleetbelt.

Boy #1: My name is Tom Long. What's yours?
Boy #2: It's Stanislaw Miklos Putterberlowski.
Boy #1: Gosh. That's a long name, but my brother's name is longer.
Boy #2: Really. What's his name?
Boy #1: Myles Long.

Which government agency cheers for senators and congressmen?
The C.I. Yah!

Why did the cowboy name his ranch Butter?
Because it was a great spread.

An elderly gentleman was having trouble with his car. The automobile stalled in traffic and wouldn't start. The driver behind him quickly started to honk his horn and wouldn't stop. Finally the elderly gentleman got out of his car and walked up to the impatient horn honker. "I can't get my car started," said the gentleman. "If you get it started for me, I'll stay here and honk your horn for you."

Show me a circus performer who eats chili peppers for lunch...and I'll show you a hot time in the old clown tonight.

Show me a medieval king ... and I'll show you a man whose home is his castle.

Show me a magician with filthy hands ... and I'll show you a guy guilty of dirty tricks.

How does a King travel around his castle?
He uses a moater boat.

Where did Sir Lancelot go to pay his parking tickets?
Knight court.

What card game do Western gunfighters like to play?
Draw poker.

What did Attila's wife give him on Saturday morning?
A Hun-ny do list.

What do you call a ring worn by a gangster?
A hood ornament.

Boy: My dad told me to keep my chin up.
Girl: What happened?
Boy: I ended up with a pain in my neck.

What did the Tin Man say to his teenage son as he was going out?
Be home oily.

Which college did the scarecrow graduate from?
Hay U.

Why did the Frankenstein Monster buy a living room set?
He liked his creature comforts.

Who cooks French fries for Bullwinkle Moose?
Rocky the Frying Squirrel.

Which Western hero was born in a laboratory?
The Clone Ranger.

What did the Scarecrow from the Wizard of Oz say to the crows?
Stop pecking on me.

How did the Scarecrow from the Wizard of Oz get smart?
He spent all of his time in a cornfield weeding.

What's the best way for a superhero to keep his cape clean?
Always remember to fly above the pigeons.

How did Sir Lancelot get his sports car into second gear?
He used the knight shift.

How do scarecrows make a decision?
They draw straws.

Pat: Why do you always date Stacy?
Matt: Because she's different from all the other girls I know.
Pat: In what way?
Matt: Stacy is the only girl I know who'll go out with me.

Where does Mr. Dial live?
On Knob Hill.

Where does Santa fly his flag?
On the North Pole.

A young man went to see a voodoo witch doctor. "I'm breaking up with my girlfriend," he explained. "And I want a voodoo doll that looks like her. What's your sticker price?"

What do you say to a pal who lives in Indiana?
Hoosier friend?

Billy: *Did you know that Jessie James was a bodybuilder?*
Willy: *I thought he was a Western outlaw.*
Billy: *He was both. He once held up a twelve-ton train for twenty minutes.*

What scarecrow works best in winter?
Frosty the Crowman.

Harry: My pretty young cousin married an old billionaire who is very ill.
Barry: Why don't you send her a get-will-quick card?

Blue Fairy: Would you like me to change you into a real boy?
Pinocchio: Yes. As long as there are no strings attached.

ATTENTION:
Pinocchio is a real blockhead.

ATTENTION: Pinocchio starred in a Broadway play, but gave a wooden performance.

What is Pinocchio most afraid of?
Termites.

DAFFY DEFINITION:
Juvenile Delinquency – child hood problems.

Boy: Hey! Let's play judge and lawyer and have a fake trial.
Girl: No thanks. I'm not in the moot to play court.

Why did the hay farmer go to jail?
He couldn't make bale.

Why did the rich man bring a chauffeur to the golf course?
Because he hired someone to drive for him.

Roman: Is it raining, Brutus?
Brutus: No, it's hail, Caesar.

Mark: Was he safe or out at home?
Brutus: Ask the Roman umpire.

What do you get if you clone a dating service?
Double dates.

What do you get if you deep-fry Santa Claus?
Crispy Cringle.

What did Abel say to his brother when they were late for school?
Hurry Cain.

Show me an expert on the great biblical flood ... and I'll show you a Noah brainer.

What do you get when a person from Czechoslovakia jumps on a trampoline?
A Czech that bounces.

What did Sailor Santa say when he discovered America?
Land Ho, Ho, Ho!

Where does a NASCAR driver from Poland start a race?

In the Pole position.

What should you do if you have insomnia?

Don't lose any sleep over it.

ATTENTION: **The Tin Man from the Wizard of Oz has a cousin named Iron Will.**

What did Peter Pan say to the pirate captain on the golf course?

Ha! Ha! You hooked your shot again.

Does Pinocchio own a suitcase?

No, but he has an old tree trunk.

What did Pinocchio say when he saw a termite?

Nothing. He was petrified by fear.

What did Pinocchio have for dinner?

A wooden steak.

Reporter: Why is your rock group called the Cars?

Singer: We spend most of our time on the road.

What did the Tin Man say to Dorothy after he took a shower?

Don't bother me on my day of rust.

Arthur: Why is Sir Lancelot wearing a cowboy hat and boots?

Galahad: He's going to a Western squire dance.

What does a scarecrow do all day?
He just hangs around.

What made the Scarecrow decide to run for political office?
He took a straw poll.

How can you tell if a vampire has been in your refrigerator?
They'll be fang marks on the ketchup bottle.

What's red and flies through the air on Christmas Eve?
Superman going home for the holidays.

How does the Scarecrow from the Wizard of Oz drink milk?
He uses a straw.

What is the Scarecrow's favorite fruit?
Strawberries.

Why did the Scarecrow go to the doctor?
He had hay fever.

Why did the Tin Man go to the police academy?
He wanted people to call him copper.

Who helped Dorothy with her algebra homework?
The Math Wizard of Oz.

Why doesn't the Tin Man ever get a bellyache?
He has a cast-iron stomach.

Why doesn't the Tin Man ever get nervous?
He has nerves of steel.

What happens if the Tin Man gets water on the knee?
His leg rusts.

Dorothy: Is it really an Emerald city?
Lion: Jewel see.

What happened to Dorothy's house after the tornado dropped it?
Its value fell quickly.

How did Dorothy get to Oz?

In a roundabout way.

Which rock group has four members who never sing?
Mount Rushmore.

What did Dorothy say when she looked at her bare feet?
Toe-toe! Toe-Toe! Toe-Toe!

Why did Dorothy leave Kansas?
She wanted to take a whirlwind tour of Oz.

Jenny: Why were Goldilocks and the Big Bad Wolf in the same house?
Lenny: It was a two-story building.

What do you get if the Wolf man bites Noah?
Noahwere wolf.

What are the Tin Man's sweaters made of?
Steel wool.

Why did the convict want to catch the measles?
So he could break out.

▶ ▶ ▶ ▶ ▶ ▶ ▶ ▶ ▶ ▶ ▶ ▶ ▶ ▶ ▶

What did the leader of the Fabulous Four say to Torch Guy?
You're fired.

◀ ◀ ◀ ◀ ◀ ◀ ◀ ◀ ◀ ◀ ◀ ◀ ◀ ◀ ◀

What do you call a bunch of human torch guys?
A firing squad.

▶ ▶ ▶ ▶ ▶ ▶ ▶ ▶ ▶ ▶ ▶ ▶ ▶ ▶ ▶

Who takes care of Mrs. Air Rifle's children?
The B.B. sitter.

◀ ◀ ◀ ◀ ◀ ◀ ◀ ◀ ◀ ◀ ◀ ◀ ◀ ◀ ◀

Student: What are we going to do in Mechanic's Class today?
Teacher: We're going to work on our motor skills.

▶ ▶ ▶ ▶ ▶ ▶ ▶ ▶ ▶ ▶ ▶ ▶ ▶ ▶ ▶

Why did the baby grenade explode?
It had no safety pin.

◀ ◀ ◀ ◀ ◀ ◀ ◀ ◀ ◀ ◀ ◀ ◀ ◀ ◀ ◀

What did the surfer say to the Invisible Man?
Hey, dude! You're out of sight.

▶ ▶ ▶ ▶ ▶ ▶ ▶ ▶ ▶ ▶ ▶ ▶ ▶ ▶ ▶

Which monster haunts Mother Goose Land?
Little Bo Creep.

◀ ◀ ◀ ◀ ◀ ◀ ◀ ◀ ◀ ◀ ◀ ◀ ◀ ◀ ◀

What prize did the busybody win?
The meddle of honor.

What did the rich Texan hang on his walls?
Oil paintings.

▶ ▶ ▶ ▶ ▶ ▶ ▶

If a man was born in Greece, raised in Poland, and killed in America, what is he?
Dead.

◀ ◀ ◀ ◀ ◀ ◀ ◀ ◀ ◀ ◀ ◀ ◀ ◀ ◀ ◀ ◀ ◀ ◀

What do you call a mugger with a sore throat?
A hoarse thief.

▶ ▶ ▶ ▶ ▶ ▶ ▶ ▶ ▶ ▶ ▶ ▶ ▶ ▶ ▶ ▶ ▶ ▶

Igor: Who's at the door?
Ivan: It's the Invisible Man.

Igor: Tell him I can't see him now.

◀ ◀ ◀ ◀ ◀ ◀ ◀ ◀ ◀ ◀ ◀ ◀ ◀ ◀ ◀ ◀ ◀ ◀

Why does Tarzan go to square dances?
He likes to swing his partner.

▶ ▶ ▶ ▶ ▶ ▶ ▶ ▶ ▶ ▶ ▶ ▶ ▶ ▶ ▶ ▶ ▶

Lady: Is your mother named Dot?
Child: Yes. I'm Dotty's girl.

◀ ◀ ◀ ◀ ◀ ◀ ◀ ◀ ◀ ◀ ◀ ◀ ◀ ◀ ◀ ◀ ◀

Ted: How did you flunk out of carpenter school?
Fred: I never did any homework.

What happened to the girl who stared at a blender? She went stir crazy.

..........

Sam: I can sleepwalk through college.
Pam: Ha! In your dreams.

..........

Jack: Did you jog through the Middle East?
Zack: Yes. Iran.

..........

Crook: I didn't break into the bank, your honor. It was foggy and I lost my way.
Judge: Don't try to cloud the issue.

..........

Kim: I have a lot of fantasies.
Tim: Well, imagine that.

..........

Merlin: Today we're going to study mathematics and astronomy.
Little King Arthur: Oh boy! Those are my favorite royal subjects.

..........

Mad Doctor: I'll trade you a manmade monster for a zombie.
Voodoo Doctor: That sounds like a fear exchange to me.

..........

Joe: Did you hear? Flint and Iron finally clashed.
Moe: What happened?
Joe: Boy! Did the sparks fly.

..........

Lena: My Aunt Lily loves to go swimming.
Gina: Maybe she's a water lily.

..........

Then there was the female convict who went to the prison beauty parlor to get a crime wave.

..........

What should you send to a couple that moves into a ranch in the desert? A get well soon card.

..........

What do Munchkins wear at the Oz Fitness Center? Gym shorts.

Why was the Tin Man found innocent of all charges against him?
He had an ironclad alibi.

. .

Lacy: Why did you break up with that bodybuilder?
Stacy: His breath was so strong it almost knocked me out.

. .

What does the Abominable Snowman get if he stays out in the sun too long?

Freezer burn.

. .

Reporter: **What's your book on growing older about?**
Writer: **I just gave a new wrinkle to an age-old story.**

. .

Melanie: I was born on June 14. That's Flag Day in America.
Morgan: No wonder your hair is naturally wavy.

MY CLIENT COULD NOT HAVE KILLED THE WITCH WITH THE BUCKET OF WATER! WATER MAKES HIM RUST!

Joe: I'll give you a hundred dollars to do my worrying for me.
Zoe: Okay. How soon do I get the money?
Joe: That's worry number one.

. .

Little Girl: Do you usually tie shoes tight?
Little Boy: Knot always.

. .

Harry: President George Washington never told a lie.
Barry: Then I guess he never made any campaign promises.

A man went into a Civil War museum and stared at a strange statue of a lesser-known general. Finally the man turned to an attendant and asked, "Isn't that an odd pose for a general?" The attendant smiled. "Yes," agreed the attendant, "but the statue was half finished when the committee realized they couldn't afford to add a horse."

What did Santa Claus say when he saw Heidi?
Heidi Ho, Ho, Ho!

Jenny: Every time I hitchhike, a nice person gives me a lift.
Lenny: You must have thumb luck.

Two old college pals bumped into each other. "I haven't seen you since graduation," said one. "Come to think of it, I didn't see you at graduation."

"That's because I graduated a year after you," said the other.

"Gee," asked the old chum, "did you get left back?"

"No," replied the pal. "I graduated summa cum later."

Mike: I never worry about money. What's the sense in worrying about something you don't have?

What does a person who has no time to eat lunch put on her salad?
Russian dressing.

What did they do with the card player in jail?
They put him in solitaire.

What do you get if you cross an exercise fanatic with an acorn?
A fitness nut.

Where does Santa stay when he's away from home?
At a ho-ho-hotel.

Convict: Warden, can we have a party in prison?
Warden: That depends. What kind of party do you want to have?
Convict: An open house party.

Where did Peter Pan hang his hat?

On the Captain's hook.

What did Ms. Trashcan shout to the garbage men?
Won't someone please take me out?

What did the elf shout when he couldn't find Santa?
This is a lost Claus.

What runs on a train track and goes puff, puff!
A late commuter running after a train.

Which hero of the Bible was a Boy Scout?
Daniel. He was in the Lion's Den.

What does a mermaid write on?
Sand paper.

Boy: **What did you do during your trip to Italy?**
Girl: **I Romed around.**

Father: How far were you from the correct answers?
Son: About two seats.

Jenny: Why are you so early? I told you to come to my house after dinner.
Benny: Dinner is what I came after. What's on the menu for tonight?

Boy: Do you want to do a Polish folk dance?
Girl: I'd love to Stan.
Boy: Okay, let's polka, Dot.

Why was Bilbo Baggins proud of his niece?
She was voted Gnomecoming Queen at school.

What makes Tarzan laugh?
The Tree Stooges.

Why did the skeleton get cut from the baseball team? He made too many boneheaded plays.

Where does Robin Hood keep his sheep?
In Sheerwood Forest.

Why does Scrooge love Santa's reindeer?
Because every buck is dear to him.

Why did the pirate join a health club?
He wanted to be in ship shape.

Prisoner: I object, your honor. I did not steal a silver yardstick.
Judge: Over ruled.

Which English king was very romantic?
King Henry the VIII. Lots of girls lost their heads over him.

Why was Noah a smart businessman?
He had one of the longest sails in biblical history.

What did Jack Knife say to the dancing partners?
Can I cut in?

WOO HOO!

Which monk is uncontrollable?
The Wild Friar.

Why do Munchkins forget a lot of things?
They have short memories.

Husband: I saved enough money for us to go to Europe this summer.
Wife: Oh, boy. When are we leaving?
Husband: As soon as I save enough money for us to come back.

A man in Los Angeles wanted to get to New York by car. A man in New York wanted to get to Los Angeles the same way. The guy from Los Angeles was in a rush and started to drive 150 miles per hour. The guy from New York was in a bigger rush and drove 200 mph. Strangely enough the two men bumped into each other at the same place. In an Alabama jail cell.

Barber: Would you like a haircut?
Boy: No. I'd like you to cut them all.

Man: Do you have names for your tools?

Farmer: Yes. This is Sam Spade and that is Jack Knife.

ATTENTION: Acupuncturists like to needle their patients.

Jan: Gosh Fran! What have you done to your hair? It looks like you're wearing a wig.

Fran: I am wearing a wig.

Jan: Really? Goodness. You'd never know it.

What does a witch say when she casts the wrong spell?

Well, hexcuse me.

What does a teacher get if she puts all of her students under a microscope?

A magnifying class.

What wears a suit of armor and drips?

A rainy knight.

Why did the bald guy lose his hair?

They just had a falling out.

Principal: How do you like our school?

Student: Closed.

A crook walked into a bank and demanded that the bank president give him all the money in the vault. The nervous president handed over all the cash and then whispered into the robber's ear, "Would you mind taking all the record books, too. I'm ten thousand dollars short."

What did the friendly neighbors say when Matthew came over to visit?

Welcome Matt.

What did one time bandit say to the other when they saw the posse approaching?

Let's cut them off at the past.

Jan: Imagine you're stranded on a desert island surrounded by sharks. You're thousands of miles from civilization and there is no help in sight. What do you do?
Fran: Gee, I don't know. What?
Jan: Just stop imagining.

What kind of dance does cowboy Santa like?

A ho-ho-ho-ho down.

Teacher: When were the Dark Ages?
Student: During the days of the knights.

Millie: What does a French skeleton say when he meets you?
Tillie: I don't know.
Millie: "Bone Jour."

What is a monster's favorite breakfast cereal?
Scream of Wheat.

Which knight made King Arthur's Round Table?

Sir Cumference.

Boy: I have a photographic memory.
Girl: Then why do you forget so many things?
Boy: Can I help it if my mind isn't fully developed yet?

What did the boy Eskimo say to his girlfriend?

I only have ice for you.

Timmy: When I grow up I'm going to marry the girl next door.
Jimmy: Why did you pick her?
Timmy: Because I'm not allowed to cross the street.

Which state would Santa live in if he didn't live at the North Pole?

Merry Land.

Why did the skeleton learn to play the piano?

He didn't have an organ.

Bill: I'm going to inherit a lot of money someday.

Will: I guess that makes you a million heir.

Who was the best actor in the Bible?

Samson. His final performance brought down the house.

Which skeleton is a Western hero?
The Bone Ranger.

Boy: I'm going to leave my unfinished math homework here while I go for a jog.

Girl: Hey! Don't you know you can't run away from difficult problems?

Phil: Are the girls at your high school pretty?

Bill: Let me put it this way. We held a beauty contest for the girls at my school last year and nobody won.

And then there was the lying boyfriend who tried to pull the wool over his girlfriend's eyes with the wrong yarn.

Two bruised and battered men were standing before an angry judge. "Why don't you two men settle your case out of court?" said the judge. A man with a black eye nodded his head. "That's just what we were doing, your honor," said he, "when a policeman came along and arrested us for assault and battery."

Why didn't the skeletons go to the prom?
They had no body to go with.

Why did Santa wear a suit of armor on December 24th?

He wanted to be a knight before Christmas.

What do you call a seasick ogre?

A green giant.

Who did Mr. Rope marry?
His coilfriend. ◀ ◀ ◀ ◀ ◀ ◀

What do you call two Munchkins having a prizefight?
Boxer shorts.

Why couldn't the Munchkin pay his bills in the Land of Oz?
He was short of cash.

Gina: After my boyfriend and I went tubing on a river, we broke up.
Tina: What happened?
Gina: Oh, we just drifted apart.

"I heard your Uncle Joe passed away a year ago," Dell said to Nell. "I was sorry to hear the sad news. How is your Aunt May getting along?"
"She's feeling better now," replied Nell, "but the cost of the funeral is making her go bankrupt."
"Was it a fancy send off?" asked Dell.
"It was a little too fancy," answered Nell. "She buried him in a rented tuxedo."

What did the college student say to the fraternity brother?
I'll consider joining your frat, just don't rush me.

KOOKY QUESTION: Do Scandinavians always have Swede dreams?

What's green, has leaves, and carries swords?
The Tree Musketeers.

Nurse Ann: Doctor Smith specializes in removing appendixes.
Nurse Fran: I guess he makes a lot of money on the side.

What does Sir Lancelot use to play golf?
Knight clubs.

Man: How do I get into your book club?
Woman: Just pay the cover charge.

Where did Sir Lancelot take his date?
To a fancy knight club.

KOOKY QUESTION: Did Noah have an Ark angel?

Does Paul Bunyan drive a car?
No. He rides a chopper.

Molly: Why didn't you open a savings account?
Polly: No interest.

Convict: Who is that old con?
Inmate: I don't know, but he's been in jail so long his prisoner number is one.

What did people say when the witch arrived on her wedding day?
Here comes the bride and broom.

Why did Mr. Scrooge take his clock to the bank?
He waned to save time.

What kind of rock music do Arab leaders like?
Sheik, Rattle, and Roll.

What did the Green Giant give his girlfriend?
An onion ring.

What do you call a poem about Munchkins?
Wee verse.

Who are the wackiest three men that live in the Arctic?
Eskimo, Larry, and Curly.

▶ ▶ ▶ ▶ ▶ ▶ ▶ ▶ ▶ ▶ ▶ ▶ ▶ ▶ ▶ ▶ ▶

Chad: I like a girl with a good head on her shoulders.

Brad: I like a girl with a good head on my shoulders.

◀ ◀ ◀ ◀ ◀ ◀ ◀ ◀ ◀ ◀ ◀ ◀ ◀ ◀ ◀ ◀ ◀

Why did St. Peter join a health club?
He wanted a heavenly body.

▶ ▶ ▶ ▶ ▶ ▶ ▶ ▶ ▶ ▶ ▶ ▶ ▶ ▶ ▶ ▶ ▶

What did Mrs. Noah serve for dessert?
Ice cream floats.

◀ ◀ ◀ ◀ ◀ ◀ ◀ ◀ ◀ ◀ ◀ ◀ ◀ ◀ ◀ ◀ ◀

What lumberjack story did Mark Twain write?
The Adventures of Tom Sawer.

▶ ▶ ▶ ▶ ▶ ▶ ▶ ▶ ▶ ▶ ▶ ▶ ▶ ▶ ▶ ▶ ▶

Who is Super Crook?
He's the Man of Steal.

◀ ◀ ◀ ◀ ◀ ◀ ◀ ◀ ◀ ◀ ◀ ◀ ◀ ◀ ◀ ◀ ◀

What do you do when a man with a shotgun demands your pickles?
Give him both barrels.

▶ ▶ ▶ ▶ ▶ ▶ ▶ ▶ ▶ ▶ ▶ ▶ ▶ ▶ ▶ ▶ ▶

What mongrel warrior was a dork?
Genghis Khan Not.

◀ ◀ ◀ ◀ ◀ ◀ ◀ ◀ ◀ ◀ ◀ ◀ ◀ ◀ ◀ ◀ ◀

Why was Mrs. Noah unhappy during the flood?
She could only take one pair of shoes.

Where did the miniature poker player live?
In a house of cards.

▷ ▷ ▷ ▷ ▷ ▷ ▷ ▷ ▷ ▷ ▷ ▷ ▷ ▷ ▷ ▷ ▷ ▷

How do you send a message to a Viking at sea?
Use Norse Code.

◁ ◁ ◁ ◁ ◁ ◁ ◁ ◁ ◁ ◁ ◁ ◁ ◁ ◁ ◁ ◁ ◁ ◁

What did Mr. Boulder yell at the concert?
It's time to rock the house.

▷ ▷ ▷ ▷ ▷ ▷ ▷ ▷ ▷ ▷ ▷ ▷ ▷ ▷ ▷ ▷ ▷ ▷

Why did the cops go to the concert?
They were looking for a band of outlaws.

◁ ◁ ◁ ◁ ◁ ◁ ◁ ◁ ◁ ◁ ◁ ◁ ◁ ◁ ◁ ◁ ◁ ◁

Uncle Al: The economy is so bad last week I hit the
jackpot in a slot machine and got paid off
in lemons.

▷ ▷ ▷ ▷ ▷ ▷ ▷ ▷ ▷ ▷ ▷ ▷ ▷ ▷ ▷ ▷ ▷ ▷

What did the cavemen cook
at their barbecue?
Spear ribs.

◁ ◁ ◁ ◁ ◁ ◁ ◁ ◁ ◁ ◁

**Jilly: Did you read the
Munchkin romance novel?
Millie: Yes. It was short
and sweet.**

▷ ▷ ▷ ▷ ▷ ▷ ▷ ▷ ▷ ▷ ▷ ▷ ▷ ▷ ▷ ▷ ▷ ▷

KOOKY QUESTION: Can zombies be scared to death of anything?

A high school senior applied for admission to a local college. He met with his guidance counselor to learn more about the school. "I think you'd like it there," said the counselor to the student. "It's one of the best nonsectarian schools on the East Coast." "Uh-oh!" gasped the student. "I bet I don't get accepted." "Why not?" asked the counselor. "I'm not nonsectarian," replied the student. "I'm a Methodist."

Dora: Tell me some more juicy gossip about Mike and Judy.
Flora: I can't. I already told you more than I've heard myself.

Cora: Why do you always take bubble baths?
Nora: There's no place like foam.

Why was the pro wrestler so lonely?
He could never get a hold of his friends.

What is the dumbest thing Adam said when he first saw Eve?
Haven't we met before?

What do you call a sorcerer turned doctor?
The Wizard of Ahs.

What do you get when King Midas touches senior citizens?
Golden Oldies.

Convict: How do you get an alias?
Inmate: Just make a name for yourself.

What did the gangster's moll say to the spot on her dress?
I'm gonna rub you out.

Reporter: Were you a big baby?
Football player: I was so big when I was born the doctor was afraid to slap me.

Why did King Kong climb the Empire State Building?
To catch a plane.

Kenny: What part of the horror movie we just saw scared you the most?

Lenny: When the school bully sat down behind us.

Gunfighter: Do you want to die!

Sheriff: No. That's the last thing I want to do.

Boy: Have you heard the joke about the big burp?

Girl: Is it really worth repeating?

Uncle: What did they teach you at the fancy military academy you go to?

Nephew: They taught me to always say "Yes, Sir" and "No, Sir."

Uncle: Are you serious?

Nephew: Sure enough, Unc!

Where did Cinderella Fortune Teller go?

To a Crystal Ball.

Artie: I once saw a magician turn a woman into a tiger.

Marty: That's nothing. I once saw a magician walk down the street and turn into a zoo.

Millie: What do you wear when you go horseback riding?

Tillie: Saddle shoes.

Where's the best place to search for Big Foot tracks? In the foothills.

Show me a boy and a girl who get stuck in a revolving door ... and I'll show you a couple that's been going around together.

What do you call a teenage Santa?
St. Nickoteen.

What do angels ride from place to place in the sky?
A nim-bus cloud.

First Woman: Adam, why are you dressed like Santa Claus?
First Man: It's Christmas, Eve.

Do zombies make a lot of mistakes?
No. Usually they're dead right.

How does St. Peter contact Betsy on earth?
He shouts, "Heaven to Betsy!"

How did Big Foot get purple feet?
He walked through a vineyard.

What did Lot say to his wife after she looked back at the wicked city.
Honey, you're the salt of the earth.

What was wrong with the man who wore six wristwatches?
He had too much time on his hands.

Farley: *I built my new house out of iron.*
Charlie: *After the rainy season, it should look very rustic.*

Dina: Marty says he's going to marry the most beautiful girl in town.
Gina: Humph! What nerve. I don't even know Marty.

What song did the Beatles sing to their pizza?
Cheese please me.

What did the surfer say to the Invisible Man?
Hey Dude, you're outta sight.

Santa: Why are you walking to work?
Frosty: My snowmobile melted.

Minister: *It makes me sad to see such a small group of people in church today. You're either my most devout parishioners or you all forgot the big NFL game starts early today. Hey! Stop! You all come back here right now!*

Girl: I bet you don't know the meaning of the word farce.
Boy: That's absurd!

What happens when a monk walks into a public school?
The friar alarms start to ring.

Girl: A fly landed on your head.

Boy: Swat it.

Girl: Okay. Wait until I get a hammer.

- -

Millie: Why did you give me an empty box for my birthday?

Tillie: Well, when I asked you what you wanted, you said nothing.

- -

And then there was Mr. and Mrs. Skeleton who had a joint account at the bank.

- -

Who fought the Battle of Poland?

The North Poles and the South Poles.

- -

Who was King Midas' first girlfriend?

Goldilocks.

- -

Girl: How did you break your leg?

Boy: Do you see those porch stairs?

Girl: Yes.

Boy: I didn't.

- -

Which member of Robin Hood's band was gone with the wind?

Will Scarlet O'Hara.

Who was the straightest man in the Bible?
Joseph. The pharaoh made a ruler out of him.

What did the waiter of Oz say to the Munchkin?
I'll be with you shortly.

Aunt Junie: Do you lie about your age?
Aunt Loony: No. I just refuse to discuss it.

What did George Washington blow his nose in?
A hanky doodle dandy.

A pessimist is a person who...
... runs for political office and votes for his opponent.
... takes a water survival course before going on a cruise.
... makes out his will before attempting a death-defying stunt.
... bets on a horse and tears up his ticket before the race starts.
... makes sure he gets a money-back guarantee on an engagement ring before he leaves the jewelry store.

Who writes nursery rhymes and squeezes oranges?
Mother Juice.

Who lives in Sherwood Forest and robs rich chicken coops?
Friar Cluck.

What do you call an unemployed Santa?
A ho-ho-hobo.

New soldier: What size uniforms do you have?
Corporal: Too big or too small.

What kind of hero isn't much help?
One that's full of baloney.

How did the band catch a wild drummer?
They used snare drums.

Boy: I make money with my drum set.
Girl: Are you in a band?
Boy: No. My parents pay me not to play them when they're home.

Ed: Do you know that everyone in the world is a coin collector?
Fred: How can that be?
Ed: We all have a little common cents.

Dan: Everybody laughed when I sat down at the piano.
Ann: Because they thought you couldn't play?
Dan: No. Because there was no stool.

ATTENTION: Pinocchio needs a sap transfusion.

ATTENTION: Pinocchio will always be a whittle boy.

What is Frosty the Snowman's best baseball pitch?
A slider.

What is the Green Giant's best baseball pitch?
A bean ball.

A Native American was sending a smoke signal to a neighbor while a cowboy watched. Suddenly, the Native American threw aside his big blanket, picked up a baby blanket and began flapping it over the flames. "What are you doing that for?" asked the cowboy.
"Now I'm just making small talk," replied the Native American.

Ray: The grass isn't always greener on the other side of the fence.
Jay: What makes you say that?
Ray: I live next to a parking lot.

What happened when Peter Pan pranked the pirate captain?
He fell for the gag hook, line, and sinker.

What do you get if Peter swallows a Neverland firefly?
A flash in the Pan.

Patient: Every time I put on my new hat I hear music. What should I do?
Doctor: Remove the hatband.

Salesman: I stand behind every used car I sell.
Mechanic: That's because you have to push it off the lot.

Zack: I was in a real jam last night.

Jack: Tell me about it, but don't spread it on too thick.

Who do you get if you cross Santa and a clock?
Jolly Old Saint Tick.

Bill: **How dangerous is your neighborhood?**
Will: **Last week I parked my car in the street and a neighbor rotated my tires for me.**
Bill: **That's just a friendly gesture.**
Will: **No. It's not. He rotated the tires from my car to his.**

Why couldn't Peter Pan touch down at Newark Airport?
His was a Neverland flight.

Which vampire won the Million Dollar Lottery?
Count Draculucky.

What famous story did Washington Irving Greetings write?
The Legend of Sleepy Hello.

A couple moved into a high-crime neighborhood. A concerned neighbor warned them to keep their front door locked and bolted at night and to never open it until morning. The first night they spent in the new neighborhood they did just that. When they got up the next morning, the front door was gone.

Why is a room full of married people always empty? Because there's not a single person in it.

What did Mega say when it slipped and injured its back? Oh! Mega hurts.

ATTENTION: Bodybuilders have feets of strength.

- -

Ark Angel #1: When will the Great Flood be over?
Ark Angel #2: In Noah time.

What is a tall person's favorite game?
Height and go seek.

8... 9... 10...

Charles: I heard Oliver Twist is sick.
Dickens: Yes, and he just took a turn for the worse.

Patient: Doc, I feel like my stomach is upside-down. What should I do?

Doctor: Try standing on your head.

What did the zombie find when he looked up his family tree?
Dead wood.

Ben: You can't face the naked truth, can you?

Jen: No. It's too embarrassing.

Who selects the best Chinese ships to buy?
The junk picker.

Harry: You're a great all around athlete. Why won't you swim the English Channel?

Barry: I'm afraid I'll get in over my head.

Carpenter: What are those holes in those planks?

Salesman: They're knotholes.

Carpenter: Well, if they're not holes, then what are they?

Why did Mr. Boulder go to New York City?
He wanted to see the Rockettes dance.

Where does a bad car driver keep his money?
In a crash register.

ATTENTION: Help stamp out philatelists!

Two fortunetellers were talking during a hurricane. "This wind and rain is awful," said one fortuneteller.
"I know," agreed the other. "It reminds me of the big storm of 2030."

Detective: Let's talk about this broken dinnerware.
Crook: Why. Is this a smash and gab crime?

ATTENTION: Humpty Dumpty's brains are scrambled.

ATTENTION: *Humpty Dumpty makes too many wise cracks.*

What did the ghoul buy for his haunted house?
Home Moaner's Insurance.

Where does a zombie entertain guests at his house?
In the funeral parlor.

What is a twin's favorite day of the week?
Twos day. ◀ ◀ ◀ ◀ ◀ ◀ ◀ ◀

Kenny: Why don't you come out and play?

Lenny: I have to stay in and help my father with my homework.

Lady: Driver, does this bus stop at the river?

Driver: If it doesn't, there'll be one big splash.

What monster pulls a lot of practical jokes?

Prankenstein.

What is a bride's favorite day of the week?

Weds day.

Girl: **Why are you wearing a glove on one hand? Did you lose a glove?**

Boy: **No. I found one.**

What does King Midas fish with?

A goldenrod.

Short Prisoner: I'm innocent, your honor. I did not punch a Munchkin.

Judge: This hearing belongs in small claims court.

John: Hey. Somebody just picked my pocket.

Lon: That's awful!

John: Not really. I'm so broke all he got was practice.

Chuck: Did you hear about the dumb bandit of Sherwood Forest?
Tuck: No. What happened to him?
Chuck: Robin Hood asked him to join his band and he went out and bought a guitar.

What did the ghoul say when she saw criminal ghost in the lineup?
That's the spirit!

Invisible Man: Did you miss me while I was gone?
Invisible Girl: Were you gone?

What did the lighthouse keeper play in the village orchestra?
A foghorn.

King Arthur and his army had been riding all day. At dusk the king led his men to a nearby inn. "How much do you charge for men to sleep here?" King Arthur asked the innkeeper.
The innkeeper grinned greedily. "Twenty dollars per knight," he replied.

Mailman: Does this letter belong to you? The name is obliterated.
Lady: No. I'm Mrs. Smith.

Boy: Would you like to read a magic encyclopedia?
Magician: No. I already know every trick in the book.

Hank: Why are you putting a band-aid on your paycheck?

Frank: I just got a salary cut.

What tornado tale did H.G. Wells write?
The War of the Whirls.

Where do you put a convict vampire?
In a blood cell.

What do you call a wise guy who inherits money?
A fresh heir.

YOU TELL 'EM...
You tell 'em doctor, I'm sick of talking.
You tell 'em playwright, it's your show.
You tell 'em truck driver, unload on them.
You tell 'em fitness instructor, exercise your right of free speech.
You tell 'em dog walker, you'll bow wow them.
You tell 'em Mr. Fly, now's not the time to zip your lip.
You tell 'em T-Rex, and bite their heads off.
You tell 'em Punter, they'll get a kick out of hearing this.
You tell 'em Snowball, hit them with the cold, hard facts.
You tell 'em Mr. Marksman, fire away.
You tell 'em Mr. Seating Chart, put them all in their place.

Did you hear about the convict who was allergic to jails? Every time they put him in a cell he started to break out.

What do you get if you cross Sir Lancelot and the sun?
A knight in shining armor.

Where does Sir Lancelot play tennis?
In King Arthur's court.

How did Hawkeye get into the Native American Club?
He was on the list of the Mohicans.

▶ ▶ ▶ ▶ ▶ ▶ ▶ ▶

Jenny: My boyfriend is so well trained I have him eating out of my hand.
Penny: Isn't that unsanitary?

ATTENTION: Life insurance keeps a poor man poor all his life so he can die rich.

Zack: *Did you hear about the burglar alarm?*
Mack: *No. What about it?*
Zack: *The burglar didn't hear it either and that's why he's in jail.*

What did Santa Giant say to Jack at the beanstalk?
Fee-fi-ho-ho-ho-hum!

• •

Man #1: What are those protestors outside of our building shouting?
Man #2: They're shouting, "Stop noise pollution!"

• •

Why didn't the golfer get drafted into the army?
He was fore-F.

• •

An exhausted camper stumbled into a hiker deep in a forest. "Boy! Am I glad to see you," cried the camper. "I've been lost for two days."
"Don't celebrate just yet," cautioned the hiker. "I've been lost for two weeks."

• •

Reporter: Are you really a chess master from Australia?
Boy: Check, mate.

• •

What did Attila say to his men?
Hunestly is the best policy.

• •

Marla: Whenever I'm down in the dumps I get a new pair of shoes.
Darla: I thought that's where you got them!

• •

What do you get if you cross a lady country singer and a huge emerald-colored being?
A Dolly Green Giant.

What is the biggest problem
the Cyclops has?
Finding a pair of sunglasses.

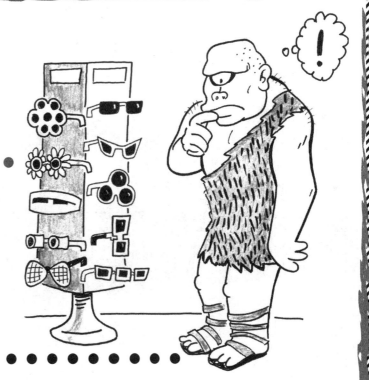

**What's hairy and strange
and goes stomp, thump,
stomp, stomp, thump?**
Big Foot tap-dancing.

*Benny: **George Washington never told a lie.***
*Jenny: **Really? Then how did he get elected president?***

Why wouldn't Jill let Jack become king?
Because he fell down and broke his crown.

What did Noah say as he loaded his Ark?
This is two much.

Lawyer: Your grandfather left you one hundred old
clocks.
Man: Gosh! I guess it'll take a long time to wind up
his estate.

**What do you get if you cross a genius with a floating
ocean marker?**
A very bright buoy.

What did Cowboy Santa say to the wagon train?
Westward Ho! Ho! Ho!

Who was Santa Claus' favorite knight in shining armor?
Sir Ivan Ho-Ho-Hoe!

What is a werewolf's favorite day of the week?
Moonday.

Joe: My uncle was afraid of flying so he took a train from New York to Los Angeles.
Moe: Did he arrive there safely?
Joe: No. A plane fell out of the sky and crashed into his train.

Tim: I wanted to drive across America in my van so I had everything that needed fixing repaired.
Jim: That sounds good. When do you leave?
Tim: Never. The work costs so much now I can't afford the vacation.

What do you get if you cross a broom and Miss America?
Sweeping Beauty.

Bald Man: *I'm in a rush. Can I buy a toupee quick?*
Wigmaker: *Sorry. I have no hair to go.*

Where does the Pope keep his Cardinals?
In birdcages.

Which king of England wore the biggest shoes?
The one with the biggest feet.

Fred: What do you call a priest, a rabbi, a pastor, and a minister all in uniform?
Jed: The Salvation Army.

Who sings hip-hop songs and sleeps for one hundred years?
Rap Van Winkle.

ALPHABET JOKES

Why did the alphabet go
to the optometrist?
It was having I trouble.

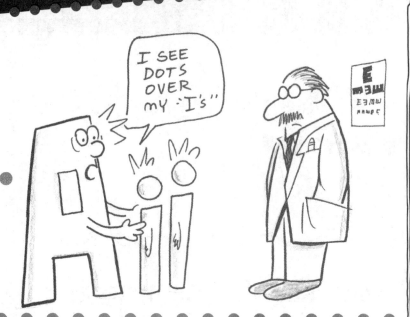

Why did the
alphabet break out
in a rash?
The B had hives.

What letters of the alphabet have good vision?
I -C.

Why did the cop give the alphabet a ticket?
It made an illegal U-turn.

Which vitamin has great vision?
Vitamin C.

Which letter makes the alphabet smarter?
Y's up.

How do you clean the 9th letter of the alphabet?
Use I wash.

What did the doctor ask the alphabet?
Is C sick?

How do you soothe a sunburned alphabet?
Use an A balm and an H balm.

Which letter of the alphabet is a sorcerer?
G Wiz.

Why did Ms. Alphabet break up with Mr. Alphabet?
He had a wandering I.

Which letter of the alphabet is very cute?
The Barbie-Q.

Which letter of the alphabet asks a lot of questions?
Y.

Which letter of the alphabet do actors rely on to perform well?
On Q.

Which letters of the alphabet are movie stars?
DVD.

Which letter of the alphabet is
the most romantic?
The V. It's always in LOVE.

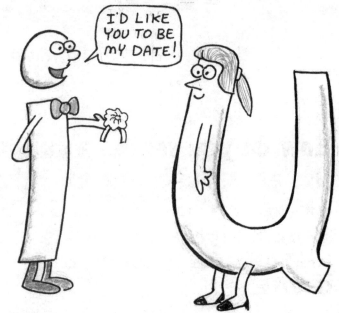

Speech bubble: I'D LIKE YOU TO BE MY DATE!

Why were Mr. and Mrs.
Alphabet so happy?
They had a new B.B.

What did Mr. and Mrs. Alphabet
say to their friends when their child was born?
C-D-B-B.

What did the alphabet say to the stranger?
L-O.

Which letter of the alphabet knows James Bond?
I Spy.

Why did the alphabet go to the dentist?
Its I teeth were aching.

Which letter of the alphabet doesn't
wear any clothes?
The naked I.

What's the difference between here and there?
The letter "T."

How did the alphabet become
a mercenary?
It joined the A-team.

What kind of soup did
the alphabet order?
P soup.

What kind of cereal did the alphabet eat
for breakfast?
Special K.

Which letter of the alphabet plays pool?
The Q.

What did the alphabet say as it
left the room?
C-U.

YOU HAVE THE RIGHT TO REMAIN SILENT!

Which letter of the alphabet
committed a crime?
E did it.

Why did the alphabet have blurred vision?
It got poked in the I.

Why is an island like the letter "T"?
They're both in the middle of water.

What does the alphabet drive on the golf course?
D-ball.

Why did the alphabet buy an alarm clock?
So it would know when it was T-time.

Why did the alphabet take a net to bed?
It wanted to catch some Zs.

◀ ◀ ◀ ◀ ◀ ◀ ◀ ◀ ◀ ◀ ◀ ◀ ◀ ◀ ◀ ◀

Which letter of the alphabet laughs like Santa?
O-O-O!

▶ ▶ ▶ ▶ ▶ ▶ ▶ ▶ ▶ ▶

What's the longest word in the dictionary?
Smiles. Because there's a mile between the first and last letters.

Which letter of the alphabet lives on a poultry farm?
The N. Ns lay eggs.

Which letter of the alphabet gobbled up the cake?
V ate it.

Which letter of the alphabet brightens up a dark room?
D light.

Where did the alphabet dig for gold?
In the B-mine.

Which two letters of the alphabet spell big trouble for your teeth?
D-K.

Why is slippery pavement like music?
Because if you don't C sharp you'll be flat.

What did the capital letters say to the jealous lowercase letters?
Y-R-U-N-V-S?

CHAPTER 2

MEDICAL MAYHEM

Why did the clothesline go to the hospital?
It had a knot in its stomach.

▶ ▶ ▶ ▶ ▶ ▶ ▶ ▶ ▶ ▶ ▶ ▶ ▶ ▶ ▶ ▶ ▶ ▶

Why did the clothesline
go to the psychologist?
Its nerves were frayed.

◀ ◀ ◀ ◀ ◀ ◀ ◀ ◀ ◀ ◀ ◀

*What did the monster
eat after the dentist
filled his sore tooth?
The dentist.*

▶ ▶ ▶ ▶ ▶ ▶ ▶ ▶ ▶ ▶

Why did the sick shoe go
to the cobbler?
It wanted to be heeled.

◀ ◀ ◀ ◀ ◀ ◀ ◀ ◀ ◀ ◀ ◀

A new patient went to see a
doctor. "Who did you consult
about your illness before you came to me?" asked the doctor.
Said the patient, "I went to the druggist down the street."
The man's reply angered the doctor who didn't like anyone
but a physician giving out medical information. "And what
idiotic advice did he give you?" snapped the doctor. Replied
the patient softly, "He told me to come see you."

▶ ▶ ▶ ▶ ▶ ▶ ▶ ▶ ▶ ▶ ▶ ▶ ▶ ▶ ▶ ▶ ▶ ▶

Doctor: The pain in your left arm is caused by old age.
Patient: But Doc, my right arm is the same age and it doesn't
hurt at all.

Patient: I'm depressed because everyone takes advantage of me.
Doctor: That's ridiculous. Don't give it another thought.
Patient: Thanks, Doc. I feel better now. How much do I owe you?
Doctor: How much do you have?

**What does a surgeon do at the end of an operation?
He makes his closing comments.**

◄ ◄ ◄ ◄ ◄ ◄ ◄ ◄ ◄ ◄ ◄ ◄ ◄ ◄ ◄ ◄

A hospital administrator was talking to a patient who demanded to be released. "Why did you jump up and run out of the operating room before your operation?" he asked the patient. "Because," the patient answered, "I heard the nurse say stop trembling and calm down. Be brave. This is just a simple operation."
"Didn't her words reassure you?" "Heck no," said the patient, "she was talking to the surgeon."

**Mad Doctor: Nurse! I see spots before my eyes.
Nurse: Relax. That's just the Invisible Man. He has the measles.**

▶ ▶ ▶ ▶ ▶ ▶ ▶ ▶ ▶ ▶ ▶ ▶ ▶ ▶ ▶ ▶ ▶

Psychologist: You are not a pocket watch?
Patient: I want a second-hand opinion.

What kind of boat does a dentist ride on?
A tooth ferry.

Patient: Doc, you have to help me. I always feel like I'm on the outside looking in.
Psychiatrist: What kind of work do you do?
Patient: I'm a window cleaner.

Nurse: What should a patient do when he's run down?

Doctor: Get the license plate of the car.

Patient to psychologist: You have to help me, Doc. I'm so depressed I have to wear a neck brace just to keep my chin up.

Girl: I wish the doctor would hurry up and see me. I'm only four years old.
Nurse: Be a little patient, dear.
Girl: I already am one.

Man: Doctor, my left ear feels hotter than my right ear. Is it an infection?
Doctor: No, your toupee is on crooked.

Mother: My 220-pound son thinks he's a trashcan.
Doctor: That's a lot of garbage.

Patient: Doc, am I really as ugly as people say I am?
Psychologist: Of course not.
Patient: Then why did you make me lie facedown on your couch?

Patient: What should I do if I can't sleep at night?
Doctor: Take naps all day long.

Lady: Doctor, my daughter thinks she's a sheet of music.
Psychologist: Bring her in and I'll take some notes.

Psychiatrist: I have a patient who thinks he's a taxicab.
Psychologist: Are you curing him?
Psychiatrist: No. Why should I? He drives me home every night.

Larry: I'm considering going to a psychiatrist.
Gary: What? Do you know how much that costs? You ought to have your head examined.

Psychologist: I think you have a duel personality.
Patient: We do not.

Patient: Help me, doctor! I just swallowed my harmonica.
Doctor: Luckily you don't play the piano.

PLINK!

Patient: What would I have to give you for a little kiss?
Nurse: Chloroform.

Why did the miner go to a podiatrist?
He had coal feet.

Patient: Help me, doctor. I think I'm a bridge.
Doctor: My! My! What's come over you?
Patient: Two trucks and a minivan.

Patient: What do you mean I'm a hypochondriac?
Doctor: Your sickness is all in your mind.
Patient: Then refer me to a psychologist.

Show me a doctor who specializes in pelvic disorders ... and I'll show you a guy with a hip job.

A doctor was talking to a patient when his nurse burst into the room. "The patient you treated before this one just collapsed on his way out of the office. What should I do?" Replied the doctor calmly, "Turn him around so he looks like he collapsed on his way in."

What does a nurse call a sunburn emergency?
Code Red.

A lady went to see a psychologist. "Doctor," she said to him. "You have to help my husband. He just won the Million Dollar Lottery and now all he does is worry about his money. "The doctor comforted the lady. "There! There!" he said. "Calm yourself. Send your husband to me and after a few months of therapy he won't have that problem anymore."

Nurse: Now the patient thinks he's a door.
Surgeon: Quick, knock him out so I can operate.

What did the patient say to the clumsy dentist?
You're getting on my nerves.

What did Dr. Oz tell the
sick Tin Man?
Go home and get plenty
of bed rust.

Doctor: What are you suffering from?
Man: Marriage.
Doctor: What? You can't suffer from marriage.
Man: Oh no? You've never met my wife.

Why did the hungry monster go to a witch doctor?
He was fed up with human doctors.

Jack: Do you still have a bad case of sunburn?
Jill: Yes, but now I'm peeling better.

Patient: My hair is falling out. What can you give me to keep it in?
Doctor: How about a paper bag?

Man: Help me, Doc. My wife thinks she's a pretzel.
Doctor: Bring her in and I'll straighten her out.

ATTENTION: Never trust a doctor who has dead plants in his waiting room.

Doctor: There's nothing wrong with you. You're just too lazy to work.
Man: What's the medical term for that so I can explain it to my boss.

Boy: If you broke your arm in two places, what would you do?
Girl: Stay out of those two places.

Patient: Doc, how do you get rid of a pain in the neck?
Doctor: Usually I give you a prescription.

TAKE TWO OF THESE AND DON'T CALL ME AGAIN!

A man went to his doctor for a checkup. After the exam the doctor gave the patient these instructions: "Take this blue pill with two glasses of water before breakfast," said the doctor. "Then before lunch take this red pill with three glasses of water. After dinner take this green pill with four glasses of water." The patient gulped. "Gee, Doc," he stammered. "This sounds serious. What's wrong with me?" "You're not drinking enough water."

A Hollywood psychiatrist received a postcard from one of her famous starlet clients who was on vacation in the South Pacific. "I'm having a wonderful time," the starlet scribbled on the card. "I wish you were here—to tell me why."

Patient: I think I'm suicidal.
Psychologist: In that case, you'll have to pay in advance.

Zack: Did you hear about the pig farmer who got swine flu?
Jack: No. What happened to her?
Zack: She went hog wild.

Kerry: Did you hear about the guy who broke his legs in a revolving door?
Jerry: No. Is he okay?
Kerry: Well, he doesn't get around much these days.

A kleptomaniac called his psychologist in the middle of the night. "Help me, Doc," he begged. "I've suddenly got the urge to steal again." The psychologist yawned, "Oh, for heaven's sake," he replied. "Go down to the drugstore, take some aspirin, and call me in the morning."

Doctor: Remember, nobody lives forever.
Patient: I hope you won't discourage me from trying, doctor.

Then there was the doctor who had a second job as a real estate agent and made lots of house calls.

Nurse: Why didn't the lady want the surgeon to operate on her husband?
Orderly: She didn't want anyone to open up her male.

ATTENTION: I'm sick of paying medical bills.

ATTENTION: Why can't the Surgeon General of the United States cure our sick economy?

Which doctor has the best voice?
The choirpractor.

Ben: My doctor told me to take a tranquilizer once a month.
Len: When?
Ben: Just before his bill arrives in the mail.

Doctor: Where does it hurt, Mr. Cherry?
Mr. Cherry: In the pit of my stomach.

Why did St. Nicholas go to a psychologist?
Because he didn't believe in himself.

Chester: How's your Aunt Charlotte?

Lester: Her memory and her health are both failing her. She can't remember the last time she felt good.

What is a podiatrist's favorite TV game show?
Heel of fortune.

ATTENTION: Podiatrists are losers. They spend all of their time with de feet.

A prison guard ran into the Warden's office. "Warden!" shouted the guard. "Ten convicts have just broken out." The Warden jumped out of his chair. "Call the state police," he shouted. "Blow all the whistles and sound the alarms. Alert the public and call for extra guards." "But Warden," interrupted the guard. "Shouldn't we call the prison doctor first? It looks like a measles epidemic."

What do you get if you cross a star and a podiatrist?
Twinkle Toes.

Patient: Please help me, doctor. I honestly believe that people don't care about anything I have to say.

Psychologist: So what?

Patient: How can I cure my double vision quickly?
Doctor: Shut one eye.

Tim: My friend is sick and I don't know what to send her to cheer her up.

Jim: Send her flowers, you dope.

Tim: But she's a florist.

Doctor: Don't you know my office hours are from nine to five and it's after five?

Patient: Yes, Doc, but the dog that bit me couldn't tell time.

Then there was the dentist who moved to Texas because he wanted to drill for oilmen.

Psychiatrist: I'm happy to say that you are cured of your delusions, Mr. Johnson. But why are you so sad?

Mr. Johnson: Wouldn't you be sad if one day you were a Hollywood movie star, a famous war hero, and a pro football player and the next day you were just an ordinary guy?

Minnie: How old is your grandfather?

Vinnie: He's at the age when all the numbers in his little black book are for doctors, nurses, and hospitals.

Ted: Did you hear about the rich hypochondriac?

Ed: No what about him?

Ted: He went around in a chauffeur-driven ambulance.

Man: I'm suing my employer because I got this bump on my head at work.

Lawyer: I bet we can get them to settle for a lump sum.

Why did the Tin Man go to a psychologist?
He was having a metal breakdown.

Cop: Why did you jump in the icy river during the middle of a blizzard just to get your hat?

Man: Because if I go without a hat in this kind of weather, I always catch a cold.

Why did Mrs. Mutant go to the doctor?
She was x-pecting a bundle of joy.

Doctor: Did those pills I gave you improve your memory?

Patient: Oops! I forgot to take them.

Patient: Did you hear what I told you? I said I'm as sick as a dog.

Doctor: Stop barking at me and sit down.

Darla: Jenny got engaged to an X-ray technician.
Carla: I wonder what he sees in her?

Joe: If that were my sore tooth, I'd have it pulled.
Moe: If it were your sore tooth, I'd agree with you.

Ned: I don't like dentists.
Ted: Why not?
Ned: They get on my nerves.

Why did the nice doctor go broke?
He never thought ill of anyone.

Patient: Doctor, you've got to help me. I'm terrified of birds.
Psychologist: Calm down, Mr. Jones. Why are you so scared of birds?
Patient: Aren't most worms?

Which famous pirate was a podiatrist?
Jean LaFeet.

Cora: I got airsick last week.
Lora: Were you in an airplane?
Cora: No. In Los Angeles.

A boy ran to his mother. "Mom, I have a splinter in my hand," he cried.

"Don't worry," replied his mom. "I'll get it out with this pin."

"What?" yelled the boy? "Don't you know using a pin is dangerous?"

"Calm down," urged the boy's mother. "It's a safety pin."

Boy: Where should I go to study the function of the human brain?

Girl: Just use your head.

Why was the old house crying?
It had windowpanes.

SIGN ON AN EYE DOCTOR'S OFFICE: If you don't see what you're looking for, you've certainly come to the right place.

Judge: Can you prove you weren't speeding?

Driver: Yes, your honor. I was on my way to a dental appointment to have a root canal.

Judge: Case dismissed.

Doctor: Do you really feel okay?

Grandfather: Yes. I'm old enough to know better.

SIGN IN A DERMATOLOGIST'S OFFICE: Give me some dead skin, dude!

LOONY EXIT LINES:

FOR LEO TOLSTOY – Rest in War and Peace.

FOR DOROTHY OF OZ – Gone with the Wind.

FOR HUMPTY DUMPTY – Rest in Pieces.

FOR BAMBI – Deerly Beloved.

FOR A BASEBALL PLAYER – Home at Last.

FOR A LAWYER – Case Closed Forever.

FOR A DETECTIVE – Arrest in Peace.

SIGN IN THE OFFICE OF A DENTIST WHO SCUBA DIVES: I do offshore drilling.

A sick man drove himself to a hospital emergency room. "My gosh," said an intern to the man. "You're in a terrible state." "B-Be fair," gasped the ill man. "New Jersey isn't that bad."

Why did the window shade go to the psychologist? It was up tight.

What did the leg bone say to the funny bone?
Your jokes fracture me.

Fred: I just burned a hundred dollar bill.
Ed: Gosh. You must be rich.
Fred: Not really. It was from my dentist.

Doctor: How much do you weigh?
Man: Two hundred and plenty.

Father: How did you make out at the pie-eating contest?
Boy: Not so good. My friend came in first and I came in sickened.

Why did the pirate take his trunk to the doctor?
It had a chest cold.

Patient: Help me, doctor. I think I'm invisible!
Doctor: Who said that?

Bill: I know an inexpensive surgeon.
Will: Does he do cut-rate operations?
Bill: No. He does cut-right operations.

NOTICE: A depressed dentist is a guy who always looks down in the mouth.

What's the best job to have in a sick economy?
Be a doctor.

Doctor: Your cough sounds better today.
Boy: It should be. I practiced all night.

What do you call a national epidemic?

Germination.

◄ ◄ ◄ ◄ ◄ ◄ ◄ ◄ ◄ ◄ ◄ ◄ ◄ ◄ ◄ ◄ ◄ ◄

Why did Humpty Dumpty go to the hospital after his fall?
He was shell-shocked.

Hiker: My doctor keeps telling me to get plenty of fresh air, but he never tells me where to find it.

Tim: I think you have bucket fever.
Jim: Why do you think that?
Tim: You look kind of pail.

► ► ► ► ► ► ► ► ► ► ► ► ► ► ► ► ► ►

Girl: Is your grandfather still in the hospital?
Boy: Yes. He's in an expensive care unit.

Lady: Doctor, my son used to love to go jogging. Now he thinks he's a car and won't run.
Doctor: Calm down. It sounds like he has a gas problem.

CHAPTER 3

DORKS AND DINGERS

Jan: Did you know it takes three sheep to make a wool sweater?
Ann: Really. I didn't even know they could knit.

Angry Man Downstairs: Hey! Didn't you hear me pounding on the ceiling?
Lady in Upstairs Apartment: Oh, don't worry about it. We were making a lot of noise ourselves.

Millie: This makeup hides the stupid zit on my chin.
Tillie: Too bad you can't make-up your mind.

Teenage girl: I'm looking for a sentimental Valentine Card.
Clerk: This one says, "To the only boy I ever loved."
Teenage girl: Great. I'll take three.

Mother: Did you fall in the mud with your new pants on?
Boy: Yes. I didn't have time to take them off.

Larry: I wish I had enough money to buy a herd of elephants.
Barry: What do you want a herd of elephants for?
Larry: I don't. I just wish I had that kind of money.

Patient: That ointment you gave me makes my arm smart.
Doctor: In that case, rub some on your head.

Teacher: Joey, I hope I didn't see you looking at Jenny's paper during the test.
Joey: I hope you didn't, too.

Lady: Have you lived on the farm all your life?
Farmer: Not yet.

▶ ▶

*Jim: I invented something that will allow people to
see through brick walls.*
Slim: What do you call it?
Jim: A window.

◀ ◀ ◀ ◀ ◀ ◀ ◀ ◀ ◀ ◀ ◀ ◀ ◀ ◀ ◀ ◀ ◀ ◀ ◀ ◀

Boy: What would you say if I asked you to go steady with me?
Girl: Nothing. I can't laugh and talk at the same time.

▶ ▶ ▶ ▶ ▶ ▶ ▶ ▶

Joey: Do cats have fleas?
Zoey: No. They have
kittens.

◀ ◀ ◀ ◀ ◀ ◀ ◀ ◀

Boy: I was a four-
letter man in
college.
Girl: Yeah. D-U-M-B!

▶ ▶ ▶ ▶ ▶ ▶ ▶ ▶

Boy: Now that we're going steady I promise to only
go out with other guys.
Girl: I promise to do that, too.

▶ ▶

*Larry: Hey, Judy, want to have a good time on
Friday night?*
*Judy: Yes, that's why I'm going out with Marty
instead of you.*

A teenage boy and a girl were discussing reincarnation. "I don't know if I'd rather come back super handsome or super intelligent," said the boy. Replied the girl, "Oh, well, either way it would be a big change."

▶ ▶ ▶ ▶ ▶ ▶ ▶ ▶ ▶ ▶ ▶ ▶ ▶ ▶ ▶ ▶ ▶ ▶ ▶

Man: I'm an entomologist. I study ants.
Boy: What do you call a person who studies uncles?

◀ ◀ ◀ ◀ ◀ ◀ ◀ ◀ ◀ ◀ ◀ ◀ ◀ ◀ ◀ ◀ ◀ ◀ ◀

Lady: My baby is two years old. He's been walking since he was eight months old.
Girl: Gee! He must be real tired by now.

▶ ▶ ▶ ▶ ▶ ▶ ▶ ▶ ▶ ▶ ▶ ▶ ▶ ▶ ▶ ▶ ▶ ▶ ▶

Tina: Must you always answer my questions with another question?
Gina: What did you say?

◀ ◀ ◀ ◀ ◀ ◀ ◀ ◀ ◀ ◀ ◀ ◀ ◀ ◀ ◀ ◀ ◀ ◀ ◀

Interviewer: What's your social security number?
Man: 182-41-0020.
Interviewer: And what's your license plate?
Man: MJP-6781.
Interviewer: And what's your cell phone number?
Man: 902-777-1928.
Interviewer: And lastly, what's your date of birth?
Man: I can't remember.

▶ ▶ ▶ ▶ ▶ ▶ ▶ ▶ ▶ ▶ ▶ ▶ ▶ ▶ ▶ ▶ ▶ ▶ ▶

Nick: My sister fell down a flight of stairs.
Rick: Cellar?
Nick: No. She can be repaired, so we'll keep her.

Darla: When I sing, people stand up and take notice.

Marla: Yeah. They notice which doors are marked "exit."

· ·

Clara: All the world is a stage.

Sara: If that's the case, why don't you get your act together?

· ·

What goes Ho! Ho! Ho! Crash?

Santa Dork falling off a roof.

· ·

Glen: Has anyone ever told you that you're very beautiful?

Jen: Why, no.

Glen: That makes sense.

· ·

Lady: I'd like to try on that red dress in the window.

Salesgirl: I'm sorry, ma'am, you'll have to use the dressing room.

· ·

Motorist: Can you balance tires?

Mechanic: No, but I can juggle sparkplugs.

· ·

Girl: You remind me of a boxer I saw last week.

Boy: Oh! Did you go to a prizefight?

Girl: No, to a dog kennel.

Dork motorist: Can you fix my directional signal?

Mechanic: What's wrong with it?

Dork motorist: One minute it blinks on. The next minute it blinks off. One minute it's on. Then it's off again.

· ·

Actor: When I perform on stage I make sure the audience is glued to their seats.

Reporter: Wow. That's a clever prank.

· ·

Jim: Did you get that quicksand joke?

Tim: No.

Jim: Just think. It'll sink in.

· ·

Can you name the dumbest letters of the alphabet?
U-R.

· ·

Mike: What happened at school yesterday?

Ike: They had to evacuate the library.

Mike: Why?

Ike: Someone found dynamite in the dictionary.

· ·

Panhandler: I haven't had anything to eat all day.

Model: Neither have I. Doesn't dieting stink?

· ·

Father: I bought your pocket calculator.

Dork: Thanks, Dad, but I don't need one. I already know how many pockets I have.

Jill: Do you want to see something swell?
Will: Sure.
Jill: Well, hit yourself in the head with a baseball bat.

Bill: I challenge you to a battle of wits.
Jill: Are you sure you have enough ammunition?

He's such a blockhead that he doesn't get dandruff.
He gets sawdust.

You were an ugly baby. A stork didn't deliver you to the hospital. It was a vulture.

Why is it that every time I look at your face I expect you to say "trick or treat"?

She's a girl with a soft heart and head to match.

Excuse me, pardner, but I think you're putting that saddle on backwards.
Is that so. Well how do you know which way I'm headed?

Jack: Why did you get expelled from barber school?
Mack: Too many cut classes.

What did Chubby Checker say
to Charles Dickens?
Look at Oliver
twist and shout.

When is the worst time of the year
for the owner of a cab company?
When it's time to pay his taxis.

Who invented the five-day work week?
Robinson Crusoe. He had all of his work done
by Friday.

Boy: I'm not my usual self tonight.
Girl: I've noticed the improvement.

Zack: I know how to enjoy life. I eat in a different
restaurant every day.
Mack: I don't tip either.

Dell: I make up poetry right out of my head.
Nell: I bet it's blank verse.

Lenny: That guy is number one on the ugly list.
Jenny: I think you forgot to count yourself.

Lonny: Why won't you go out with me? Guys like me don't grow on trees.

Bonnie: I know. They grow under rocks.

Rudy: **You've got to admit that guys like me don't grow on trees.**

Judy: **No. They swing from them.**

Jen: Did you hear Walter snoring in the back of class today? Wasn't it awful?

Len: It sure was. It woke me up.

Fire Chief: **How did the fire on your stove start?**

Ms. Dork: **The title read, "cook book." So I did.**

Man: I'd like a bottle of acetylsalicylic acid.

Druggist: You mean aspirin?

Man: Oh yeah. I can never remember that name.

Mork: Do you sleep on your left side or your right side?

Dork: Both. All of me goes to sleep at the same time.

Zack: What does "coincidence" mean?

Mack: That's strange. I was going to ask you the same thing.

Dork: Is this the other side of the street?
Mork: No. It's over there.
Dork: What? The guy across the street said it was over here.

Patron: I can't eat this soup!
Waiter: Sorry sir. I'll call the manager.
Manager: What's the trouble, sir?
Patron: I can't eat this soup.
Manager: Sorry, sir. I'll call the chef.
Chef: Yes?
Patron: I can't eat this soup.
Chef: Sorry, sir. I'll call the owner.
Owner: What seems to be the problem?
Patron: I can't eat this soup.
Owner: Why not?
Patron: I don't have a spoon.

Joe: Don't you ever use toothpaste?
Moe: Why should I? My teeth aren't loose.

Boy: Yuk! What kind of pie is this?
Girl: What does it taste like?
Boy: Sour glue.
Girl: It's apple. The peach tastes like bitter mud.

Boy: Where's the park?
Cop: This is a curb, sonny.
Boy: Then why does the sign say "Park Here"?

▶ ▶ ▶ ▶ ▶ ▶ ▶ ▶ ▶ ▶ ▶ ▶ ▶ ▶ ▶ ▶

Ms. Dork: *I haven't seen my identical twin sister in five years. When we meet again, I probably won't even recognize her.*

◀ ◀ ◀ ◀ ◀ ◀ ◀ ◀ ◀ ◀ ◀ ◀ ◀ ◀ ◀ ◀

Bart: I've just changed my mind.
Art: I hope the new one works better than the old one.

▶ ▶ ▶ ▶ ▶ ▶ ▶ ▶ ▶ ▶ ▶ ▶ ▶ ▶ ▶ ▶

Bill: My stomach aches.
Jill: That's because you have an empty stomach.
Bill: Is that why you get so many headaches?

◀ ◀ ◀ ◀ ◀ ◀ ◀ ◀ ◀ ◀ ◀ ◀ ◀ ◀ ◀ ◀

Bill: I'm tired of Jenny.
Will: Well stop running after her.

▶ ▶ ▶ ▶ ▶ ▶ ▶ ▶ ▶

What kind of foreign car does a dork drive?
A Maz-Duh.

◀ ◀ ◀ ◀ ◀ ◀ ◀ ◀

Lady: Can I put this wallpaper on myself?
Salesman: Yes, but it will look better on a wall.

A man rushed into a hardware story and shouted, "I need to buy a trap. Please hurry. I have to catch a train." The salesman looked at him and shook his head. "I'm sorry sir. We don't have any traps big enough for that."

Wife: Why are you driving so fast?
Husband: Because we're low on fuel and I want to reach the filling station before we run out of gas.

Driver's Ed. Teacher: Statistics say a man is hit by a speeding car every four minutes.
Student Driver: Gee, poor guy.

Lady: Pardon me, young man. Does this train stop at New City?
Passenger: Yes, ma'am. Just keep your eyes on me and get off one stop before I do.

Three men were staggering across a desert. One man was carrying a water jug. "If we get thirsty," said the man, "we can drink this." The second man was carrying a sack of bread. Said he, "If we get hungry we can eat this." They both looked at the third man. He was dragging a car door. "If we get hot," gasped the third man as he pointed at the car door. "We can roll down the window."

Grandmother: Will you join me in a cup of tea, dear?
Little Girl: You get in first, Granny, and then we'll see if there's any room for me.

A little girl called the local fire department because her neighbor's garage was on fire. "Tell me, little girl," said the Chief. "How do we get there?" The little girl replied, "Duh, drive a fire truck."

Girl: Why are you eating your math homework?
Boy: The teacher said it was a piece of cake.

Jill: Want to see something stupid?
Bill: Sure.
Jill: Look in a mirror!

Boy: Are you tan from the sun?
Girl: No. I'm Jan from the earth.

Rudy: I haven't spoken to my girlfriend in two days.
Judy: Gosh. Why not?
Rudy: I don't like to interrupt her.

Clara: My boyfriend talks to himself.
Sara: So does mine but he doesn't know it. He thinks I'm listening.

Cara: I just came from the beauty parlor.
Sara: It looks like they were closed.

Man: Few women admit their age.
Woman: Few men act theirs.

Boyfriend: So when did you become an animal lover?
Girl: When I started going out with you.

Girl: Are you a light sleeper?
Boy: No. I sleep in the dark.

Andy: Do you like nuts?
Sandy: Are you asking me for a date?

Joey: I call my girlfriend Snickers.
Zoey: How cute. Is that because she's so sweet?
Joey: No. She's half nuts.

Snobby Girl: Humph! Excuse me for living.
Wise guy: Okay, but don't let it happen again.

Dan: Do you think Ann could be happy with a boyfriend like me?
Fran: Maybe ... if he's not too much like you.

Jim: What's the best way to raise potatoes?
Tim: Stick 'em on your fork and lift 'em to your mouth.

RHYME TIME:
Roses are red
Violets are blue
I copied your test answers
And now I flunked too.

SIGN IN A DORK RESTAURANT: "Special today. Homemade imported caviar."

Girl: Where are you going?
Dork: I don't know. My mind is wandering and I'm just following its lead.

Then there was the dork acrobat who couldn't even flip a coin.

Gary: I've been seeing spots before my eyes.
Harry: Have you seen an optometrist?
Gary: No, just spots.

Gino: Did you ever hear the memory joke?
Dino: Yes.
Gino: Well forget about it!

Customer: Tell me waiter, does the fried fish platter come by itself?
Waiter: No, sir. I bring it to you.

A young actor went to see a producer about a job on stage. The producer asked her, "Miss, have you had any acting experience in the past?" The young lady replied, "Well a few years ago I got a big break and my leg was in a cast."

Jenny: I want to have my fortune told. Should I go to a palm reader or a mind reader?
Penny: Go to a palm reader. At least you know for sure you have a palm.

Why did the dork plant an orchard in the desert?
He wanted to grow dried fruit.

..

Captain: Our ship is sinking. Quick! Send out an S.O.S.
Dork: How do you spell that?

..

Babe: He's such a dumb jock he thinks a football coach has four wheels and is pulled by a team of horses.

..

Chef: The last cook intern we had was so dumb he tried to open an egg with a can opener.

..

Private Dork: I was in the army for five years.
Mr. Geek: Did you get a commission?
Private Dork: No. They paid me a straight salary.

DUMB IS...

- Forgetting your twin brother's birthday.
- Buying tickets for a door prize and winning a door.
- Knocking on wood for luck and getting splinters in your knuckles.
- Owning a cattle ranch and becoming a vegetarian.
- Canceling your doctor's appointment because you don't feel well enough to go out.
- Wearing a suit of armor to a masquerade pool party.

What did Noah say when the dorks got on his Ark?
There goes a pair of idiots.

Millie: If they made a clone of me I'd be twice as beautiful.
Tillie: And twice as dumb.

Mork: What do you think of the Dow Jones Average?
Dork: I don't even know which baseball team Dow Jones plays for.

Why didn't the Dork Brothers invent the airplane?
They didn't have the Wright material.

Dell: I could really go for a girl like you.
Nell: Really? So get going.

GO FARTHER!

What did the geek's brother nail to their front door?
A Beware of the Dork sign.

Girl: I love men who are frank.
Boy: Well, I guess I'll be seeing you. My name is Joe.

A dork got into an elevator. He glanced at the elevator operator and said, "Take me to the sixth floor." The elevator operator looked back at the dork and replied, "I'm sorry sir, but I can't do that. This building is only five stories high." The dork scratched his head. "In that case," said he, "take me to the third floor twice."

Boy: **It's a good thing someone invented electricity.**
Girl: **Why?**
Boy: **I don't think I'd enjoy watching TV by candlelight.**

Girl: Humph! You're not so smart. In fact, you're the closest thing to an idiot I've seen.
Boy: In that case, I'll move away from you.

Dorky was visiting his friend Mork on a winter's day when a blizzard struck unexpectedly. For hours the snow built up making conditions dangerous outside. "I think you'd better stay over at my house tonight," Mork said to Dorky. "Okay, Mork," Dorky replied. Then Mork watched in shock as Dorky put on his hat and coat and headed toward the door. "Hey! Where are you going?" Mork shouted. "Aren't you spending the night here?" "Sure, I am," Dorky replied. "I'm just going home to get my dog. He doesn't like being home alone at night."

"Hey Dorky, congratulations," Mork called to his geeky pal. "I heard your aunt had twins. Did she have two boys or two girls?" Dorky stopped to ponder the question. "I think she had a boy and a girl," Dorky replied. Then he scratched his head and added, "However, I'm not really sure. It may be the other way around."

Geek: Did you know statistics claim every time I breathe someone dies?

Dude: Try using stronger mouthwash, Bro.

Boy: Do you know where I'd be if I had a million dollars?

Girl: Yeah. In jail for counterfeiting.

Ike: Do you make up these jokes yourself?

Mike: Yup. Out of my head.

Ike: You must be.

Chester: Hey! I have a great idea!

Lester: It must be beginner's luck.

Jack: Oops! Pardon me for walking on your feet.

Mack: That's okay. I often walk on them myself.

Girl: You should have been born during the Dark Ages.

Boy: Why?

Girl: Your face looks awful in the light.

And then there was the dumb baseball player who took his mitt to the lake to catch fish.

Tim: My classmates think I'm going to be a comedian someday.
Jim: How do you know that?
Tim: In our senior poll, they voted me the student most likely to be laughed at as an adult.

A large and varied group of guests attended a big Washington party. One guest turned to a stranger and asked, "Have you heard the latest dumb White House employee joke?" "No," admitted the stranger, "but I must warn you. I work at the White House." "Don't worry about that," answered the joker, "I'll tell it very, very slowly."

A young boy really liked a new girl who just moved into town. "I'm not rich, so I don't have a beach house or a new sports car like Martin Rogers," said the boy to the girl. "But I really, really care for you." Answered the girl, "I care for you, too, but tell me more about this Martin Rogers and how I can meet him."

Dork: Sometimes Christmas annoys me.
Mork: Why is that?
Dork: It always comes when the stores are crowded.

Mork: What are you doing?
Dork: I'm sending this package to myself.
Mork: Isn't that expensive?
Dork: Nah. I'm sending it C.O.D.

What is a dork's best baseball pitch?

A knucklehead ball.

Mr. Dork: *I invented a refrigerated stove.*
Mrs. Geek: *What do you use it for?*
Mr. Dork: *To cook cold suppers.*

▷ ▷ ▷ ▷ ▷ ▷ ▷ ▷ ▷ ▷ ▷ ▷ ▷ ▷ ▷ ▷ ▷ ▷

Dork: If I doze off, wake me up at midnight.
Mork: Why?
Dork: That's when my doctor told me to take my sleeping pills.

◁ ◁ ◁ ◁ ◁ ◁ ◁ ◁ ◁ ◁ ◁ ◁ ◁ ◁ ◁ ◁ ◁ ◁

Boy: What makes you think I'm stupid?
Girl: Well, yesterday I said hello to you and you couldn't think of an answer.

▷ ▷ ▷ ▷ ▷ ▷ ▷ ▷ ▷ ▷ ▷ ▷ ▷ ▷ ▷ ▷ ▷ ▷

Larry: Did you hear about the dork lifeguard who drowned?
Gary: No. How awful! What happened?
Larry: He jumped in the pool and forgot he knew how to swim.

◁ ◁ ◁ ◁ ◁ ◁ ◁ ◁ ◁ ◁ ◁ ◁ ◁ ◁ ◁ ◁ ◁ ◁

Porky: What are you doing?
Dorky: I'm writing a letter to myself.
Porky: What does it say?
Dorky: I won't know that until the postman delivers it.

▷ ▷ ▷ ▷ ▷ ▷ ▷ ▷ ▷ ▷ ▷ ▷ ▷ ▷ ▷ ▷ ▷ ▷

Director: You'd be a terrific tap dancer except for two things.
Dancer: What are they?
Director: Your feet.

◁ ◁ ◁ ◁ ◁ ◁ ◁ ◁ ◁ ◁ ◁ ◁ ◁ ◁ ◁ ◁ ◁ ◁

Girl: Where did you learn to swim?
Boy: In the water.

Harry: Are you okay, Gary?
Your face is flushed.
Gary: How many times do I have
to tell you to knock off
the bathroom humor?

▶ ▶ ▶ ▶ ▶ ▶ ▶ ▶ ▶ ▶ ▶ ▶ ▶ ▶ ▶ ▶ ▶ ▶ ▶

Mork: What's the weather like outside?
Dork: It's so foggy out there I can't tell.

◀ ◀ ◀ ◀ ◀ ◀ ◀ ◀ ◀ ◀ ◀ ◀ ◀ ◀ ◀ ◀ ◀ ◀ ◀

Zack: **We came to this restaurant to enjoy a good meal. What are you staring at?**
Dork: **My coat! I hung it on the rack over there next to yours.**
Zack: **Stop watching our coats and eat your food.**
Dork: **I'm not watching our coats. Yours disappeared twenty minutes ago.**

▶ ▶ ▶ ▶ ▶ ▶ ▶ ▶ ▶ ▶ ▶ ▶ ▶ ▶ ▶ ▶ ▶ ▶ ▶

Dork: I have absolutely no flaws.
Mork: I agree. You're a perfect idiot.

◀ ◀ ◀ ◀ ◀ ◀ ◀ ◀ ◀ ◀ ◀ ◀ ◀ ◀ ◀ ◀ ◀ ◀ ◀

Then there was the dork who tried to start a metal Christmas tree farm. He went broke fast. Now he's trying to hunt down the wise guy who sold him 5,000 aluminum pinecones.

▶ ▶ ▶ ▶ ▶ ▶ ▶ ▶ ▶ ▶ ▶ ▶ ▶ ▶ ▶ ▶ ▶ ▶ ▶

Dork: How long can a person who is brain dead live, Doc?
Doc: I'm not sure. How old are you?

Tillie: Did you fill in that blank yet?
Billy: What blank?
Tillie: The one between your ears.

Why did the dork plant birdseed? He wanted to grow canaries and parakeets.

Why did the dork go to the department store the day after Christmas?
To exchange the gift certificate his aunt gave him.

Judge: You are charged with running over a man's foot and speeding. How do you plead?
Lady: Guilty and not guilty.
Judge: Huh?
Lady: I ran over his foot, but I was just trying to get over it as fast as possible.

NOTICE: Keep America beautiful. Deport ugly people.

Mork: That new kid told me I look just like you.
Dork: Where is he now?
Mork: In the nurse's office. I slugged him.

Nurse: I'm the doctor's nurse.
Patient: Oh, is he sick, too?

Fay: My grandfather used to be a handwriting expert.
Ray: What's that?
Fay: He was an expert on telling one person's handwriting from another.
Ray: No, what's handwriting?

Why couldn't the dork work as an elevator operator?
He didn't know which way was up.

Joe: Don't insult my intelligence. I went to college, stupid!
Moe: And you came back the same way!

Mork: Do you think it's true that dumb people have an attention problem?
Dork: Huh? Did you say something?

What do you get if you cross a dork and a question mark?
A dumb question.

Why did the dork put bullets on the stove?
He thought it was a pistol range.

POPCORN ANYONE?

POW!
POP!
ZING!
PING!

Mork: Why did you turn down the free trip around the world?

Dork: Hey! I wanted to go someplace else, that's why.

What do you call a 2,000-pound dork?
A simple ton.

Then there was the English teenager from London who was very sad because he tried to kiss his girlfriend in the fog and mist.

Boss: Homer! Wake up! If you want to sleep, go home!

Homer: I can't do that, sir. I won't get paid to sleep at home.

Mork: Do you know the name of our national anthem?

Dork: Hmm. That question is a star spangled brainer.

Mork: Just because the whole world is a stage, you don't have to go around acting stupid.

Dork: Hey. I don't know how to act.

Where do dork football players go to college?
They go to the University of Notre Dumb.

Boy: I bet you wouldn't go out with me in a million years.

Girl: That's not true. Ask me for a date again a million years from now.

Boy: Keep an open mind.
Girl: Maybe that's why you're such an airhead.

- - - - - - - - - -

Girl: Say something soft and sweet to me.
Boy: Marshmallow.

- - - - - - - - - -

Restaurant Owner: Have you filled the saltshakers yet?
Dork: No sir. It's hard pushing the salt through those little holes.

- - - - - - - - - -

Tim: I can't start the outboard motor.
Jim: All it takes is a jerk on the cord.
Tim: In that case you'd better try it.

- - - - - - - - - -

Why didn't the dork have mince pie for Thanksgiving?
Because he went hunting for a mince, but couldn't find any.

- - - - - - - - - -

Dork: This matchstick won't light.
Geek: What's wrong with it?
Dork: I don't know. It lit before.

- - - - - - - - - -

Jack: Mary fell in love with me at first sight.
Zack: Quick. Ask her to go steady before she takes a second look.

Larry: Thinking too much always gives me a pain in the rear end.

Barry: I always figured that's where your brain was located.

Mother: **Where are you going with the watering can?**
Dork: **Out to water my garden.**
Mother: **But it's raining out.**
Dork: **Oh, silly me. I'll put on my raincoat first.**

◀ ◀ ◀ ◀ ◀ ◀ ◀ ◀ ◀ ◀

Boss: *Do you know what the motto of our company is?*
Employee: *Sure. It's push!*
Boss: *What gave you that silly idea?*
Employee: *Well that's what it said on the entrance to the building.*

Robber: What will it be? Your money or your life?

Banker: My life. I'm saving my money for my old age.

How do you perform a stupid waltz?
First learn some dunce steps.

▶ ▶ ▶ ▶ ▶ ▶ ▶ ▶ ▶ ▶ ▶ ▶ ▶ ▶ ▶ ▶

Girl: Do you have holes in your socks?
Boy: Of course not!
Girl: Then how do you get your feet into them?

Zack: Why don't you buy a concrete swimming pool?

Jack: What for? I don't want to swim in concrete.

WACKY WORDS OF WISDOM

Do unto others as you would have them do unto you...unless you are a mugger.

Land developers make molehills out of mountains.

People who keep their ear to the ground end up with dirt on the side of their face.

Time heals all wounds and is cheaper than going to the doctor's.

People who live in glass houses get arrested for indecent exposure.

The road of life is a rocky one for gangsters... and sometimes they get bumped off.

When opportunity knocks, look through the peephole first just to be safe.

Man does not live by bread alone, but if you have a lot of dough you can buy everything you need.

▶ ▶ ▶ ▶ ▶ ▶ ▶ ▶ ▶ ▶ ▶

A man's best friend is his dog, but only after it's housebroken.

◀ ◀ ◀ ◀ ◀ ◀ ◀ ◀ ◀

Time waits for no man, but of course you can get a second opinion on that.

▶ ▶ ▶ ▶ ▶ ▶ ▶ ▶ ▶

Misery loves company, so share your cold or flu with a friend.

The sky's the limit...well; it used to be until we landed on the moon.

▶ ▶ ▶ ▶ ▶ ▶ ▶ ▶ ▶ ▶ ▶

Great men are made not born, but steroid use is dangerous and illegal.

◀ ◀ ◀ ◀ ◀ ◀ ◀ ◀ ◀

Every dark cloud has a silver lining, which is probably some form of air pollution.

▶ ▶ ▶ ▶ ▶ ▶ ▶ ▶ ▶ ▶

It's not if you win or lose, but how you play the game, unless there's big money riding on the outcome of the contest.

◀ ◀ ◀ ◀ ◀ ◀ ◀ ◀ ◀ ◀

Love is blind, but ugliness is a frightful sight to behold.

▶ ▶ ▶ ▶ ▶ ▶ ▶ ▶ ▶ ▶ ▶

The path of true love never runs smooth, so expect a few lumps and bumps if you argue with your wife.

Life is short; so don't waste it telling tall tales about how great you are.

▶ ▶ ▶ ▶ ▶ ▶ ▶ ▶ ▶ ▶

Rules are made to be broken, but if you follow that advice, remember that jails are made not to be broken out of.

◀ ◀ ◀ ◀ ◀ ◀ ◀ ◀ ◀

Silence is golden, unless you're a paid police informant. Then money talks loudly.

▶ ▶ ▶ ▶ ▶ ▶ ▶ ▶ ▶ ▶

No man is an island, unless your name is St. Thomas.

◀ ◀ ◀ ◀ ◀ ◀ ◀ ◀ ◀

The bigger they are, the harder they fall and if they're football linemen, sometimes they fall on top of you, so look out.

▶ ▶ ▶ ▶ ▶ ▶ ▶ ▶ ▶ ▶

There's no fool like an old fool, so if you're a senior citizen it's not too late to fool around.

There's no place like home, unless you live in a bad neighborhood.

◀ ◀ ◀ ◀ ◀ ◀ ◀ ◀ ◀

There's no place like home, unless you're homeless.

▶ ▶ ▶ ▶ ▶ ▶ ▶ ▶ ▶ ▶

Beauty is only skin deep, and nobody cares if you have ugly bones.

◀ ◀ ◀ ◀ ◀ ◀ ◀ ◀ ◀

Honesty is the best policy, unless you can cheat and get away with it.

▶ ▶ ▶ ▶ ▶ ▶ ▶ ▶ ▶ ▶

Time waits for no man and neither do Amtrak trains.

◀ ◀ ◀ ◀ ◀ ◀ ◀ ◀ ◀

Absence makes the heart grow fonder. Ha! Who wants to visit their dentist more than one or twice a year?

▶ ▶ ▶ ▶ ▶ ▶ ▶ ▶ ▶ ▶

An elephant never forgets. Big deal! What does it have to remember?

CHAPTER 4

SPORTS SNICKERS

Boy: Have you ever heard of the invisible golf course or the unknown country club?

Golfer: No. Where are they located?

Boy: They're the missing links.

What do you call a photograph of a baseball hurler hanging on the wall?
A pitcher framed.

Where do baseball batting champions march?
In a hit parade.

SIGN ON A WEIGHT ROOM: "The weak ends here."

Who is the laziest person in sports?
The coach potato.

Penny: How many slopes did they have at the ski resort you went to?

Jenny: Three. There was a beginners' slope, an intermediate slope, and lastly, the call-an-ambulance slope.

Rick: **Do you ever take an illegal golf shortcut?**
Nick: **No. I always play the fairway.**

What kind of cookies do baseball players eat in Maryland?
Baltimore Oreos.

Nell: I'm a White Sox fan.
Dell: I'm a Red Sox fan.
Mel: I'm a fan of going barefoot.

What does a prizefighter wear on a hot day?
Boxer shorts.

What does a golfer who can't get a date use to hit his ball?
A lonely hearts club.

NOTICE: A caddy who stands behind a golfer and tells him how to hit the ball is a backseat driver.

What toy did the quarterback ask Santa to bring him?
A set of blocks.

KOOKY QUESTION:
Does a baseball hurler eat with a pitchfork?

Zack: I'm not much of an athlete.

Mack: What do you mean?

Zack: I got tennis elbow playing golf.

SIGN ON A GOLF COURSE- Children's playground ahead. Drive carefully.

What do you get if you cross a busy highway with a skateboard?
A trip to the hospital.

Golfer: Have you noticed any improvement since last year?

Caddy: Yes. You bought a new set of clubs.

Which country makes the best rods and reels?
Fishing Pole Land.

Why did the cherry pull its car off the racetrack?
It was time for a pit stop.

What did the boxer say to the passing tornado?
Can I go around with you?

Wife: Why do you have to play golf every Saturday?
Husband: A steady diet of greens makes a person healthy.

When is the best time to play golf?
At fore o'clock.

ATTENTION: If someone says, "I love tennis," do they have zero interest in sports?

▶ ▶ ▶ ▶ ▶ ▶ ▶ ▶ ▶ ▶

What do poker players like to get in December?
Christmas cards.

◀ ◀ ◀ ◀ ◀ ◀ ◀ ◀ ◀ ◀

What does a winning NASCAR driver have?
wheels of fortune.

▶ ▶ ▶ ▶ ▶ ▶ ▶ ▶ ▶ ▶

Why did the egg quit the baseball team?
It couldn't crack the starting lineup.

◀ ◀ ◀ ◀ ◀ ◀ ◀ ◀ ◀ ◀ ◀ ◀ ◀ ◀

*Reporter: **When do you get to hit?***
*Baseball player on bench: **Only in a pinch.***

▶ ▶ ▶ ▶ ▶ ▶ ▶ ▶ ▶ ▶ ▶ ▶ ▶ ▶ ▶ ▶

Why was the football halfback arrested?
It was a fell-on-knee offense.

◀ ◀ ◀ ◀ ◀ ◀ ◀ ◀ ◀ ◀ ◀ ◀ ◀ ◀ ◀

Why did the detective take the baseball players to the police station?
To put them in his lineup.

▶ ▶ ▶ ▶ ▶ ▶ ▶ ▶ ▶ ▶ ▶ ▶ ▶ ▶ ▶ ▶ ▶

Then there was the plumber who took up golf because he wanted to sink a putt.

◀ ◀ ◀ ◀ ◀ ◀ ◀ ◀ ◀ ◀ ◀ ◀ ◀ ◀ ◀ ◀

Band Student: Our school orchestra played Beethoven last night.
School Athlete: Who won?

What did the salt cheerleaders do?
They held a pepper rally.

▷ ▷ ▷ ▷ ▷ ▷ ▷ ▷ ▷ ▷ ▷ ▷ ▷ ▷ ▷ ▷ ▷

Why did the golfer get a ticket?
He was driving without a license.

◁ ◁ ◁ ◁ ◁ ◁ ◁ ◁ ◁ ◁ ◁ ◁ ◁ ◁ ◁ ◁ ◁ ◁

How do pool players play poker?
They use cue cards.

▷ ▷ ▷ ▷ ▷ ▷ ▷ ▷ ▷ ▷ ▷ ▷ ▷ ▷ ▷ ▷ ▷ ▷

What kind of boat did Babe Ruth own?
A dugout canoe.

◁ ◁ ◁ ◁ ◁ ◁ ◁ ◁ ◁ ◁

What do you call a
quick sketch of Derek Jeter?
A Yankee doodle.

▷ ▷ ▷ ▷ ▷ ▷ ▷ ▷ ▷ ▷ ▷

Where did the baseball
player's union stage a rally?
In the strike zone.

◁ ◁ ◁ ◁ ◁ ◁ ◁ ◁ ◁ ◁ ◁ ◁ ◁ ◁ ◁ ◁ ◁ ◁

Why was Mr. Locomotive so proud?
His son was a track star.

▷ ▷ ▷ ▷ ▷ ▷ ▷ ▷ ▷ ▷ ▷ ▷ ▷ ▷ ▷ ▷ ▷ ▷

Why do basketball players spend so much time at home?
Because they're not allowed to travel.

ATTENTION: Did you hear about the artist who wanted to be a color man for TV sports broadcasts?

..

Then there was the tennis player who became a chef because he wanted to serve dinner.

..

Why did the NASCAR driver buy four toupees?
His car had bald tires.

..

Fran: Did you hear about the hairdresser who became a bodybuilder?
Jan: No.
Fran: Now she's curling iron.

..

What do you get if you cross a good poker player with a golfer?
The Ace of Clubs.

..

ATTENTION: Fishermen like to hum catchy tunes.

..

What happened to the couch potato who tried to play quarterback?
He got sacked.

..

What did the driver say to the putter?
Let's go clubbing.

What do you call a high school golfer?
A student driver.

How do you light a fire under a lazy prizefighter?
Use a boxing match.

What do you call a funny bodybuilder?
A hee he-man.

What did one sprint car racer say to the other?
This job is getting to be a real drag.

Show me a picnic meal outside of a baseball dugout...and I'll show you players who step up to the plate.

What job did the bad golfer have at the deli?
He sliced cold cuts.

Which sports channel do vipers watch?
E-Hiss-P-N.

Jack: I jumped over a guy from Poland.
Mack: I guess that makes you a pole vaulter.

What did one golf club say to the other?
Let's go for a drive.

What did the Irish golfer carry for luck?
A fore-leaf clover.

Why did the quarterback name his favorite pass play the Traffic Light?
Because it was a stop-and-go pattern.

Joe: I can tell you the score of any football game before the opening kickoff.
Moe: That's astonishing.
Joe: Not really. It's always zero to zero.

What kind of tennis did they play on Noah's Ark?
Doubles.

What did the boxer say to the blackjack dealer?
Count me out.

What do you get when you don't refrigerate a jock?
A spoil sport.

What is a couch potato's best golf stroke?
A chip shot.

What do you get if you cross electricity and an athlete?
A shock jock.

Which football play do flies hate the most?
A screen play.

Why did the football lineman go to a psychologist?
He was having problems with a mental block.

◄ ◄ ◄ ◄ ◄ ◄ ◄ ◄ ◄ ◄ ◄ ◄ ◄ ◄ ◄ ◄ ◄ ◄

When do boxers wear gloves?
When it's cold outside.

Father: I wish I'd brought our big-screen TV set with us.
Boy: Why? We're outside Yankee Stadium.
Father: I left our tickets to the ball game on top of it.

Who invented the game of golf?
Our forefathers.

► ► ► ► ► ► ► ► ► ► ► ► ► ► ► ► ► ►

What did the baseball manager say to his new infielder?
If at first you don't succeed, we'll try you at second or third base.

Why did the corn farmer hire prizefighters?
He wanted them to box his ears.

What casts spells and plays croquet?
A wicket witch.

What did the baseball pitcher put on the floors of his house?
Throw rugs.

Then there was the Australian athlete who bought a new boomerang and went crazy trying to throw the old one away.

Why did the mailman become a NASCAR driver?
He wanted to be in the post position.

Why didn't the Olympic diver run for political office?
He had no platform.

Mickey: My wife says she'll leave me if I don't give up golf.
Ricky: What are you going to do?
Mickey: I'm going to miss her a lot.

What do you get when surfers riot?
A beach brawl.

Two little league teams were battling it out when a spectator walked up. "What's the score?" he asked the coach of one team. "We're losing 30 to 0." The spectator was stunned. "That's terrible," he remarked. "Why don't you just forfeit the game?" The coach glared at the spectator. "What for?" he snapped. "We haven't even been up yet."

What does a librarian play golf with?
A book club.

Then there was the baseball batter who got a job with a boxer as a hitting instructor.

What do you get if you cross lots of mud with NASCAR drivers?
A stuck car race.

Where did the judge play on the court softball team?
Nowhere. The judge was on the bench.

ATTENTION: Is a bad golfer a bogeyman?

A ticket clerk came up to the manager of a minor league baseball team. "Three guys outside asked for free passes," said the clerk. "They claim they're friends of the home-plate umpire." "Ha!" scoffed the manager. "They're lying. No umpire alive has three friends."

Golfer: I cut ten strokes off my golf game today.
Caddy: How did you do that?
Golfer: I didn't play the last hole.

Guy: Look at those golf clubs on top of that funeral car. That fella must have really loved golf.
Man: He still does. That's his wife in the car. After the funeral he's going right to the golf course.

CRAZY QUESTION: Do pro boxers make money hand over fist or fist over hand?

Why did the ghost win
a football scholarship?
He was a boochip athlete.

MOST TEAM SPIRIT

Why did the boxer wear a
tutu and ballet shoes?
He wanted to dance around the ring.

Show me a boxer who throws short, quick punches at an opponent in the ring...and I'll show you a fighter getting on-the-jab training.

Golfer: I've never played so badly.
Caddy: You mean you've played before?

Who do you get if you cross a great centerfielder with a cornfield?
Willie Maize.

What did the football coach say to the glue cornerback?
Stick to the wide receiver on this next play.

How do you catch a Miami Dolphin?
Use tackle.

What does an Miami basketball fan do in the winter?
He or she turns on the Heat.

Soccer player: **What should I do if someone kicks the ball high in the air?**
Coach: **Just use your head.**

A former pro football player held a press conference to announce the opening of his new furniture outlets. Said the former gridiron star, "Before long I expect my stores to be the nation's top chairleaders in furniture sales."

What do you get if you cross a firefly with a famous hitter known as "the Yankee Clipper"?
Glow DiMaggio.

Who is the meanest home-run hitter in history? Babe Ruthless.

What is Captain Hook's favorite baseball team?
The Pittsburgh Pirates.

Which Hall of Fame baseball player became a shoe repairman?
Ty Cobbler.

Mel: My dad is crazy about jogging. My brother is crazy about jogging. I'm crazy about jogging.
Nell: It sounds like jogging runs in your family.

NOTICE: Wrestlers don't wear boxer shorts.

Reporter: Tell us, Mr. Jordan, what kind of underwear do you wear and please be brief.

KOOKY QUESTION: Do professional boxers have to punch a time clock when they work out?

Reporter: What's it like to ride in the Tour de France year after year after year?
Lance: It's a vicious cycle.

Coach: Yesterday the snail athletes held their 100-yard dash.
Reporter: Who won?
Coach: I don't know. We're still waiting for someone to finish.

Which football player is the least trustworthy?
The quarterback sneak.

What sport do athletic rodents play?
Mice hockey.

Who is the world's best Egyptian basketball player?
Ali Hoop.

Bowler #1: When are you going to knock down those remaining pins?
Bowler #2: When I have some spare time.

What has a cow at shortstop, a sheep in centerfield, and a pig on the pitcher's mound?
A baseball farm team.

What do you call four disorganized people playing tennis?
Mixed-up doubles.

What do you get if you cross a martial-arts expert with a young goat?
The Karate Kid.

Why did the vampire become a NASCAR driver?
He always wanted to be a Drac racer.

Why did the football player wear a blank jersey?
He had an unlisted number.

What is a hobo's favorite pass play?
A down-and-out pattern.

What should you do if you don't like a kickoff?
Just return it.

◀ ◀ ◀ ◀ ◀ ◀ ◀ ◀ ◀ ◀ ◀ ◀ ◀ ◀ ◀ ◀ ◀

How do you get a full backfield?
Feed them a big meal before the game.

Who delivers football fan mail?
The goal postman.

What do you call a blizzard in the middle of a football game?
A big halftime snow.

Show me a football star who hangs his laundry out to dry...and I'll show you a quarterback standing behind his line.

Defensive lineman: Hey, quarterback. Will you run a play already!
Quarterback: Okay, but don't rush me.

What Hall of Fame linebacker has webbed feet?
Duck Butkus.

Which pro football team is named after a small bottle of pop?
The Mini-soda Vikings.

▶ ▶ ▶ ▶ ▶ ▶ ▶ ▶ ▶ ▶ ▶ ▶ ▶ ▶ ▶ ▶ ▶

What's the biggest difference between pro wrestling and pro football?

In wrestling there are no holding penalties.

◀ ◀

How do you stop a team from using fly patterns?
Try a screen play.

What has wings and plays defensive line?
A flying tackle.

Why did the fullback wear swimming trunks?
The coach told him to run some dive plays.

What does a football team use on a rainy day?
An umbrella defense.

What has soft feathers and weighs three hundred pounds?
A down lineman.

What is the cleanest play in football?
A sweep play.

How do offensive linemen celebrate a victory?
They throw a block party.

Which football player tells the best sports stories.
The tale-back.

Why was Santa golfer so happy?
He made a ho-ho-hole in one.

Why was the baseball player's mom so happy?
Because her son reached home safely.

Mr. Cereal: **What do you want to do today?**
Mr. Milk: **Let's bowl together.**

Show me a hockey player wearing ice skates...and I'll show you an athlete who is slipshod.

Show me an athlete kangaroo who plays pro basketball...and I'll show you a player with a fantastic jump shot.

SLAM DUNK!

Which fish is the best basketball player in the ocean?
Mackerel Jordan.

ATTENTION: Smart plumbers who play golf know how to sink putts.

Fisherman: Not only am I a great fish catcher, I'm also a good basketball player.
Reporter: Oh, really?
Fisherman: Absolutely. I have a terrific hook shot.

What did the angry umpire say to the bald baseball coach.
You're outta' hair!

Basketball player: You're giving me a speeding ticket?
Cop: Just think of it as a traveling violation.

Ryan: What do you think of Ivy League football?
Brian: It's vine with me.

NOTICE:

The Navy football team was penalized for trying to sneak a sub into the game.

Air Force football players are New York Jet supporters.

West Point football players always pay attention to formations.

Knock! Knock!
Who's there?
Irish.
Irish who?
Irish Notre Dame went undefeated every football season.

What is a Western gunfighter's favorite football play?
The draw play.

What do you get if you cross a running back with a sledgehammer?
A fullback who hits the line hard and breaks through a wall of tacklers.

Why did the football leave the stadium?
The punter kicked it out.

How did the quarterback celebrate Father's Day?
He threw a pop pass.

What do you get if you cross a pro wrestler with a defensive end?
A lineman who really throws the quarterback for a loss.

Why did the jogger take up acting?
He wanted a part in a long-running play.

What kind of shirts do
golfers wear?
Tee shirts.

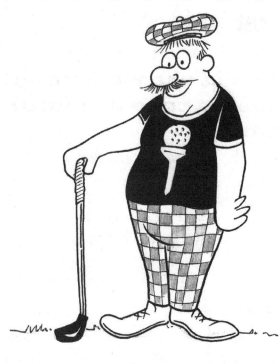

NOTICE: A pro hockey goalie has a
net income.

DAFFY DEFINITION:
Wrestling Mat – a pin cushion.

Why is a hockey goalie like
the Lone Ranger?
They're both masked men.

What's the hottest part of a tennis contest?
The end of the match.

Coach: **Do you want jelly on your toast?**
Basketball player: **No. I'll jam it.**

Where did King Henry the VIII play tennis?
On his royal court.

What is Smokey the Bear's favorite ice hockey team?
The New York Forest Rangers.

What is a merman's favorite sport?
Water polo.

Why did the patient with amnesia take up distance running?
He hoped it would jog his memory.

What do you get if you cross a tennis player and a comedian?
A court jester.

MESSAGE ON A BASEBALL PLAYER'S CELL PHONE:
"Sorry, I'm out."

Show me a grimy billiards expert...and I'll show you an athlete who plays dirty pool.

DAFFY DEFINITION:
NASCAR Pit Crew - people who tire quickly.

Show me a baseball player who received a foreclosure notice...and I'll show you an athlete who will be out at home.

Farmer Hitter: I just hit the ball into the chicken coop. That's a home run.
Farmer Fielder: No way! The chicken coop is fowl territory.

What do you call an angry person who competes in a marathon?
A very cross country runner.

YOU TELL 'EM SPORT

You tell 'em football center... and snap it up!

You tell 'em heavyweight champ...you know the punch line.

You tell 'em soccer player... we'll all get a kick out of the story.

You tell 'em tight end... they'll catch on.

You tell 'em pitcher...you have a funny delivery.

You tell 'em NASCAR driver...and don't race through the story.

You tell 'em quarterback... I'll pass up the chance.

You tell 'em hockey player... and no slips of the tongue.

You tell 'em golfer...and drive home your point.

You tell 'em tennis star...and give them some lip service.

You tell 'em sprinter...you're a fast talker.

You tell 'em jogger...but don't run off at the mouth.

What did the baseball pitcher say to the blackjack dealer?
Don't you dare hit me.

What kind of defense did the vampire basketball team use?
A twilight zone.

What do you get if you cross a prizefighter with a fast baseball pitcher?
A boxer who is hard to hit.

What did the golf ball say to the duffer?
You drive me wild.

Where do pigs play baseball?
At the ballpork.

▷ ▷ ▷ ▷ ▷ ▷ ▷ ▷ ▷ ▷ ▷ ▷ ▷ ▷ ▷ ▷ ▷ ▷ ▷

What does an owl cheerleader shout?
Who-ray for our team!

◁ ◁ ◁ ◁ ◁ ◁ ◁ ◁ ◁ ◁ ◁ ◁ ◁ ◁ ◁ ◁ ◁ ◁ ◁

What do you get if you cross a library with a golfer?
Book clubs.

▷ ▷ ▷ ▷ ▷ ▷ ▷ ▷ ▷ ▷ ▷ ▷ ▷ ▷ ▷ ▷ ▷ ▷ ▷

What did the boxer say to the ref when he got knocked down?
You can count on me.

◁ ◁ ◁ ◁ ◁ ◁ ◁ ◁ ◁ ◁ ◁ ◁ ◁ ◁ ◁ ◁ ◁ ◁ ◁

What kind of fans follow the New York Jets?
Just plane folks.

▷ ▷ ▷ ▷ ▷ ▷ ▷ ▷ ▷ ▷ ▷ ▷ ▷ ▷ ▷ ▷ ▷ ▷ ▷

What did the weightlifter say after bench-pressing a three-hundred-pound barbell?
Phew! That's a load off of my chest.

◁ ◁ ◁ ◁ ◁ ◁ ◁ ◁ ◁ ◁ ◁ ◁ ◁ ◁ ◁ ◁ ◁ ◁ ◁

NOTICE: Hockey players are not cold-hearted athletes.

▷ ▷ ▷ ▷ ▷ ▷ ▷ ▷ ▷ ▷ ▷ ▷ ▷ ▷ ▷ ▷ ▷ ▷ ▷

What do you get if you cross a speedy skier with something that removes pencil marks?
A downhill eraser.

◁ ◁ ◁ ◁ ◁ ◁ ◁ ◁ ◁ ◁ ◁ ◁ ◁ ◁ ◁ ◁ ◁ ◁ ◁

What did the ball say to the golf coach?
Putt me in, coach.

What do jockeys wear on hot days?
Jockey shorts.

▶ ▶ ▶ ▶ ▶ ▶ ▶ ▶ ▶ ▶ ▶ ▶ ▶ ▶ ▶ ▶ ▶ ▶ ▶

What do you get if you cross a baseball player with an electric clock?
A pitcher who doesn't need a windup.

◀ ◀ ◀ ◀ ◀ ◀ ◀ ◀ ◀ ◀ ◀ ◀ ◀ ◀ ◀ ◀ ◀ ◀ ◀

Which baseball player never goes to many games?
The left home fielder.

▶ ▶ ▶ ▶ ▶ ▶ ▶ ▶ ▶ ▶ ▶ ▶ ▶ ▶ ▶ ▶ ▶ ▶ ▶

How do you hit a nasty screwball?
You never hit a nasty screwball. You take it to a psychiatrist for counseling.

◀ ◀ ◀ ◀ ◀ ◀ ◀ ◀ ◀ ◀ ◀ ◀ ◀ ◀ ◀ ◀ ◀ ◀ ◀

Do old baseball players like rock and roll?
No. They like swing music.

▶ ▶ ▶ ▶ ▶ ▶ ▶ ▶ ▶ ▶ ▶ ▶ ▶ ▶ ▶ ▶ ▶ ▶ ▶

Why are union leaders like baseball umpires?
They both have the power to call strikes.

◀ ◀ ◀ ◀ ◀ ◀ ◀ ◀ ◀ ◀ ◀ ◀ ◀ ◀ ◀ ◀ ◀ ◀ ◀

What did the batting coach say to the player named "Swede Chariot" when the pitcher started throwing him knee high fastballs?
Swing low, Swede Chariot!

▶ ▶ ▶ ▶ ▶ ▶ ▶

What do you get if you cross a baseball hurler with a certified letter?
A pitcher with a special delivery.

Why did the fast pitcher throw a slow ball?
It was a nice change of pace.

What do you get if you cross a hobo with an umpire?
A lot of bum calls.

◀ ◀ ◀ ◀ ◀ ◀ ◀ ◀ ◀ ◀ ◀ ◀ ◀ ◀ ◀ ◀ ◀ ◀

What do you get if you cross a screwball with a change-up?
A screw-up.

What do you get if you cross an infielder with a cello player?
An athlete who plays base fiddle.

DAFFY DEFINITION:
Single batter - a swinging bachelor.

▶ ▶ ▶ ▶ ▶ ▶ ▶ ▶ ▶ ▶ ▶ ▶ ▶ ▶ ▶ ▶ ▶ ▶

Show me a baseball team owner who hands out a cash
bonus every time his team scores...and I'll show you a
guy who gets runs for his money.

**What has four wheels and is in the baseball Hall of
Fame.**
Connie Mack Truck.

Then there was the baseball umpire who had plate-glass windows
installed in his home.

Mom: All Junior does is race around the house all day long.
Dad: Maybe he's a home runner.

What do you get if you cross a bank cashier with a baseball batter?
A lot of checked swings.

What does a baseball team do if their field floods?
They paddle to safety in a dugout canoe.

What did the baseball umpire say after a long road trip?
Ah, there's no place like home.

What do you get if you cross an anchor with a baseball pitch?
A sinker ball.

What do you get if you cross a lawnmower with a baseball pitch?
A cut fastball.

What do you get if you cross a hockey rink with a baseball pitch?
A slider.

Pitcher: Why are you wearing an oven mitt?
Infielder: I may have to catch a sizzling line drive.

Babe: Why did the batter need bandages?
Ruth: I don't know.
Babe: Because he got three cuts at the plate.

What did the condemned baseball batter say to the hangman?
Is it okay if I take a few practice swings?

What do you call a baseball batter who belongs to an organized crime family?
A mafia hitman.

ATTENTION: Wood bats have tree strikes in them.

What do you get if you cross an outfielder with a frog?
A player who is great at catching flies.

SIGN IN AN OUTFIELDER'S SEAFOOD RESTAURANT: "Come in for our catch-of-the-day special."

Billy: Uh-oh! It's a run home.
Willie: Don't you mean a home run?
Billy: Nope! I just hit the ball through the neighbor's window.

Where do baseball officials hold their yearly convention?
At the Umpire State Building.

▶ ▶ ▶ ▶ ▶ ▶ ▶ ▶ ▶ ▶ ▶ ▶ ▶ ▶ ▶ ▶ ▶ ▶

Why did the sheep umpire get fired?
It made too many baa calls.

◀ ◀ ◀ ◀ ◀ ◀ ◀ ◀ ◀ ◀ ◀

What do you get if you cross a
baseball official with a neat freak?
An umpire who keeps home plate
really, really clean.

▶ ▶ ▶ ▶ ▶ ▶ ▶ ▶ ▶ ▶

NOTICE: Hall of Fame batter
Ty Cobb couldn't sing a
note, but he had a lot of
records.

◀ ◀ ◀ ◀ ◀ ◀ ◀ ◀ ◀ ◀

Why did the baseball
player punch Marge Simpson's husband?
His coach told him to sock a homer.

**What do you get if you cross a
baseball batter with a bike racer?
An athlete who hits for the cycle.**

ATTENTION: Pro baseball players who win championships get
diamond rings.

ANSWERS TO KOOKY QUESTIONS:

Athletes Foot! What do you find at the end of an athlete's leg?

A double play! What do you see when you walk out on one Broadway show and go to another one?

Oddball! What do you call a pool ball with the number three on it?

Catcher! What do you do when you chase a girl who runs slower than you do?

Horseshoes! What does a racehorse wear when he's not wearing slippers?

Touchdown! What do you do when you pet a baby duck?

DO THEY COME IN SIZE 6½?

Rick: Are you a basketball fan?
Nick: No. I think the game is a lot of senseless hoopla.

What do you call a male sports fan who tries to excite a quiet, uninspired crowd?
The cheerman of the bored.

Coach: How do you feel about competing in the high hurdles event?
Athlete: I can take it or leap it.

Show me a baseball hurler who opens a used car lot... and I'll show you a guy with an excellent sales pitch.

Why did the jogger get arrested?
He ran with a bad crowd.

Hockey player: I really need a job. Can't you give me some ice time?
Hockey coach: Sorry. We're in the middle of a hiring freeze.

What do you get if you cross a NASCAR racer with a thunderstorm?
Driving rain.

What do you get if you cross a NASCAR racer with a stove? ◄ ◄ ◄ ◄ ◄ ◄
A driving range.

What do you get if you cross a NASCAR racer with a Texas state policeman?
A driving Ranger.

Gymnast: Who gets the last slice of pizza?
Acrobat: I'll flip you for it.

Athlete: I want to set a world record in the pole vault.
Coach: Gee, you have high hopes.

Boy #1: I'd like to meet that pretty girl bowler.
Boy #2: Well, walk over there and strike up a conversation.

DAFFY DEFINITIONS:
Bowling Team — pin pals.
Bowler — a roll player.

What kind of cats like to go bowling?
Alley cats.

What is a baker's favorite football play?
A roll-out pass.

Track star: I don't like to high jump before noon.
Coach: Why not?
Track star: I find it hard to get up in the morning.

What do you get if you cross a ping pong set with a canoe?
A paddle boat.

What did the angry race horse say to the jockey?
Get off of my back already!

Mountains play valleyball. Rivers run. What do gardens do?
Mostly they just veg out.

Show me a football kicker who sharpens pencils at both ends...and I'll show you a guy who makes extra points.

Why did the baseball closer take an electric blanket into the bullpen?
He needed it in case he had to warm up fast.

What do you get if you cross an octopus with a tailback?
A runner who gives a lot of straight arms.

I OFTEN FEEL A GREAT BURDEN UPON ME!

ME TOO!

Why did the racehorse go for counseling?
He was saddled with a lot of personal problems.

Coach: Two zombie athletes ran a race.
Reporter: Who won?
Coach: They finished in a dead heat.

What did the hockey coach say to the player who was caught breaking team rules?
Watch your step! You're skating on thin ice.

What do you get if you cross an accountant with an ice skater?
A figure skater.

Zeke: Why is your racing car in the shape of a banana?

Deak: I like to peel out.

Golfer #1: Your ball landed in a mud puddle.

Golfer #2: That's a dirty lie.

Which players protect a star quarterback?

The security guards.

Show me a bike racer speeding down a road...and I'll show you a street pedaler.

Why did the golf club rush to the hospital?

It was having a stroke.

How did the tennis player get his girlfriend to marry him?

He courted her.

Why did the politician take up jogging over the summer?

Because he had to run for re-election in the fall.

Which member of the Rolling Stones rock band likes to run laps?

Mick Jogger.

What happens when young cows do lots of leg lifts?
They get great calf muscles.

ATTENTION: *A husband and wife who jog together are running mates.*

What do you get if you cross a NASCAR driver with a basketball player?
A player who knows how to drive down the lane.

ATTENTION: Basketball players who study law make good judges because they know how to run a court.

What do you get if you cross a basketball point guard with a gardener?
A give-and-grow play.

Coach: Have you found a permanent home yet?
Basketball Player: No. I keep bouncing from one team to another.

Then there was the soccer star who tried out for the basketball team and got cut because he kept dribbling with his feet.

NOTICE: A nervous basketball player is very jumpy.

What do you get if you cross a basketball timer with a chicken?
A shot cluck!

▶ ▶ ▶ ▶ ▶ ▶ ▶ ▶ ▶ ▶ ▶ ▶ ▶ ▶ ▶ ▶

ATTENTION: Lumberjacks who play basketball take lots of tree-point shots.

◀ ◀ ◀ ◀ ◀ ◀ ◀ ◀ ◀ ◀ ◀ ◀ ◀ ◀ ◀

Why didn't the basketball player show up for his court date?
He jumped bail.

▶ ▶ ▶ ▶ ▶ ▶ ▶ ▶ ▶ ▶ ▶ ▶ ▶ ▶ ▶

Why are boxers' fists like a Western six-gun?
They both have a lot of slugs in them.

◀ ◀ ◀ ◀ ◀ ◀ ◀ ◀ ◀ ◀ ◀ ◀ ◀ ◀ ◀

What do you get if a fighter wears designer shoes in the ring?
A boxer with fancy footwork.

▶ ▶ ▶ ▶ ▶ ▶ ▶ ▶ ▶ ▶ ▶ ▶ ▶ ▶ ▶

What do you get if you cross a baseball pitcher with a boxer?
A guy who throws the fight.

◀ ◀ ◀ ◀ ◀ ◀ ◀ ◀ ◀ ◀

What do you get if you cross a boxer with an octopus?
I don't know, but it throws a lot of punches.

▶ ▶ ▶ ▶ ▶ ▶ ▶ ▶ ▶

Manager: Is your new girlfriend pretty?
Boxer: She's a real knockout.

Jenny and Mia were professional boxers scheduled to fight each other. Before the first round, Jenny asked her manager what she had to do to win the bout. Her manager replied, "Sock it to Mia!"

▶ ▶ ▶ ▶ ▶ ▶ ▶ ▶ ▶ ▶ ▶ ▶ ▶ ▶ ▶ ▶ ▶ ▶

What's the most important thing for a boxing referee to know?

How to count to ten.

◀ ◀ ◀ ◀ ◀ ◀ ◀ ◀ ◀ ◀ ◀ ◀ ◀ ◀ ◀ ◀ ◀ ◀

What do you call a small nick on a boxer's forehead?
An upper cut.

▶ ▶ ▶ ▶ ▶ ▶ ▶ ▶ ▶ ▶ ▶ ▶ ▶ ▶ ▶ ▶ ▶ ▶

Why don't bicycles exercise?
They're two tired.

◀ ◀ ◀ ◀ ◀ ◀ ◀ ◀ ◀ ◀ ◀ ◀ ◀ ◀ ◀ ◀ ◀ ◀

Why don't trees exercise?
Working out saps their strength.

▶ ▶ ▶ ▶ ▶ ▶ ▶ ▶ ▶ ▶ ▶ ▶ ▶ ▶ ▶ ▶ ▶ ▶

Why don't mountains lift weights?
They're already rock hard.

◀ ◀ ◀ ◀ ◀ ◀ ◀ ◀ ◀ ◀ ◀ ◀ ◀ ◀ ◀ ◀ ◀ ◀

What's the best way to catch a fish?

Have someone pitch it to you.

▶ ▶ ▶ ▶ ▶ ▶ ▶ ▶ ▶ ▶ ▶ ▶ ▶ ▶ ▶ ▶ ▶ ▶

Why did the rabbit go to the pool?
To practice springboard diving.

◀ ◀ ◀ ◀ ◀ ◀ ◀ ◀ ◀ ◀ ◀ ◀ ◀ ◀ ◀ ◀ ◀ ◀

I knew a magician who played ice hockey and scored a lot of hat tricks.

*Where did the clams
go to work out?*
Mussel beach.

What did the angry
coach say to the
basketball player?
When I give an order,
you jump.

Why didn't the power plant play sports?
It didn't have enough energy.

Why is a soldier absent without leave like a baseball
player who takes a huge lead?
Because they'll both be in trouble if they don't get
back to base.

Why is Swiss cheese like a golf course?
They both have a lot of holes.

When is a horse race not won by a horse?
When it's won by a nose.

What sport only allows its athletes
to take one jump at a time?
Sky diving.

What do you get if you cross fencing with water polo? The favorite sport of swordfish.

Coach: Would you like to try out for the fencing team?
Athlete: I'll take a stab at it.

What do you get if you cross a gymnast with a miniature girl from a fairy tale?
Tumbelina.

Man #1: I compete in dogsled competitions.
Man #2: Oh! You're a race cur driver.

What do you get if you cross a martial arts expert with a lumberjack?
A person who karate chops wood.

Golfer #1: That was the best drive of my life. Let's celebrate right now.
Caddy: Okay. I'll arrange a tee party.

Then there was the greedy billiard parlor owner who soaked people plenty to get into his pool hall.

What do you call a surfing celebration?
A boarding party.

What is a carpenter's favorite track and field event?
The hammer throw.

SILLY SPORTS TITLE REVIEWS

"Weightlifting Made Easy" - a muscle-bound book.

"How to Size Up a Putting Green" - a book of lies.

"How to Run Fast" - a quick read.

"Improve Your Biceps" - a good book to curl up with.

"Train for a Marathon" - terrific from start to finish.

"The Game of Golf" - a book of the month club.

"How to Intercept Passes" - a good pick.

Why did the tennis fan go to an eye doctor?
Because every time he watched a match he saw doubles.

Gymnast: Do you mind if I jump over the vaulting horse?
Coach: No. Hop to it.

Why wasn't the lace put in the pair of football spikes?
It was third string.

Hog Farm Fielder: Hey! No fair! You hit the ball into the pigpen and a hog swallowed it.

Hog Farm Batter: Tough luck. It's an inside-the-pork homerun!

SILLY SPORTS NAMES

Ron Fast – track star

Mike D. Tackle – football star

Teal A. Base – baseball star

Carl D. Play – umpire

Hud L. Upp – football star

Harry A. Long – marathon runner

Seth Down – football lineman

S.P. Lashe – diving star

NOTICE: Sponge Bob tried out for football, but only made the scrub team.

• •

What did the nervous pitcher say to the homerun hitter?
How'd you like to take a walk?

• •

Show me a chicken roosting in a judge's chambers... and I'll show you a backcourt fowl.

What do you get if you cross a baseball official with a judo expert?
An umpire who really throws players out of the game.

Why are soccer players so successful?
Because they spend their lives moving toward goals.

Why did the baseball batter go into the music business?
He wanted to produce some big hits.

What does a miser wear on his feet to play ice hockey?
Cheap skates.

Why is a track team like a sleigh?
They both need good runners.

What is the wrong way to buy a tennis racket?
With no strings attached.

Who barks signals to the pitcher from behind the plate?
The dog catcher.

Show me a baseball hitter who stores his gear in a church steeple...and I'll show you a person with bats in his belfry.

Jogger #1: Do you have a fever?
Jogger #2: No. It's only a runny nose.

What do you call a pig that plays ice hockey?
A skate pork.

Why is a middle infielder like a farm hand?
They're both good in the field.

Why is a wrestler like a bowler?
They both want to score a lot of pins.

Why did the caterpillar go out for the swim team?
He wanted to learn the butterfly stroke.

What did the goldfish do for fun?
It went bowling.

Why don't tennis newlyweds care if they're poor?
Because in tennis when you have nothing it's really love.

ATTENTION: When gophers play against moles in football, the contest is decided by which team has a better ground game.

What do racecar drivers do when they need to lose weight?
They go fast.

Show me a baseball batter on the top level of a cruise ship...and I'll show you a player standing on deck.

NUTTY TRACK NAMES:

Hy Hurdles
Maury Thon
Paul Vaulter
Miles Torun

Sign on a NASCAR Deli — We serve wheel good food.

Father: Why did you take up jogging?
Teenager: I enjoy running away from home.

What does a minister wear to play street hockey?
Holy roller blades.

Who cheers for Smokey and Yogi when they play baseball?
The Root Bear.

WANTED: Minor league baseball players...athletes over eighteen need not apply.

What do you get if you cross an outfielder with a track sprinter?
A baseball player who makes a lot of running catches.

What do you call a new ice hockey player?
A rink amateur.

What did the comedian say to the racecar driver?
I know some jokes that will crack you up.

Then there was the football quarterback who became an author and wrote a football play.

And then there was the baseball batter who became a play producer and had a hit show on Broadway.

Finally there was the heavyweight fighter who became a comedy writer and penned some classic punch lines.

What's the difference between bowling and baseball?
In bowling three strikes are good.

Which Hall of Fame baseball catcher loves to eat sandwiches?
Hoagie Berra.

What did the wrestler say when someone called his cell phone during a match?
Can I put you on hold?

What do you call a football player who hurries through a gorge?
A pass rusher.

What do you get if you cross an athlete with a lucky charm?
A sporting chance.

Show me two cops jumping center at the start of a basketball game...and I'll show you a police tip-off.

When does an acrobat go to a psychologist?
After he flips out.

What do you get if you cross a minister and a sportscaster?
A pray-by-play announcer.

Why did the wrestler go to college?
He wanted to get a fraternity pin.

What does a prizefighter wear on his finger?
A boxing ring.

What do you get when a boxer meets a giant orange in the ring?
Fruit punch.

What do you need when twins play golf?
Tee for two.

Which football player is very itchy?
The flea safety.

Show me a hockey goalie who puts glue in his glove…and I'll show you a player who makes a lot of stick saves.

How does a stupid weightlifter get a three-hundred-pound dumbbell off the floor?
He jumps into the air.

Why did the cheerleader go to the dentist?
She needed a root-root-root canal.

Why is it good to be punctual if you're a football running back?
Because then you never have to rush to score a touchdown.

How can you tell if two elephants are prizefighters? If they're prizefighters, they'll have boxing trunks.

▶ ▶ ▶ ▶ ▶ ▶

What kind of retro dance did the boxer go to?

He went to a sock hop.

▶ ▶ ▶ ▶ ▶ ▶ ▶ ▶ ▶ ▶ ▶ ▶ ▶ ▶ ▶ ▶ ▶ ▶ ▶ ▶

KOOKY QUESTION: Do astronomers who are sports fans vote for all-star teams?

▶ ▶ ▶ ▶ ▶ ▶ ▶ ▶ ▶ ▶ ▶ ▶ ▶ ▶ ▶ ▶ ▶ ▶ ▶ ▶

Jack: Is it easy to play offensive center?
Zack: Sure. The position is a snap.

▶ ▶ ▶ ▶ ▶ ▶ ▶ ▶ ▶ ▶ ▶ ▶ ▶ ▶ ▶ ▶ ▶ ▶ ▶ ▶

What did one baseball player say to the other while they were fishing?

Let's play a game of catch.

▶ ▶ ▶ ▶ ▶ ▶ ▶ ▶ ▶ ▶ ▶ ▶ ▶ ▶ ▶ ▶ ▶ ▶ ▶

What happened when Sponge Bob pitched for his baseball team?
He got sent to the showers.

▶ ▶ ▶ ▶ ▶ ▶ ▶ ▶ ▶ ▶ ▶ ▶ ▶ ▶ ▶ ▶ ▶ ▶

How does a quarterback unlock his car?
He uses a pass key.

ATTENTION: Bus drivers who are sports fans love Greyhound racing.

◄ ◄ ◄ ◄ ◄ ◄ ◄ ◄ ◄ ◄ ◄ ◄ ◄ ◄ ◄ ◄ ◄ ◄

What do you call coffee brewed at a baseball stadium?
Ball perk.

◄ ◄ ◄ ◄ ◄ ◄ ◄ ◄ ◄ ◄ ◄ ◄ ◄ ◄ ◄ ◄ ◄ ◄ !

Does a quarterback stop to pay tolls?
No. He uses his E-Z pass.

◄ ◄ ◄ ◄ ◄ ◄ ◄ ◄ ◄ ◄ ◄ ◄ ◄ ◄ ◄ ◄ ◄ ◄

What do you get if you cross a savings account with a quarterback?
A pass book.

◄ ◄ ◄ ◄ ◄ ◄ ◄ ◄ ◄

SIGN ON A GOLFER'S DELI:
Sink your teeth into our
new club sandwich.

◄ ◄ ◄ ◄ ◄ ◄ ◄ ◄ ◄

Spy guy: How do you destroy a baseball field?

James Bond: You can't destroy a baseball field. Diamonds are forever.

◄ ◄ ◄ ◄ ◄ ◄ ◄ ◄ ◄ ◄ ◄ ◄ ◄ ◄ ◄ ◄ ◄ ◄

NOTICE: People needed to pack crates. No experience necessary. We give free boxing lessons.

◄ ◄ ◄ ◄ ◄ ◄ ◄ ◄ ◄ ◄ ◄ ◄ ◄ ◄ ◄ ◄ ◄ ◄

Who is responsible for keeping the baseball stadium neat and tidy?
The clean-up hitter.

What did the golfer say to his rolling ball?
Stay putt.

What do you get if you cross sports nuts with a driver and a nine iron?
Fan clubs.

Then there was the softball star named Kitty who pitched a purrfect game.

ATTENTION: NASCAR drivers never have mental breakdowns. They just go a little steer crazy.

What do you get if you cross a hunting dog with a basketball player?
A pointer guard.

Why did the baseball batter break up with the softball pitcher?
They just didn't hit it off together.

What did one football official say to the other after a big pile-up over a fumble?
Quick! Let's get to the bottom of this!

Why did the baseball manager put a ram second in the batting order?

That way if the leadoff man got on base, the ram could butt him over to second.

What do you get if you cross a football player with an armadillo?
A player with built-in padding.

Why is football like baseball?
Because both games usually have a lot of hits.

NOTICE: When a bike racer is deep in thought, you can hear the wheels turning.

What do you call tag-team wrestlers who are best friends?
Pin pals.

What do you get if you cross a catcher with an offensive tackle?
A baseball player who knows how to block the plate.

What do you get if you cross a baseball with a clumsy rabbit?
Ground balls that take a lot of bad hops.

. .

What do you get if you cross a billiards player with a football blocker?
A pooling guard.

. .

What kind of steaks do golfers like best?
Tee-bone steaks.

. .

What did the mean boxer give Santa Claus?
Christmas punch.

. .

Then there was the baseball pitcher with E.S.P. who didn't need to get signals from his catcher. He just read his mind.

. .

In Australia they crossed athletes with kangaroos and got pole-vaulters who can clear the bar without using a pole.

. .

What is the Jolly Green Jockey's favorite vegetable?
Horseradish.

. .

Then there was the dork quarterback who called all running plays because he saw a sign outside the stadium that read, "This is a no passing zone."

Did you hear about the football captain who didn't believe he lost the coin toss and asked to see it on instant replay?

Our middle linebacker is so tough that as a child he didn't have a teddy bear. He slept with a live grizzly.

"I'm a doctor who performs Tommy John surgery, so I like baseball," said one fan in the stands.
"I like hockey," answered the fan seated next to him.
"I'm a dentist."

Then there was the pro football fan that got arrested for scalping tickets to Washington Redskins games.

Man: Pro football tickets in New York cost too much.
Fan: It's a small price to pay for a Giant victory.

Coach: How fast can you run?
Player: That depends.
Coach: On what?
Player: Who's chasing me.

Joe: Did you hear about the dorky quarterback who got everything backwards?

Moe: No. Tell me.

Joe: Every time he stepped up to the line to call signals, he yelled: "Tuh! Tuh! Tuh!"

Football Coach: Hit them high! Hit them low!
Player: Well, make up your mind already.

What kind of baseball do Munchkins play?
Small ball.

Hockey Player: Last year I broke my nose in five places.
Sports Reporter: Really?
Hockey Player: Yup. In Pittsburgh, Buffalo, Montreal, Toronto, and Philadelphia

Girl: Do you know gymnastics?
Geek: Jim who?

ATTENTION: During a pro hockey game, players love to sample knuckle sandwiches.

The N.Y. Giants signed an offensive lineman who was so big he took a taxi home after the game. The next day the police made him carry it back to the stadium parking lot.

Rumor has it that the Grand Canyon was formed when Paul Bunyan took up golf and quickly discovered that he was a duffer.

Then there was the baseball umpire who was a fortuneteller and called plays before they happened.

Once there was a baseball manager so stupid he thought he needed a giant python to pull off a squeeze play.

Then there was the football player who got cut from the team and was hired as a stadium janitor. The coach handed him a broom and told him to run some sweep plays.

If golf is good exercise for your heart, why do older golfers have so many strokes?

A racetrack is the only place in the world where the windows clean people.

Then there was the bad pitcher who was sent to the showers so often he quit baseball and took up swimming.

The contagious disease professional wrestlers fear most is ringworm.

Then there was the pro fighter who quit boxing to join the circus because he wanted to be a ringmaster.

Then there was the dumb college football coach who hired a drivers ed instructor to teach his offense how to drive the ball down he field.

Of course you've heard about the wacky hockey goalie that wore a different Halloween mask every game.

What do you get if you cross a kangaroo and a quarterback?
A pocket passer.

Caddy: Are you a Democrat or a Republican?

Golfer: Neither. I'm a member of the Tee Party.

Which season do hockey players dislike?

They could do without a fall.

What do you get if you cross an outfielder with a born loser?

A guy who can't catch a break.

What did the barbell say to the bodybuilder?

Hey dude! How about a lift?

Why is a tennis court so noisy?

Because every person on it raises a racket.

Why did the Green Giant have to leave the baseball game?

The pitcher beaned him.

NOTICE: Golf carts are good for long drives.

What do you get if you cross athletes and NASCAR vehicles?

Sports cars.

Why did the bowler rush away from his lane after only one shot?
He had no time to spare.

··

Coach: They say everyone loves a large man.
Fitness Expert: Yes, but they make up jokes at his expanse.

··

Caddy: Sir, you just scored a hole-in-one on the 18th hole.
Golfer: Yippee!
Caddy: Calm down sir, we're only on the 9th hole.

··

Baseball reporter: Have you ever been trapped between bases when the infielders have the ball?
Player: Heck no! I wouldn't be caught dead in a rundown place like that.

··

Mother: Why aren't you having fun at the skate park?
Son: Because I'm skate bored.

··

How does a movie director start a rollerblade race?
He yells, "Roll 'em!"

··

Which bird is a famous skateboarder?
Tony Hawk.

What kind of rollerblades did Scrooge buy?
Cheap skates.

What do you get if you cross a baseball player and a surfer?
A person who knows how to catch waves.

What do you call an athlete who plays baseball, football, tennis, soccer, golf and basketball?
A jock of all trades.

Who rode waves in Medieval England?
Serf boarders.

Jed: **Do you like to shoot skeet?**
Ned: **Yes. I get a bang out of the hobby.**

What hat wears rollerblades?
The roller derby.

DAFFY DEFINITION:
Skateboarding: Wheel entertainment.

What makes a golfer happy?
His glee club.

Why did the boxer lose at blackjack?
He wouldn't let the dealer hit him.

▶ ▶ ▶ ▶ ▶ ▶ ▶ ▶ ▶ ▶ ▶ ▶ ▶ ▶ ▶ ▶ ▶

Why did the golfer hit Abe with a club?
He wanted to drive a Lincoln.

◀ ◀ ◀ ◀ ◀ ◀ ◀ ◀ ◀ ◀ ◀ ◀ ◀ ◀ ◀ ◀ ◀

Knock! Knock!
Who's there?
Golan.
Golan who?
Golan and I'll throw you a deep pass.

▶ ▶ ▶ ▶ ▶ ▶ ▶ ▶ ▶ ▶ ▶ ▶ ▶ ▶ ▶ ▶ ▶

Tim: Do punters ever get cut from a football team?
Jim: No. They get kicked off the squad.

◀ ◀ ◀ ◀ ◀ ◀ ◀ ◀ ◀ ◀ ◀ ◀ ◀ ◀ ◀ ◀ ◀

Football tackle: I heard you were dead.
Punter: No. I'm still alive and kicking.

▶ ▶ ▶ ▶ ▶ ▶ ▶ ▶ ▶ ▶ ▶ ▶ ▶ ▶ ▶ ▶ ▶

Bill: I know an old baseball player who is still single.
Will: Well, I know an old baseball player who has a double chin.
Jill: I know an old baseball player who was served a foreclosure notice and now he's out at home.

CHAPTER 5

FAMILY FUN

Lady: Did you meet your mother at the train station?
Teenager: Heck no. I've known her all my life.

▶ ▶ ▶ ▶ ▶ ▶ ▶ ▶ ▶ ▶ ▶ ▶ ▶ ▶ ▶ ▶ ▶

Millie: Is that Mrs. Margarine's husband?
Tillie: No. It's her butter-in-law.

Who was Alexander the Lesser?
He was Alexander the Great's not-so-famous cousin.

Mother: Why are you crying?
Boy: My teeth stepped on my tongue.

◀ ◀ ◀ ◀ ◀ ◀ ◀ ◀ ◀ ◀ ◀ ◀ ◀ ◀ ◀ ◀ ◀

Husband: My wife is so fond of arguing she never eats anything that agrees with her.

Father: The new baby looks just like me.
Aunt: That doesn't matter as long as he's healthy.

Zack: I sent my wife away for a vacation.
Mack: That was thoughtful of you.
Zack: I know. I really needed the vacation.

Son: Yuk! I made really sour lemonade.
Mother: Well you're old enough to know bitter.

Fran: I hear your rich grandfather married a young model.

Dan: Yup. She's his childhood sweetheart.

Fran: Honestly?

Dan: Absolutely. His second childhood started at age 80.

Teacher: How many children are in your family?

New Student: We have eight children in our family.

Teacher: My goodness! That must cost a lot of money.

New Student: On no. My parents don't buy them; they raise them.

A motorcycle cop pulled over a man driving down the highway. "What's the problem officer?" asked the man. "Your mother-in-law fell out of the back seat when you went around that last curve," said the cop. "Phew!" sighed the driver in relief. "And all the time I thought I'd suddenly gone stone deaf."

Husband: Why are you knitting three socks?

Wife: Our daughter said her new baby has grown a foot since we last saw him.

▶ ▶ ▶ ▶ ▶ ▶ ▶ ▶ ▶ ▶ ▶ ▶ ▶ ▶ ▶ ▶ ▶ ▶ ▶

Little Broom: When were you born, Dad?

Father: I was a baby broomer.

What did the bedroom say to the sloppy teenager?

Here's another fine mess you've gotten me into.

What do werewolves read to
their children at bedtime?
Furry tail stories.

Mother: Don't swim on
a full stomach.
Son: Okay, Mom. I'll do
the backstroke.

What did the tidy mom tell
her sloppy kids?
Quit messing around the house.

"Take me to the fifth floor please," said the young company president to the elevator operator. The operator smiled and nodded. Soon the elevator car jerked to a stop. "Here you are, son," said the elevator operator.
"How dare you call me son!" snapped the snobby company president. "Hey! I brought you up didn't I," replied the operator.

NOTICE: Mr. & Mrs. Emory Board just filed for divorce.

Grandmother: How long does your father sleep on Sunday morning?
Little Girl: That depends.
Grandmother: On what?
Little Girl: The length of our pastor's sermon.

Husband: **Last night I dreamed I fixed our leaky sink.**
Wife: **That was just another one of your pipe dreams.**

Son: Hey, Mom! Look at the huge fish I caught.
Mom: Wowie! That's a real whopper. Did your father catch anything?
Son: Yes. I used what Dad caught as bait to hook this monster.

Jed: My dad has Abe Lincoln's old potato peeler.
Ned: That's nothing. My dad has Adam's apple.

Boy: Hey Dad! Here comes the parade. Where's Mom?
Father: She's upstairs waving her hair.
Boy: Can't we afford a flag?

What did the Invisible Boy call his Invisible Mom and Dad?
His Transparents.

Patient: Can you cure me, doctor?
Doctor: I'm afraid not. Your illness is hereditary.
Patient: In that case, send the bill to my parents.

What did Mom say to Dad when she decided to toilet train their infant?
It's potty time!

Uncle Moe asked his nephew Harold if his two-year-old brother Morty had started to talk yet. "Why should Morty talk?" Harold said. "He gets everything he wants by hollering."

A girl was mailing a bible to her grandmother. The postal clerk asked if her package contained anything breakable. The girl smiled and replied, "Only the Ten Commandments."

A young husband and his wife were at a youngster's tenth birthday party. "That's the fourth time you've gone back for ice cream and cake," the wife scolded her husband. "Aren't you ashamed of yourself?"
The husband shrugged his shoulders. "Why should I be?" he answered. "I keep telling everyone it's for you."

Joey: When my grandpa sneezes, he always puts his hand over his mouth.
Zoey: To stop germs from spreading?
Joey: No. To catch his teeth.

Husband: My wife and I have a marriage partnership. I'm the silent partner.

Husband: I've been happily married for ten years.
Lady: That's marvelous.
Husband: Not really. Next week my wife and I celebrate our 45th wedding anniversary.

Son: Can I go out tonight?
Father: With so much homework?
Son: No. With my girlfriend.

Don: My dad is our house supervisor.
Juan: You mean he's the boss?
Don: No. My mom is the boss.

Cherry: There goes Grandpa Pie.
Plum: He's a crusty old guy.

Father: Stop misbehaving and I'll tell you the joke about the big Christmas present.
Boy: And if I don't stop misbehaving?
Father: Then you won't get it.

ATTENTION: You can tell when a child is growing up when he stops asking where he came from and refuses to tell you where he's going.

Agent: Was your late husband insured?

Wife: No. He was a total loss.

Uncle Al: I know I'm ugly. Last Christmas my parents gave me a turtleneck sweater that had no hole for my head.

Lindy: My husband is such a couch potato that during the football season all he does is lie there and vegetate.

Cindy: Does he root for the home team?

Millie: You're wearing your wedding ring on the wrong finger.

Tillie: That's because I married the wrong man.

Girl: How old is your great-grandfather?

Boy: He's at muddle age.

Ken: My uncle is now with the FBI.

Len: I knew they'd catch up with him sooner or later.

Son: When I grow up, I want to drive a steamroller.

Father: Well in that case son, I won't stand in your way.

Chester: I heard your sister married a second lieutenant.

Lester: Yeah. The first one got away.

Little Boy: Mom! I spilled a six-pack of soda all over the stovetop.

Mom: Oh great! Foam on the range.

Mr. Jones: *Is that the prom dress you bought for our daughter? I can't help but laugh at it.*

Mrs. Jones: *That'll stop when I tell you how much we paid for it.*

Mother: All right, who put dirty fingerprints all over the newly painted wall? Was it Matthew or Marty?

Marty: It was Matthew, Mom. I saw him at the scene of the grime.

Dora: We named our son after English royalty.

Nora: Really. What do you call him?

Dora: The Prince of Wails.

Jill: I can be sick for nothing because my mother is a doctor.

Bill: Big deal! I can be good for nothing because my father's a minister.

Worker: My wife told me to ask you for a raise.
Boss: Fine. I'll ask my wife if I can give you one.

Newlywed wife: Humph! My nasty husband says I mumble.
Girlfriend: Well why don't you go home to mutter.

Anne: How many relatives were at your family picnic?
Jan: There were six uncles and about a million ants.

Boy: I did two good deeds today. I went to see Aunt Stacy.
Father: That's only one good deed.
Boy: No it's two. Aunt Stacy was happy when I went to see her. She was even happier when I finally left.

A small girl greeted a visiting relative at the door. It was her mother's sister. "I'm glad you came Aunt Clara," said the girl. "Now dad will do the trick he talked about." Aunt Clara was confused. "What trick?" she asked her little niece. "Dad said if you came to visit, he'd climb the walls for sure."

Monster Dad: Where's my cloak? Where's my shovel? Where's my axe?
Monster Boy: I'm hungry, Mom.
Monster Girl: Help me frizz my hair, Mom.
Monster Mom: Calm down all of you and be patient. I only have four hands.

Teenage Girl: What a beautiful car. Let's go buy it.
Father: Right. Let's go right by it.

Aunt: Don't children brighten up a home?

Father: Absolutely! They never turn off any lights.

Jack: My uncle cleaned up on Wall Street.
Mack: Is he an investor?
Jack: No. A janitor.

Cabin Boy #1: My grandfather dug the Panama Canal.
Cabin Boy #2: Big deal. My uncle killed the Dead Sea.

Father: Do you want me to help you swing that big baseball bat, son?
Boy: No Dad. It's time for me to strike out on my own.

Jill: My father makes sofas all day.
Bill: What does he do when he comes home?
Jill: He sleeps on his job.

What did Mr. and Mrs. Drum name their twin sons?
Tom-Tom.

Girl: I made my husband a millionaire.
Friend: What was he before you married him?
Girl: A billionaire.

Mother: Billy! Stop reaching across the dinner table. Don't you have a tongue?
Billy: Yes, Mom, but my arms are longer.

"Donna, what happened to our pet canary?" a mother asked her daughter. "The cage is empty. The bird is gone." "Hmm," answered the little girl. "That's funny. It was there a minute ago when I vacuumed out its cage."

Man: Doctor, my wife thinks she's a traffic light.
Doctor: That's terrible.
Man: Actually, the only time it really bugs me is when we go out.
Doctor: Why is that?
Man: She always takes too long to change.

Ted: How old is your great-grandfather?

Jed: I'm not sure, but he must be pretty old. His social security number is one.

Mother: The butcher gave me a pork chop on sale.

Son: That's nothing. The school bully gave me a karate chop for free.

"I've got to get rid of our new young chauffeur," grumped Big Louie to his wife Dixie. "His driving is terrible. He almost killed me three times." "Oh," pleaded Dixie, "just give him one more chance."

Mother: I told you to wash your hands. Look at those filthy wrists.

Boy: Ah, gee, Mom. A guy has to draw the line somewhere.

Mother: When it comes to cleaning his room, my teenage son likes to do nothing better.

Mother: Marty! Are you spitting in the goldfish bowl?

Marty: No Mom, but I'm getting closer with every try.

Mother: Do you know what happens to little boys who constantly tell fibs?

Son: Yes. They grow up to be successful politicians.

The son of a very wealthy family was sent to a public school so he'd learn to get along with average people. "Now don't tell anyone we're rich son," said his father. "Act like we're very poor and everyone will like you." "Okay father," promised the rich youngster. The boy's first day in school he was asked to write a composition about his family to be read in front of the class. "We're poor," read the boy. "My dad is poor. My mom is poor. Our butler is poor. Our maids are poor. Our chauffeur is poor. The cook and the gardener are poor. I'm just a regular poor kid."

What did the big raindrop say to the little raindrop?

My plop is bigger than your plop.

Father: Why did your friend Tim get an A on his homework while you only got a C?

Boy: Tim has smarter parents.

◀ ◀

What did the calf say to the silo?
Is my fodder in there?

Phil: My uncle made a fortune in crooked dough.

Jill: Is he a counterfeiter?

Phil: No. A pretzel maker.

Boy: **My** name is **Seven** and a **Quarter.**
Girl: **Where'd** you get a silly name like that?
Boy: **My** parents picked it out of a hat.

Boy: I learned to say "yes" and "no" in school today.
Father: Did you really?
Boy: Yep.

Mom: Billy! Why didn't you answer me?
Billy: I did. I shook my head.
Mom: Well did you expect me to hear it rattle all the way upstairs?

A boy handed his report card to his father. "Dad," said the boy. "Remember at the start of school you said if I got all "A's" on my report card you'd give me a fifty dollar bill." The father smiled. "I remember son, and I'll keep my word." "Well Pop," said the boy. "I just saved you fifty bucks!"

Boy: *I know a kid who eats out of garbage cans.*
Mother: *That's horrible. What kind of parents does he have?*
Boy: *They're goats.*

Boy: My folks are sending me to summer camp.
Girl: Why? Do you need a vacation?
Boy: No. They do.

▶ ▶ ▶ ▶ ▶ ▶ ▶ ▶ ▶ ▶ ▶ ▶ ▶ ▶ ▶ ▶ ▶ ▶

Father: Before we hike to our campsite let's check our gear.
Cell phones? i-Pods? Portable laptop? Portable DVD player?
Instant gourmet food?
Son: We have all of that, Dad.
Father: Good. Let's go. I'm looking forward to roughing it.

◀ ◀ ◀ ◀ ◀ ◀ ◀ ◀ ◀ ◀ ◀ ◀ ◀ ◀ ◀ ◀ ◀ ◀

KOOKY QUESTION: If evolution really works, why do mothers still only have two hands?

▶ ▶ ▶ ▶ ▶ ▶ ▶ ▶ ▶ ▶

Reporter: I understand you started to train for a career in the boxing ring as a child?
Boxer: True. My parents made me sit in the corner a lot.

◀ ◀ ◀ ◀ ◀ ◀ ◀ ◀ ◀ ◀ ◀ ◀

Father: **I gave my daughter plastic surgery.**
Friend: **What do you mean?**
Father: **I cut off her credit cards.**

▶ ▶ ▶ ▶ ▶ ▶ ▶ ▶ ▶ ▶ ▶ ▶ ▶ ▶ ▶ ▶ ▶ ▶

Mother: Robert, share your new sled with your little brother.
Robert: I am, Mom. I use it going down the slope and he gets to use it going up it.

What kind of music should you listen to on Father's Day?
Pop music.

▶ ▶ ▶ ▶ ▶ ▶ ▶ ▶ ▶ ▶ ▶ ▶ ▶ ▶ ▶ ▶ ▶ ▶ ▶

Son: I only told one lie this month.
Father: When was that?
Son: Just now.

◀ ◀ ◀ ◀ ◀ ◀ ◀

Big Brother: Don't you think it's time we took our little brother to the zoo?
Sister: If they want him, let them come and get him.

▶ ▶ ▶ ▶ ▶ ▶ ▶ ▶ ▶ ▶ ▶ ▶ ▶ ▶ ▶ ▶ ▶ ▶ ▶

Mom: I sent you to the store and you brought home the wrong thing.
Daughter: What's wrong with the margarine I got?
Mom: Nothing, but you're old enough to know butter.

◀ ◀ ◀ ◀ ◀ ◀ ◀ ◀ ◀ ◀ ◀ ◀ ◀ ◀ ◀ ◀ ◀ ◀

Mother: *Johnny, did you eat the entire package of cookies?*
Johnny: *I didn't touch one.*
Mother: *But there's only one left.*
Johnny: *That's the one I didn't touch.*

A father was pushing his baby son in a carriage through the park. The baby was throwing a tantrum and screaming at the top of his lungs. As he passed people, the father kept softly repeated, "Take it easy, Robert. Calm down, Robert. Control yourself, Robert." Finally, a curious lady walked up to the pair. "I admire the job you're doing," she said to the father. "Little Robert is cute, but he sure is noisy." "You've made a mistake," replied the father. "My son's name is Johnny. I'm Robert."

Boy: Doctor, first my uncle thought he was a door key. Now he thinks he's a doorknob.

Doctor: It sounds like he's taken a turn for the worse.

Mel: My father is the greatest dad in the world.

Stella: How do you know that?

Mel: He's number one on all the pop charts.

Boy: My name is Paste.

Man: Is that your brother?

Boy: Yes. His name is Glue. We stick together.

Boy: My mom let my aunt name my new baby sister.

Girl: What did she name her?

Boy: Denise.

STUPID FAIRY TALES

Did you hear about the smart wolf that didn't try to blow down the pig's house of bricks? He just blew it up with dynamite.

Did you hear about the dorky princess who did everything wrong? She once kissed a prince and turned him into a frog.

Have you ever read the fairy tale about Tom Thumb's baby brother Pinky?

They updated the story of the Ugly Duckling. Instead of waiting to grow into a beautiful swan, she just had cosmetic surgery.

Cinderella wised up. She went to the ball wearing an alarm clock around her neck so she wouldn't forget when to leave.

Rapunzel didn't let down her long hair to escape from the tall tower she was trapped in. She used a parachute instead.

Then there was the story of the lazy grasshopper that watched the busy ant work all summer. When the weather got cold, the grasshopper flew to Florida.

The story of the wooden puppet Pinocchio is a sad one. He got caught in a rainstorm and ended up with a warped mind.

The Seven Dwarfs threw Snow White out of their home when they discovered she had a secret slush fund.

The Little Mermaid loves to go fish bowling.

Knock! Knock!
Who's there?
Myah.
Myah who?
Myah mother told me to come over here.

Knock! Knock!
Who's there?
Slater.
Slater who?
Slater alligator.

Knock! Knock!
Who's there?
Seldom.
Seldom who?
Seldom some lottery tickets.

Knock! Knock!
Who's there?
Eve N.
Eve N. who?
Eve N. Steven.

Knock! Knock!
Who's there?
Weight.
Weight who?
Weight a minute and I'll tell you.

Knock! Knock!
Who's there?
Russ T. Potts.
Russ T. Potts who?
Russ T. Potts make food taste bad.

Knock! Knock!
Who's there?
Marsha.
Marsha who?
Marsha mellow.

Knock! Knock!
Who's there?
Andy.
Andy who?
Andy man special today.
Do you need anything fixed?

Knock! Knock!
Who's there?
Glow.
Glow who?
Glow ahead punk. Make my day.

. .

Knock! Knock!
Who's there?
Reed.
Reed who?
Reed the search warrant
I'm holding up.

. .

Knock! Knock!
Who's there?
Polk.
Polk who?
Polk your head out and take a look.

. .

Knock! Knock!
Who's there?
Euro.
Euro who?
Eurolder than you
sound.

. .

Knock! Knock!
Who's there?
Puskin.
Puskin who?
Puskin come to shove
over this dispute.

Knock! Knock!
Who's there?
Scott.
Scott who?
Scott free is what you'll be
if you open up.

Knock! Knock!
Who's there?
Mums.
Mums who?
Mums the word, so be quiet.

SHHHH!

Knock! Knock!
Who's there?
Nick.
Nick who?
Nick tie.

Knock! Knock!
Who's there?
Duncan.
Duncan who?
Duncan doughnuts can be sloppy work.

Knock! Knock!
Who's there?
Handel.
Handel who?
Handel this problem for me.

Knock! Knock!
Who's there?
Hoffa.
Hoffa who?
Hoffa league onward.

Knock! Knock!
Who's there?
Quint.
Quint who?
Quint fooling around and open the door.

Knock! Knock!
Who's there?
Folger.
Folger who?
Folger hands and say a prayer of thanks.

Knock! Knock!
Who's there?
Herm.
Herm who?
Herm a hair on his head and you'll be sorry.

Knock! Knock!
Who's there?
Gary.
Gary who?
Gary, Indiana.

Knock! Knock!
Who's there?
Flinch.
Flinch who?
Flinch Fried Potatoes.

Knock! Knock!
Who's there?
Hugh Paine.
Hugh Paine who?
Hugh Paine in the neck.

TELL HIM I SAID "THANKS"!

Knock! Knock!
Who's there?
I Otis.
I Otis who?
I Otis dollar to your father.

Knock! Knock!
Who's there?
Sara.
Sara who?
Sara Bellum.

Knock! Knock!
Who's there?
Mark.
Mark who?
Mark this date on your calendar.

Knock! Knock!
Who's there?
Magda.
Magda who?
Magda Carta.

Knock! Knock!
Who's there?
Tinker.
Tinker who?
Tinker folks are more friendly?

Knock! Knock!

Harve.

Harve your tickets ready.

Knock! Knock!
Who's there?
Nicholas.
Nicholas who?
Nicholas, penniless, and broke.

Knock! Knock!
Who's there?
Hester.
Hester who?
Hester any refreshments in there?

Knock! Knock
Who's there?
Bias.
Bias who?
Bias a new big screen TV, please.

Knock! Knock!
Who's there?
Sandy.
Sandy who?
Sandy check by Express Mail.

Knock! Knock!
Who's there?
Distress.
Distress who?
Distress is too short. I'll wear a skirt instead.

Knock! Knock!
Who's there?
Ty.
Ty who?
Typhoon.

Knock! Knock!
Who's there?
O. Leo.
O. Leo who?
O. Leo Leahy.

Knock! Knock!
Who's there?
Sybil.
Sybil who?
Sybil Wrights.

Knock! Knock!
Who's there?
Trains.
Trains who?
Trains-formers are crafty robots.

Knock! Knock!
Who's there?
I lecture.
I lecture who?
I lecture dog out when I came in.

Knock! Knock!
Who's there?
Adeline.
Adeline who?
Adeline and your essay will be complete.

Knock! Knock!
Who's there?
Thea Laura.
Thea Laura who?
Thea Laura inertia.

Knock! Knock!
Who's there?
Tattle.
Tattle who?
Tattle be the day when I tell you.

Knock! Knock!
Who's there?
Burton.
Burton who?
Burton up your shirt.

Knock! Knock!
Who's there?
Zita.
Zita who?
Zita moon coming up? It's getting late.

Knock! Knock!
Who's there?
Hood.
Hood who?
Hood care if you let me in.

Knock! Knock!
Who's there?
Your maid.
Your maid who?
Your maid your bed, now sleep in it.

Knock! Knock!
Who's there?
Harpy.
Harpy who?
Harpy birthday to you!

Knock! Knock!
Who's there?
Clara.
Clara who?
Clara-bunga, dude!

Knock! Knock!
Who's there?
Cosmo.
Cosmo who?
Cosmo people are arriving every minute.

Knock! Knock!
Who's there?
I Lois
I Lois who?
I Lois my way. Can you help me?

Knock! Knock!
Who's there?
Vine.
Vine who?
Vine weather we're having isn't it?

Knock! Knock!
Who's there?
Laurel and Hardy.
Laurel and Hardy who?
Laurel and Hardy Harr Harr!

Knock! Knock!
Who's there?
Hussar.
Hussar who?
Hussar stranger. You know me.

Knock! Knock!
Who's there?
Orwell.
Orwell who?
Orwell, I finally give up.

Knock! Knock!
Who's there?
Alas.
Alas who?
Alas in Wonderland.

Knock! Knock!
Who's there?
Auntie.
Auntie Who?
Auntie-histimine.

Knock! Knock!
Who's there?
Juno.
Juno who?
Juno I walked all the way over here.

Knock! Knock!
Who's there?
Hula.
Hula who?
Hula-la! It's a beautiful day.

Knock! Knock!
Who's there?
Muffin.
Muffin who?
Muffin ventured, muffin gained.

Knock! Knock!
Who's there?
Stirrup.
Stirrup who?
Stirrup the lemonade.

Knock! Knock!
Who's there?
Bizet.
Bizet who?
Bizet me at my house next weekend.

Knock! Knock!
Who's there?
Peace.
Peace who?
Peace open the door.

Knock! Knock!
Who's there?
Hut.
Hut who?
Hut diggity dog!

Knock! Knock!
Who's there?
Franz.
Franz who?
Franz is where you'll find the city of Paris.

Knock! Knock!
Who's there?
It's Max.
It's Max who?
It's Max no difference to me.

Knock! Knock!
Who's there?
Frame.
Frame who?
Frame and fortune await on your doorstep.

YOU WILL RECEIVE A PUZZLING GIFT AT YOUR DOORSTEP!

Knock! Knock!
Who's there?
Pig.
Pig who?
Pig me up at two o'clock.

Knock! Knock!
Who's there?
Attila.
Attila who?
Attila you open the door, I'm staying right here.

Knock! Knock!
Who's there?
Howe.
Howe who?
Howe do ma'am. I'm from Texas.

Knock! Knock!
Who's there?
Hits.
Hits who?
Hits later than you think.

Knock! Knock!
Who's there?
A cargo.
A cargo who?
A cargo fast when you step on the gas.

Knock! Knock!
Who's there?
Marie.
Marie who?
Marie thon.

Knock! Knock!
Who's there?
Shell.
Shell who?
Shell we dance?

Knock! Knock!
Who's there?
Asa.
Asa who?
Asa diamonds.

Knock! Knock!
Who's there?
Merry.
Merry who?
Merry Poppins.

Knock! Knock!
Who's there?
Hiam.
Hiam who?
Hiam here on police business. Open up!

Knock! Knock!
Who's there?
Gandhi.
Gandhi who?
Gandhi kids come out to play?

Knock! Knock!
Who's there?
Hardy.
Hardy who?
Hardy har har! The joke is over. Let us in.

Knock! Knock!
Who's there?
Nobel.
Nobel who?
Nobel so I knocked instead.

Knock! Knock!
Who's there?
Dee.
Dee who?
Dee heck with you! I'm leaving.

Knock! Knock!
Who's there?
Whirl.
Whirl who?
Whirl try again later.

Knock! Knock!
Who's there?
Ireland.
Ireland who?
Ireland you five bucks if you promise to pay me back.

Knock! Knock!
Who's there?
Ali
Ali who?
Ali bama is a fine state.

Knock! Knock!
Who's there?
Atom.
Atom who?
Atom and Eve.

Knock! Knock!
Who's there?
Bruno.
Bruno who?
Bruno me. I live next door.

Knock! Knock!
Who's there?
Dot Burnett.
Dot Burnett who?
Dot Burnett I'm tired of this dumb game.

Knock! Knock!
Who's there?
Dairy.
Dairy who?
Dairy goes!
After him, men!

Knock! Knock!
Who's there?
Burton.
Burton who?
Burton up your coat.
It's cold outside.

. .

Knock! Knock!
Who's there?
Almond.
Almond who?
Almost a very good mood.

. .

Knock! Knock!
Who's there?
Wilda.
Wilda who?
Wilda plane be
landing soon?

. .

Knock! Knock!
Who's there?
Z.
Z who?
Z you in the morning.

. .

Knock! Knock!
Who's there?
Olive.
Olive who?
Olive the Springtime, don't you.

Knock! Knock!
Who's there?
Jester.
Jester who?
Jester minute.
I'm still thinking.

. .

Knock! Knock!
Who's there?
Rock it.
Rock it who?
Rock it ships fly into space.

. .

Knock! Knock!
Who's there?
Skip.
Skip who?
Skip it! I'll go next door.

Knock! Knock!
Who's there?
Christopher Columbus.
Christopher Columbus who?
Duh! Christopher Columbus, the guy who discovered America.

Knock! Knock!
Who's there?
Kent.
Kent who?
Kent you see who I am?

Knock! Knock!
Who's there?
Otto.
Otto who?
Otto know.

Knock! Knock!
Who's there?
Juno.
Juno who?
Juno how long I've been waiting out here?

Knock! Knock!
Who's there?
Howard.
Howard who?
Howard you like to buy some magazines?

Knock! Knock!
Who's there?
Ernie.
Ernie who?
Ernie got scraped when she fell on the sidewalk.

Knock! Knock!
Who's there?
Canopy.
Canopy who?
Canopy ever grow up to be a string bean?

Knock! Knock!
Who's there?
Pig.
Pig who?
Pig me up at five o'clock.

Knock! Knock!
Who's there?
Wilder.
Wilder who?
Wilder out let's order pizza.

Knock! Knock!
Who's there?
Ozzie.
Ozzie who?
Ozzie a bad moon rising.

Knock! Knock!
Who's there?
Osborne.
Osborne who?
Osborne on the 4th of July.

Knock! Knock!
Who's there?
Winnie.
Winnie who?
Winnie gets home, he's in for a big surprise.

Knock! Knock!
Who's there?
Nelda.
Nelda who?
Nelda bell doesn't work either.

Knock! Knock!
Who's there?
Oil.
Oil who?
Oil paint your picture if you'll pose for me.

Knock! Knock!
Who's there?
Dot com.
Dot com who?
Dot com home, we miss you.

Knock! Knock!
Who's there?
Freeze.
Freeze who?
Freeze a jolly good fellow, which nobody can deny.

Knock! Knock!
Who's there?
Hour.
Hour who?
Hour you feeling?

Knock! Knock!
Who's there?
Venice.
Venice who?
Venice the next train to Rome?

Knock! Knock!
Who's there?
Hubie.
Hubie who?
Hubie a good boy while we're gone!

Knock! Knock!
Who's there?
Al.
Al who?
Al in favor, say aye!

Knock! Knock!
Who's there?
Aussie.
Aussie who?
Aussie you tomorrow, mate.

Knock! Knock!
Who's there?
Snow.
Snow who?
No. Snow what and the Seven Dwarfs.

Knock! Knock!
Who's there?
Closure.
Closure who?
Closure mouth and open the door.

Knock! Knock!
Who's there?
Gwen.
Gwen who?
Gwen are you going to open this door?

Knock! Knock!
Who's there?
Vicious.
Vicious who?
Vicious a fine howdy-do for a visitor.

Knock! Knock!
Who's there?
Data.
Data who?
Data nice boy.

Knock! Knock!
Who's there?
Kenya.
Kenya who?
Kenya come out to play?

Knock! Knock!
Who's there?
Althea.
Althea who?
Althea later, dude.

Knock! Knock!
Who's there?
Rut.
Rut who?
Rut do you want me to say?

Knock! Knock!
Who's there?
Megan.
Megan who?
Megan dinner is a lot of work.

Knock! Knock!
Who's there?
Ride.
Ride who?
Ride you tell a fib about me?

Knock! Knock!
Who's there?
Will Hugh?
Will Hugh who?
Will Hugh marry me?

Knock! Knock!
Who's there?
Ham Bacon.
Ham Bacon who?
Ham Bacon you to let me in.

Knock! Knock!
Who's there?
Japan.
Japan who?
Japan my trampoline and bounce around.

Knock! Knock!
Who's there?
Reveal.
Reveal who?
Reveal you deserve a promotion.

................................

Knock! Knock!
Who's there?
Lassie.
Lassie who?
Lassie what's on TV.

................................

Knock! Knock!
Who's there?
Jamaica.
Jamaica who?
Jamaica a snack for us?

................................

Knock! Knock!
Who's there?
Hygiene.
Hygiene who?
Hygiene! What's new with you, Gene?

................................

Knock! Knock!
Who's there?
Marcella.
Marcella who?
Marcella is flooded. Can I borrow a mop?

Knock! Knock!
Who's there?
Habit.
Habit who?
Habit you're afraid to open the door.

................................

Knock! Knock!
Who's there?
Wagons.
Wagons who?
No. It's wagons ho!

................................

Knock! Knock!
Who's there?
Mo.
Mo who?
Mo lasses is very sweet syrup.

................................

Knock! Knock!
Who's there?
Maggie.
Maggie who?
Maggie doesn't fit in the lock.

CHAPTER 7

WACKY INVENTIONS

Pancakes that harden into Frisbees if you don't eat them.

Doorbells that only work if someone you really want to see is at your front door.

Pants with lead-lined cuffs to keep people who are full of hot air from floating away.

A special clock that runs extra fast during school and work days and extra slow during vacation and weekends.

Real Christmas trees that never dry up and can be used year after year.

Robot babysitters that can be activated on a minute's notice, so parents never have to hunt for one in an emergency.

Refillable ice cream cones.

A cookbook that reads its recipes to you as you prepare the dish.

Kids shoes that grow at the same speed kids' feet grow.

Giant wetsuits for chilly hippos.

Murder mystery novels that have the last chapter first for people who can't wait to find out who did it.

A flyswatter tennis racket, so you can practice your swing and whack annoying insects at the same time.

Headlights for deer so car drivers can see them better at night.

Floating schoolbooks you don't have to carry in a backpack.

Huge bird baths for ostriches.

A basketball that dribbles itself for clumsy athletes who like to play hoops.

Hot air conditioners for cold, winter nights.

An economy car that can turn into a mini-helicopter in traffic jams.

Doggie bags for ice cream sundaes you can't finish.

A mirror that shows the reflection of a beautiful person even if the person who looks into it is homely.

Balsa wood bricks for karate experts who want to break things but have delicate hands.

Shoes that automatically change into slippers when you come home from work.

A cookie jar that magically refills itself when treats get low.

Doughnuts with handles for people who like to dunk but want to keep their fingers dry.

Sturdy potato chips you can easily chew, but never snap off in the dip.

Sprinkler flowerpots that automatically turn on to water your houseplants when they need moisture.

An escalator stepladder that you don't have to climb, which stops at a predetermined height.

A cellophane shirt for men who have to watch their waistline.

Diet dog biscuits for chubby pooches that overeat.

A perfume that drives rich bankers wild. It smells like freshly minted money.

Neon thumbs that glow for people forced to hitchhike on dark highways at night.

A comfortable reclining bicycle seat.

An alarm calendar that rings on relatives' and friends' birthdays so you never forget to buy a gift.

Disposable pots and pans that never have to be washed.

A boomerang baseball that returns to you after you throw it so you can play catch alone.

Eyeglasses with tiny watches in the frames for clock-watchers.

A bicycle that can go forward or backward.

High heel sneakers for models who want to look fashionable while jogging.

A spray that makes your skin so tough that bees, mosquitoes, and other stinging insects can't bite through it.

Traffic lights for wild animals so they can cross busy streets.

A bicycle that automatically pedals itself up steep hills while the rider rests.

Pancakes that automatically flip themselves when they're done on one side.

Bait worms that squeak like mice to attract catfish.

A rollerblade chair for people who are too tired to skate standing up.

Electric rocking chairs that rock when you plug them in—for kids with short legs.

Knick-knacks that repel dust.

Kites with wings that flap so you can fly them when there's no wind.

Grass toupees for bald spots in the front lawn.

▶ ▶ ▶ ▶ ▶ ▶ ▶ ▶ ▶ ▶ ▶

A backyard birdie shower for birds who don't like to take baths.

◀ ◀ ◀ ◀ ◀ ◀ ◀ ◀ ◀ ◀ ◀

A dentist drill that plays sweet music instead of making that awful sound.

▶ ▶ ▶ ▶ ▶ ▶ ▶ ▶ ▶ ▶ ▶

Tree leaves that explode into mulch when they hit the ground. You don't have to rake them and they feed the grass.

◀ ◀ ◀ ◀ ◀ ◀ ◀ ◀ ◀ ◀ ◀ ◀ ◀ ◀ ◀ ◀

Doughnuts with no holes so you get more bites for your money.

▶ ▶ ▶ ▶ ▶ ▶ ▶ ▶ ▶ ▶ ▶ ▶ ▶ ▶ ▶ ▶

Suitcases with beeper signals that make them easy to locate at an airport.

◀ ◀ ◀ ◀ ◀ ◀ ◀ ◀ ◀ ◀ ◀ ◀ ◀ ◀ ◀ ◀

Animal bridges over busy country roads for deer, turtles, and other creatures.

▶ ▶ ▶ ▶ ▶ ▶ ▶ ▶ ▶ ▶ ▶ ▶ ▶ ▶ ▶ ▶

A people vacuum for dirty kids who don't like showers or baths.

◀ ◀ ◀ ◀ ◀ ◀ ◀ ◀ ◀ ◀ ◀ ◀ ◀ ◀ ◀ ◀

A T-bone steak with an edible bone so there's less waste.

A Congressional Ordinary Medal, which can be awarded to folks who never do anything heroic or special, so they can feel important too.

▶ ▶ ▶ ▶ ▶ ▶ ▶ ▶ ▶ ▶ ▶

Dog collars with iPod earphones for pets who like to listen to music while being walked.

◀ ◀ ◀ ◀ ◀ ◀ ◀ ◀ ◀ ◀ ◀

Pancakes that have maple syrup mixed into the batter to save time at the breakfast table.

▶ ▶ ▶ ▶ ▶ ▶ ▶ ▶ ▶ ▶ ▶ ▶ ▶ ▶ ▶ ▶

A talking cell phone that comes up with wise answers to insulting remarks made to you.

◀ ◀ ◀ ◀ ◀ ◀ ◀ ◀ ◀ ◀ ◀ ◀ ◀ ◀ ◀ ◀ ◀

A car that runs on pollutants instead of producing them.

▶ ▶ ▶ ▶ ▶ ▶ ▶ ▶ ▶ ▶ ▶ ▶ ▶ ▶ ▶ ▶ ▶

Refrigerated trailers made out of ice cubes for Eskimos who want to live in mobile homes.

◀ ◀ ◀ ◀ ◀ ◀ ◀ ◀ ◀ ◀ ◀ ◀ ◀ ◀ ◀ ◀

Floating golf balls for golfers plagued by the water hazard.

▶ ▶ ▶ ▶ ▶ ▶ ▶ ▶ ▶ ▶ ▶ ▶ ▶ ▶ ▶ ▶

A combination basketball court and trampoline so everyone can dunk the ball.

Nerf dumbbells for weaklings who want to lift weights.

Pockets with combination locks to discourage pickpockets.

Automatic neckties that tie themselves around your neck.

Pizza flavored bubblegum.

A Venus flytrap plant that gobbles up dust particles so you never have to dust your house.

Fruits like bananas and oranges with edible skins so you don't have to peel them.

Butter glue that sticks to corn on the cob.

Preheated soup that comes out of the can warm for hungry folks who can't wait to eat.

Super smart sheep that knit their own wool into clothing so you can cut out the middleman and reduce cost.

Air-conditioned hats for hotheads.

Rainproof-domed parks so picnics and barbeques will never again be washed out.

Air-cooled sidewalks so the pavement never gets too hot during the summer.

Rowboats with motorized oars that work by themselves when you get tired.

Interactive television shows that allow you to verbally debate the host or question guests from the privacy of your own home.

Report cards that automatically self-destruct if a student gets bad grades.

Books that are totally condensed into a foreword and an epilogue for people who have limited time to read.

Paper money that sticks to your fingers so it's harder to spend and easier to hold onto.

A joke book that contains canned laughter so you don't have to chuckle alone as you read it.

Tiny capsules that grow into artificial flowers when you plant them in your garden.

Pillows stuffed with cotton candy for folks who crave a sweet snack in the middle of the night.

Metal earmuffs for music lovers who have tin ears.

A hair blower that dries your hair and also combs or styles it at the same time.

Miniature cabanas attached to trees and shrubs that lazy caterpillars can use to turn into butterflies.

Wristwatches with tiny alarms that sound off if you have bad breath.

A bowling ball made out of foam rubber for little kids.

A remote-controlled bowling ball for lazy athletes.

Special miniature brainwave recorders that print out your thoughts for people who always forget what they were going to say.

Robot shoes programmed to perform any dance in the world, so people never have to master any steps on their own.

Special tape you can use to mend rips or tears in clothing for people who don't know how to sew.

Underwater rocking chairs for senior citizen mermaids.

Hovercraft blue jeans for chubby people who want to crowd surf during rock concerts.

Miniature working vacuums for dollhouses.

A showerhead that plays music as water streams out so you can sing your favorite songs as you scrub yourself.

Large trees with Swiss-cheese-type holes so telephone wires can pass through and the trees don't have to be cut down.

Toupees that actually grow on their own so bald guys can enjoy going to the barbershop once again.

Houses with mechanical robot arms so they can paint themselves.

Maple trees with special faucets that grow out of their trunks.

Gift-wrapped empty boxes to give to people who never want you to give them anything.

A bed with a built-in catapult that shoots you out of bed when the alarm goes off.

A TV set that automatically shuts itself off and on before and after commercials.

Galoshes with holes in them for kids who promise to wear rain boots, but love to get their feet wet.

Clothes with adjustable sizes you can still wear if you lose or gain weight.

A mirror that makes you look good early in the morning.

A bed with robot arms that makes itself.

Special satellite lighthouses in the sky so birds won't get lost in the fog when they migrate.

A bathroom scale with no numbers on it for people who hate to gain weight.

A fork that bends if you put too much food on it—for people on diets.

An exercise bike that helps generate electricity for your house or apartment that keeps you fit and saves you money.

Special peel-off bark that can be made into paper products so trees never have to be cut down.

Nails that automatically drill themselves into wood so you never chance hitting your thumb with a hammer.

Giant parachutes for airliners so they'll never be any plane crashes.

Miniature bathing suits for shy goldfish.

Toupees that naturally turn gray as bald guys age ... so men don't have to buy new ones every few years.

Moving sidewalks in school halls so students never have to run to their next class.

Frisbee plates you can eat off of and play with at picnics and at the beach.

CHAPTER 8

FUNNY THINGS

What happened when the sink and the bathtub had a shootout?
They plugged each other.

What did the clothesline say to the wet laundry?
Don't think you're going to hang around with me, you drips.

What did one speaker system say to the other?
I have some sound advice for you.

Why did the parked clock get a ticket?
It was over the time limit.

What did the nose say to the index finger?
Stop picking on me.

What's the best way to ship someone a toupee?
Send it hairmail.

What did the guitar say to the rock musicians?
Pick me.

Why was the arrow so angry?
It was fired from a crossbow.

Why did the mattress go to the doctor?
It had spring fever.

What does a novel wear to keep warm?
A book jacket.

Man: Does your wristwatch keep accurate time?
Jogger: No, it runs fast.

What do you get when a cell phone wears a shirt?
Ring around the collar.

What did the
broken clock say?
Will someone please
give me a hand?

Why was the letter
delivered in the morning
all wet?
It had postage dew.

What did one bicycle wheel say to the other?
Was it you who spoke to me?

Kenny: Have you ever heard of broom fever?

Jenny: No. What is it?

Kenny: It's an epidemic that's sweeping across the country.

Jenny: How do you avoid catching it?

Kenny: Lead a clean life.

When do old clocks pass away?
When their number is up.

What did one helicopter say to the other?
Drop by my pad later today.

What did the sharpener say to the pencil?
You can leave now. You've made your point.

What did the sword say to the angry saber?
Don't get all bent out of shape.

Publisher: Is this book about blankets any good?
Editor: It's just another cover story.

Why did the revolver go to the doctor's office?
It was a sick shooter.

What do you get if you cross the ocean and a cartoon duck?
Salt Water Daffy.

What kind of dots dance?
Polka dots.

What did the clothesline say to the clean laundry?
Hey guys! Hang around with me for a while.

What language do clocks speak?
Tick talk.

What did the old lawn chair say to the new lawn chair?
Welcome to the fold.

What did one lounge chair say to the other lounge chair?
Go chaise yourself.

SILLY SLOGAN:
ACME LABS — You'll grow mold working here.

What did one cemetery say to the other?
Are you plotting against me?

Jenny: **Did you hear the rumor about the burning building?**
Penny: **No. Is it hot gossip?**

Why did the trumpet take an algebra class? It wanted to be a math tooter.

How do you lock up a motel?
Use a hotel chain.

What do you get if you cross a diaper and a handbag? A change purse.

What did the cowboy say to the tangled lasso? That's knot funny.

What should you do if your clothes keep getting wet? Dry harder.

ATTENTION: A man who frequently puts his foot in his mouth sometimes ends up with a sock on his jaw.

Where did the old tire end up? On skid row.

What do you get from a zombie furnace? A dead heat.

SIGN IN DRY CLEANERS – We're opposed to a free press.

What did the fast car say to the sharp curve?
It was an honor to swerve you.

What happens when you jog
in a tough neighborhood?
You run into trouble.

RHYME TIME
Dollar for dollar
Pound for pound
Money is a nice thing
To have laying around.

What did the ceiling say to the chandelier?
You're the only bright spot in my life.

Which cards in the deck went to a psychologist?
The crazy eights.

Hal: What do you call a boomerang that doesn't work?
Val: A stick.

A man built a car totally out of wood. It had wooden seats, a wooden body and wooden wheels. It even had a wooden engine. There was only one big problem with his invention. The car wooden go.

What did the drumstick say to the drum?
Let's race. I bet I can beat you.

Who tells scary nursery rhymes?
Mother Goosebumps.

ATTENTION: There was a freak accident at the carnival sideshow last night.

What did the drapes say to the fresh decorator?
Don't sash me.

What did the dying window shout?
It's curtains for me!

Why was the window worried?

He thought he was going blind.

What did the handyman say to the wall?
One more crack like that and I'll plaster you.

Son: Hey, Dad! You know that black box that always survives plane crashes?
Father: Yes. What about it?
Son: Why don't they make the whole plane out of the same stuff?

What did Honest Abe drive after he joined the circus?
A Lincoln Clown Car.

ACME TOYS – Our life's work is child's play.

Why did the parachute school close?
It had too many dropouts.

What did the little toe say to the big toe?
Don't look back, but there's a heel following us.

What did Mr. Candle say to Ms. Candle?

Are you going out tonight?

Anne: Do you want some parting advice?
Dan: Sure.
Anne: Look in a mirror when combing your hair.

Why did the little boy pull the plug on the bathtub? He wanted to go for a drain ride.

What does Santa use to shoot arrows? A ho-ho-bow.

Why was the door shaking? It was all keyed up.

SILLY SLOGANS:

ACME WELL DIGGERS — We're in the hole sale business.

ACME AIR CONDITIONED PLANE HANGERS — We cool your jets.

Why did the bulletin board quit his job?
He just couldn't tack it anymore.

Reporter: I had to leave that new play early. Did it have a happy ending?
Critic: Indeed it did. We were all happy when it was over.

NOTICE: A high fever is when the sweat on your brain turns into steam.

TONGUE TWISTERS:
She sawed six slick, sleek, slim, slender saplings.
The sun shines on the shop signs.
Six sick soldiers sighted seven slowly sinking ships.

What college did Mr. Clock graduate from?
Georgia Tick.

What did the hole say to the trench?
Let's ditch your friend.

What did one cabinet say to the other?
Help your shelf.

Why did the shoe say ouch?
It bit its tongue.

Why are everybody's pants too short?
Because their legs always stick out two feet.

Why did the wheel get a liberal education?
Because it wanted to be well-rounded.

Cowgirl: Do you want to hear a joke about a cattle roundup?
Cowboy: No thanks. When you've herd one, you've herd them all.

Which state is the trouser state?
Pantsylvania.

Zeb: My new scarecrow is so ugly it scared away every crow for miles.
Jeb: Well my new scarecrow is so ugly it scared our crows into bringing back the corn they stole last year.

Which state is very cold in the winter?
Burrmont.

Which state is kind of sloppy?
Messachusetts.

Which state has the most highways?
Road Island.

What do you get if you cross a traffic light and a bonfire?
Smoke signals.

What is full of holes but still holds water?
A sponge.

What did the lasso say to the steer that escaped?
I guess you're not in the loop anymore.

Why did the thermometer go to college?
It wanted a higher degree.

Where do Mack trucks go to have fun?
To a trailer park.

Volunteer #1: **Yahoo! We found the**
lost child.
Volunteer #2: **Let's celebrate by**
organizing a search party.

Where does a train go to work out?
To a jogging track.

What kind of trousers does a new conductor wear?
Training pants.

What did the highway construction boss say as he climbed a hill?
I guess we'll have to upgrade our plans for this road.

House Hunter: Does this home have a finished
basement?
Real Estate Agent: Yes. In fact, it's ranked
number-one on our best cellar list.

Why was the little radio sad?
His mother wouldn't let him play outside.

SILLY SLOGANS:

ACME FOOTWEAR - Try our shoes and you'll be happy to put your foot down.

ACME BED & BREAKFAST - The Inn Crowd loves us.

ACME HUMIDIFIERS - You can't dew without our product.

ACME SURVEILLANCE - We watch where you're going.

ATTENTION:

Grammar instructors always mark your words.

ATTENTION: Glue and paste now on sale. Low sticker prices.

ATTENTION: Dentist bills can take a big bite out of your paycheck.

ATTENTION: Road hogs are pig-headed motorists.

ATTENTION: Army barbers know all the short cuts.

ACME CLOTHESPINS - We produce top of the line products.

What did the cart say to the shopper?
Quit pushing me around.

What do you get if you cross the Green Giant and a popgun?
A peashooter.

Jack: How did you repair that broken grandfather clock?

Mack: I used ticker tape.

What do you get if you kiss glue?
Lip stick.

What do you get if you cross a water cooler with a ballpoint?

A fountain pen.

What do you get if you cross cotton with detergent?
Soft soap.

Did you hear about the farmer who crossed a sewing machine with a tractor and got a vehicle that sews seeds?

What's the easiest way to hold your breath?
Blow it into a balloon.

SWIFTIES:

"I'm lost," Tom cried remotely.

"I loved the Valentine you sent me," sighed Tom heartily.

What's the best way to tear up a Valentine card?
Half-heartedly.

What do you call an exact duplicate of Texas?
The Clone Star State.

WANT ODDS:
Drama school needs acting principal.
Car repair shop needs motor head.
Bodybuilder needs new muscle car.
Math department needs add expert.

"This new robot will do half of your work," the salesman promised the hard-working self-employed man. "That's marvelous," said the potential buyer. "In that case, I'll take two."

The furniture department needed to have a conference.
"Who'll come to the meeting?" asked the sofa.
"I'll come and shed some light on our problem areas," said the lamp. "You can count on me," said the table.
"All we need now," said the sofa, "is someone to chair our committee."

KOOKY QUESTIONS:

Are tailors sewer workers?

Are Native American lawyers members of the Sue Tribe?

What do you find on the ogre turnpike?
Troll booths.

What word is always pronounced badly?
Badly.

Why did the chef put a clock in a hot pan?
He wanted to see time fry.

What do you take when you're going from your old house to your new house?
Moving pictures.

Ted: **You should never write a love letter on an empty stomach.**
Fred: **Why not?**
Ted: **Paper is better.**

Where does one find an ocean with no water?
On a map.

ATTENTION: Pillow Company needs workers looking for a soft job.

Why did the window answer the cell phone?
It was a curtain call.

What happened when the cruise ship Red crashed into the steamship Blue at sea?
All of the passengers were marooned.

What goes up and down but doesn't move?
A staircase.

What does fat pollution have?
Lots of toxic waist.

What did the hill say to Mount Rushmore?
I remember you when you were two-faced.

Where did the sick tugboat go?
To the nearest dock.

Billionaire: Thanks for building this elegant estate for my family.
Contractor: Don't mansion it.

Where did the U.S. president live in prehistoric times?
Washington, B.C.

What kind of pants did the corn farmer wear?
Husky pants.

Clerk: Would you like to buy one of our mountain bikes, sir?
Customer: Perhaps! If the price isn't too steep.

What did the measles say to the chicken pox?
Don't do anything rash.

What kind of stories should you tell during a slow boat ride?
Ferry tales.

Fran: How's your coin purse? Still empty?
Anne: Yes, no change.

Where do planes wash up?
In a jet stream.

What's Slime's favorite game?
Slimon says.

Why doesn't a steam locomotive like to sit down?
Because it has a tender behind.

What card game did the artist play?
Draw poker.

What do you get if you plant an orchard in Astroturf?
Artificial fruit.

What do you get if you cross a pot of glue and a croquet set?
A sticky wicket.

What's crazier than a nutty caboose?
A loco-motive.

When is a card game not tame?
When the deuces are wild.

Which card in the deck is helpful if you have a flat tire?
The Jack.

Why did the poker player run to the bathroom?
He had a flush.

Show me a dumb light bulb...and I'll show you a dim wit.

▶ ▶ ▶ ▶ ▶ ▶ ▶ ▶ ▶ ▶ ▶ ▶ ▶ ▶ ▶ ▶ ▶

Show me an outlaw with a noose around his neck...
and I'll show you a knot-head.

▶ ▶ ▶ ▶ ▶ ▶ ▶ ▶ ▶ ▶ ▶ ▶ ▶ ▶ ▶ ▶ ▶ ▶

What did the father broom say to baby broom?
It's time to go to sweep.

▶ ▶ ▶ ▶ ▶ ▶ ▶ ▶ ▶ ▶ ▶ ▶ ▶ ▶ ▶ ▶ ▶

NOTICE: Stones for sale · rock bottom prices!

HINKY PINKY—WHAT DO YOU CALL . . .

...A boy named Richard covered in glue?
A sticky Ricky.

...A small child with a fever?
A hot tot.

...A father who is always patting folks on the back?
A slap-happy pappy.

...A story told in a stable?
A barn yarn.

...A moron who likes to play billiards?
A pool fool.

FUNNY HAND PUPPETS:

THE STOOL PIGEON - you put your hand in it and it points an accusing finger at you.

THE PSYCHOANALYST - you put your hand into it and it nods its head as if it understands.

THE SURGEON - you put your hand into it and it stitches itself to your wrist permanently.

THE POLITICIAN - you put your hand into it and it shakes your other hand.

THE CROOK - you put your hand into it and it picks your pocket.

◄ ◄ ◄ ◄ ◄ ◄ ◄ ◄ ◄ ◄ ◄ ◄ ◄ ◄ ◄

And then there was the sick light switch that didn't know when he was well off.

► ► ► ► ► ► ► ► ► ► ► ► ► ► ►

Trumpet: **Do you like being bagpipes?**
Bagpipes: **Yes. I'm proud to be a windbag.**

◄ ◄ ◄ ◄ ◄ ◄ ◄ ◄ ◄ ◄ ◄ ◄ ◄ ◄ ◄

ATTENTION: Buy Acme speakers for your big screen TV. They're a sound investment.

What did the hand say to the arm?
How about giving me a raise?

What did the college mattress look forward to?
Spring Break.

ATTENTION: **A big grandfather clock is a long timer.**

How do you dial a cell phone?
Use your ring finger.

Uncle Al: Things are so depressing in the world today that smile buttons are considered antiques.

What do you call mops and dusters produced in New York?
American Maid Products.

Uncle Al: The tough economy has even trickled down into the toy market. The newest Barbie doll comes with second-hand fashions and her dream house is furnished with used furniture.

Why was the wooden chair so unpopular?
It had a warped sense of pride.

What do you call a very young cannon?
A baby boomer.

What did the little pebbles go down at the playground?
The rock slide.

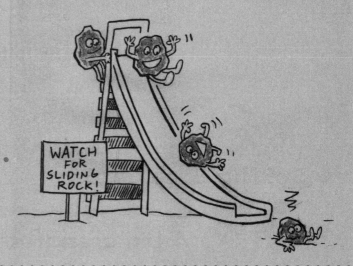

ATTENTION: Stonehenge is a rock hall of fame.

TONGUE TWISTERS:
"Shoot Sally," slim Sam shouted shyly.
"Bye, Bye Bluebird," Billy Beaver bellowed.
Lucky Louie Lion likes licking lemon lollipops.
Friendly Freda Fly flips flapjacks.

What's the best way to pass a geometry exam?
Figure out all the angles.

WACKY WORDS OF WISDOM:
In sports it's not important who wins or loses. What's important is which team is victorious.

If you're working on commission, sixty percent of making a successful sale is half mental.

The truth will set you free if you make a good deal with the D.A. to testify.

What happens when the sun is happy?
It beams with joy.

What is the favorite story of little drums?
Uncle Tom-Tom's Cabin.

How do you write to a deep hole for mining minerals?
Send a quarry letter.

Where does rich slime live?
On Oozy Street.

What city was the capital of the ancient corn civilization?
Cornstantinople.

CRAZY QUESTION:
Are convicts' suits jailor-made?

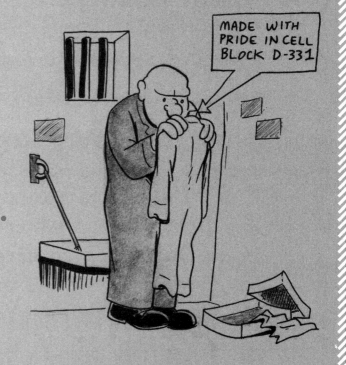

Ms. Bracelet: **Why are you so exhausted?**
Mr. Clock: **I've been running the whole day.**

Lady: Do cruise ships like this one sink very often?
Sailor: No, ma'am. Only once.

What do you find at the foot of the turnpike?
A toe booth.

ATTENTION: You know you live in a tough neighborhood when the local police station has a burglar alarm.

What do you get if you cross a trampoline and Gospel music?
A jump hymn.

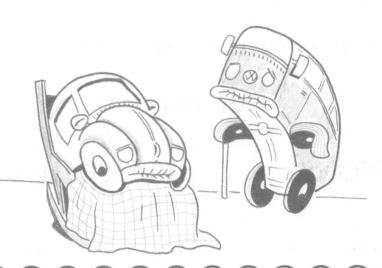

Where can you buy a vintage Volkswagen?
Try an Old Volks Home.

KOOKY QUESTION: Does a sword swallower have a razor-sharp tongue?

Man: **I'd like to buy a round trip ticket.**
Bus Depot Clerk: **Where to?**
Man: **Duh! Back to here.**

Woman: Can I get a ticket for Madison?
Ticket Clerk: Where is Madison?
Woman: He's the little boy standing by the vending machines.

Man: I'll give you a dollar if you bring me a lock of your older sister's beautiful blond hair.
Boy: Make it five bucks and I'll bring you the whole wig.

Judge: Tell the truth, Mr. James. Were you and Mr. Smith having a fistfight?

Mr. Jones: No, your honor.

Mr. Smith: Yes, your honor.

Mr. Jones: Don't believe him, judge. He's still punchy.

NOTICE: *A kleptomaniac is a person who helps himself because he can't help himself.*

KOOKY QUESTION: Did Colonel Custer blow the Little Big Horn?

What do you get if you cross a watch with a politician running for election?

A clock with a hand that shakes.

Dora: Why do you have a piece of string tied around your finger?

Cora: My mom tied it to me. It's to remind me to mail a letter for her.

Dora: Did it work? Did you mail your mom's letter?

Cora: No. She forgot to give it to me.

Reporter: What's your name?

Convict: I'm number 816124-860.

Reporter: Is that your real name?

Convict: No. It's my pen name.

Why was Mr. Match so happy?
He was voted into the Hall of Flame.

Uncle Al: My alma mater was so small we didn't have a college choir. We had a college duet.

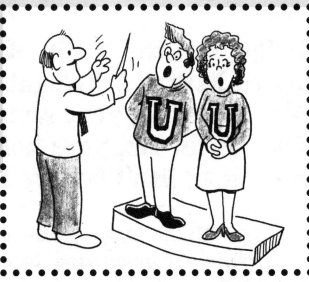

What did the black checker say to the red checker?
So long. I'm going to move.

Uncle Jim: Where do you want to go to college Melanie?
Melanie: I want to go to Football University.
Uncle Jim: But the student population of Football U. is 80 percent male.
Melanie: That's why I want to go there.

What did the price tag yell at the checkout counter?
Help! I've been ripped off.

SIGN IN A SPEECH CLASS: Don't be quiet.

What do you get if you cross a watch with a boxer?
A clock with fists instead of hands.

ATTENTION: Not only doesn't a dollar go far these days; it doesn't stay around long either.

SIGN ON A POST OFFICE: We were the first to be letter perfect.

SIGN IN ALASKA: Charity begins at Nome.

ATTENTION: Middle age is when you have more fun remembering what you did than doing what you're doing.

What do you get if you cross a watch with a nice person?
A clock that's always willing to give you a hand.

What do you call a safe in Dublin?
The Lock of the Irish.

How do you keep your house dry?
Don't pay the water bill.

Millie: What's a skeleton?
Billy: It's a person with the inside out and the outside off.

What do you call secretive instructions for opening a zipper?
A zip code.

What kind of dirt is lots of fun?
Playground.

What do you get if you cross the beach with Irish music?
Sandpipers.

TONGUE TWISTED:
Round the rugged rocks the ragged rascal ran.
Green and gray geese gaily grazing in Greece.
Blue black bugs' blood.
Surely the sun shall shine soon.
Windy weather makes Wendy Worm wiggle wildly.

ATTENTION: Don't get cold feet. But warm socks!

Why did the traffic light turn red?
It had to change on a public street.

What did Ms. Clock say to her student wristwatches when the bell rang?
Please exit the class in a timely fashion.

ATTENTION: If you want a fresh holiday tree, do your Christmas chopping early.

What did the clock say at the board meeting?
I second that proposal.

Mr. Hour: Why did you name your little clock Tick?
Father Time: Because he doesn't tock much.

Jill: Have you ever seen a barn dance?
Bill: No, but I've seen a house party.

What is a twack?
Something a twain rides on.

How do you make an apple go bananas?
You drive it out of its rind.

How do you catch a beach monster?
Use a sand trap.

What did the road say to the bridge?
You made me cross.

What color do you paint a piano?
Plink.

Where did the pianos vacation in Florida?
At Key Largo.

Bill: Did you hear the joke about the new airplane?

Jill: No.

Bill: Never mind. It'll probably go over your head.

What do you get if you cross a rundown shack and Saint Nicholas?
Shanty Claus.

Where do monster locomotives live?
In Trainsylvania.

Why did the chimney sweep go to a doctor?
He needed a flue shot.

How do you repair a broken joke?
Use slapstick humor.

ACME DATING SERVICE – Let us show you around.

Then there was the picture that was guilty of a hanging offense.

Where do concrete blocks meet new friends?
At a cement mixer.

What's red and white and bumpy?
A snowman with acne.

What do you get if you cross a drinking cup and a bullet?
A mug shot.

What do you get if you cross fossils and dishes?
Bone china.

How bad is the economy?

The economy is so bad my **ATM** gave me an **I.O.U.**
The economy is so bad I started a new diet. It's called I Can't Afford Food.
The economy is so bad I got a pre-unapproved credit card in the mail.
The economy is so bad I ordered a burger at a fast food place and the girl behind the counter asked me if I could afford fries with that.
The economy is so bad going out to eat means having a peanut butter sandwich on my porch.

Which piece of living room furniture plays football?
The end table.

What did the track official say to the dining room table?
Get set.

When should you wrap a pill in a blanket?
When it's a cold tablet.

Why was the rifle shaking?
Its nerves were shot.
▶ ▶ ▶ ▶ ▶ ▶ ▶ ▶ ▶

What has four wheels, flashing lights, and is a coward?
A yellow school bus.

◀ ◀ ◀ ◀ ◀ ◀ ◀ ◀ ◀ ◀

Jill: Is the horn on your car broken?
Bill: No. It just doesn't give a hoot.
▶ ▶ ▶ ▶ ▶ ▶ ▶ ▶ ▶ ▶ ▶ ▶ ▶ ▶ ▶ ▶ ▶

What did the shovel say to the hole?
Let's get to the bottom of this.
◀ ◀ ◀ ◀ ◀ ◀ ◀ ◀ ◀ ◀ ◀ ◀ ◀ ◀ ◀ ◀ ◀ ◀

Why do pillows make fine lawyers?
They know a good case when they see it.
▶ ▶ ▶ ▶ ▶ ▶ ▶ ▶ ▶ ▶ ▶ ▶ ▶ ▶ ▶

What kind of pipe is found in a civil court?
A sewer pipe.
◀ ◀ ◀ ◀ ◀ ◀ ◀ ◀ ◀ ◀ ◀ ◀ ◀ ◀ ◀ ◀ ◀

Show me America's first pair of false teeth and I'll show you the George Washington bridge.
▶ ▶ ▶ ▶ ▶ ▶ ▶ ▶ ▶ ▶ ▶ ▶ ▶ ▶ ▶

How do you put a hearse in second gear?
Use the graveyard shift.

How did Noah see in the dark?
He put up ark lights.

▷ ▷ ▷ ▷ ▷ ▷ ▷ ▷ ▷ ▷ ▷ ▷ ▷ ▷ ▷ ▷ ▷ ▷

Which came first? Boys Clubs or Girls Clubs?
Neither. Cavemen's clubs came first.

◀ ◀ ◀ ◀ ◀ ◀ ◀ ◀ ◀ ◀ ◀ ◀ ◀ ◀ ◀ ◀ ◀ ◀

**Why is a quarter smarter
than a dime?**
It has more cents.

▷ ▷ ▷ ▷ ▷ ▷ ▷ ▷ ▷ ▷

*What did the robot say to
the gas pump?*
*Take your finger out of
your ear and listen to me.*

◀ ◀ ◀ ◀ ◀ ◀ ◀ ◀ ◀ ◀ ◀ ◀ ◀ ◀ ◀ ◀ ◀ ◀ ◀

What is a trumpet's favorite day of the week?
Toots Day.

▷ ▷ ▷ ▷ ▷ ▷ ▷ ▷ ▷ ▷ ▷ ▷ ▷ ▷ ▷ ▷ ▷ ▷

Why should you never read books about witchcraft?
They're hex-rated.

◀ ◀ ◀ ◀ ◀ ◀ ◀ ◀ ◀ ◀ ◀ ◀ ◀ ◀ ◀ ◀ ◀

Why is the piano giggling?
Someone was tickling its keys.

▷ ▷ ▷ ▷ ▷ ▷ ▷ ▷ ▷ ▷ ▷ ▷ ▷ ▷ ▷ ▷

What do you need to fasten spy pants?
A zip code.

Where did the creek stream live?
On face brook.

Which vegetable won the hurdles event at the track meet?
The Jumping Bean.

Bill: Where can you buy a buck?
Jill: Go to a dollar store.

Bill: If I wash my face, will it be clean?
Jill: Let's soap for the best.

SWIFTIES:

"I paint and sculpt," Tom said artfully.

"I like making art projects at home," said Tom in a crafty way.

Why is an Army recruiting center warm?
There are no more drafts.

Why did the clock go to court?
He was a witness in a time trial.

Bob: Why did the wood-burning stove join a fitness club?
Rob: It was turning into a pot-bellied stove.

What did the mother give her toddler?
A surprise potty.

How did the tornado win a medal for bravery?
It fought in Whirl War II.

What did the drill sergeant say to the rope?
Line up.

What did the drill sergeant say after the rope lined up?
Knot now!

What did the drill sergeant say to the rope after the wet laundry came out?
Soldier, your job is to keep them pinned down.

NOTICE: The Navy announced the cost of upgrading its submarines has tripled this year. Even the price of going down has gone up.

How do you fix a Charley Horse?
Go to a cramp counselor.

STUPID SENTENCES:

When you change Judy's diaper sprinkler with baby powder.

The gym teacher said Billy and I make quite a pear.

Absent a letter to my Aunt June.

The tree in my backyard is so tall I can't climate.

If your blankets are too short, your fiddlestick out.

Yes, we do currently have a room toilet.

The President decided to commuter sentence.

Mr. Jones walks around with a stiff neck because he's afraid his wiggle fall off.

How do you handcuff a barber?
Use locks of hair.

Why did the crooked belt go to jail?
The judge suspended his sentence.

A man walked into a shoe store and said to the manager, "Do you have any loafers?" "Yes," replied the manager, "but I'm sure I can find someone to wait on you."

What do you get if you cross a minister and an organ?
A prayer piano.

Which city in Nebraska is a real funny place?
Omaha-ha.

Jim: Which side of the cake is the right side?
Slim: I don't know.
Jim: The side that is eaten because the other side is left.

What do you get if you cross a clock and a man who stepped on a small nail?
Tick tack toe.

Ken: Why did you move to Hawaii?
Jen: I wanted to spend my vacations at home and still enjoy myself.

Who speaks all the languages of the world?
An echo.

ATTENTION: Life is like a shower. One wrong turn and you're in hot water.

What did Pinocchio say to the woodpecker?
Go away. I don't need another hole in my head.

Why was the clock crying?
A bully twisted its arm.

What did the old watch say to the digital clock?
The time business is getting out of hand.

UNSOLVED SILLY MYSTERIES...

Dig a hole. Carefully pile the dirt you take out nearby. Now try to fill the same hole back up with the same dirt. You always end up with too much dirt or not enough.

The richest guy you know ends up winning a million dollars in the state lottery. The poorest guy you know wins a two-dollar cash prize.

The last piece of cheesecake magically disappears from the fridge and nobody admits taking it.

Fertilize, water, and pamper a plant you want to grow and it dies. Ignore a plant you don't care about and it grows and multiplies.

The guy who never bothers with his lawn has great grass. The guy who slaves over his lawn grows weeds.

When you barbecue, the cheap burgers turn out perfect and the expensive steak burns to a crisp.

The biggest and best piece of fruit always grows on the top of the tree far out of reach.

The kid who is too tired to do his homework has plenty of energy for video games.

All the best movies you're dying to see are on cable the day you have no time for TV. When you have all day to watch TV, only lousy moves and reruns are on.

The dude with a makeshift bamboo pole hooks a whopper, while the angler with expensive fishing gear reels in a minnow.

CHAPTER 9

JOLLY JOBS

How did the man build his flea collar company?
He started from scratch.

Who is in charge of erecting boundaries on our borders?
The Secretary of the Fence.

KOOKY QUESTION:
Do commercial fishermen need to maintain a strong line of credit?

NOTICE: Train to be a commercial fisherman · no hidden catches.

Tim: What do you plan to do after high school?
Jim: I have a burning desire to be a professional fireman.

Joe: Are cameramen generous?
Moe: Yes. I know one who lens everything.

What does a plumber do when he sees a swimming pool?
He plunges right in.

What do miners put on their faces at night?
Coal cream.

Then there was the florist who had two sons, one was a budding genius, and the other was a blooming idiot.

Harry: My brother has an important job. He works with hundreds of people under him.
Larry: What does he do?
Harry: He mows the grass in a cemetery.

Boss: I'll pay you ten dollars an hour now and raise it to twelve dollars an hour in three months. When would you like to start work?
Man: Three months from now.

What do you call a person who operates an armored truck?
A safe driver.

Where do most bankers come from?
The Check Republic.

Why did the accountant go to acrobat school?
He wanted to learn how to balance her books.

Ben: What do you do for a living?
Ken: I work with figures.
Ben: Are you an accountant?
Ken: No, I'm a fitness instructor.

Larry: What do you do for a living?
Barry: I make playing cards out of chocolate.
Larry: Wow! What a sweet deal.

A rancher was talking with his new neighbor. "What's the name of your cattle?" asked the neighbor. "It's M.J.P. Lazy Bar Q Double RR Circle Star K," said he. "And how many head of cattle do you have?" continued the neighbor. "We only have about a dozen," admitted the rancher. "Not many survive the branding."

What do you call a lumberjack who finishes second in a tree-cutting contest?
A saw loser.

What did Sergeant Apple say to the fruit troopers?
Pear up, men!

Why do ministers, pastors, and priests like Sunday so much?
It's their big pray day.

What did the driver do after he quit the wagon train?
He got a job coaching.

Tim: How's your job at the shirt factory?
Slim: It makes me hot under the collar.

Which one of King Arthur's knights was a real estate agent?
Sir Sellalot.

▶ ▶ ▶ ▶ ▶ ▶ ▶ ▶ ▶ ▶

What did the lumberjack say when he saw the forest?
Now that's a sight for saw eyes.

◀ ◀ ◀ ◀ ◀ ◀ ◀ ◀ ◀

Why did the detective-turned-farmer plant carrots and potatoes?
He was fond of undercover crops.

▶ ▶ ▶ ▶ ▶ ▶ ▶ ▶ ▶ ▶ ▶ ▶ ▶ ▶ ▶ ▶ ▶ ▶

Why did the rock musicians bring scissors to the recording studio?
They wanted to cut an album.

◀ ◀ ◀ ◀ ◀ ◀ ◀ ◀ ◀ ◀ ◀ ◀ ◀ ◀ ◀ ◀ ◀

Why did the circus animal trainer put on a bad show?
Because he forgot his lions.

▶ ▶ ▶ ▶ ▶ ▶ ▶ ▶ ▶ ▶ ▶ ▶ ▶ ▶ ▶ ▶

What did Sergeant Cyclops say to the soldier?
Watch your step. I have my eye on you.

◀ ◀ ◀ ◀ ◀ ◀ ◀ ◀ ◀ ◀ ◀ ◀ ◀ ◀ ◀ ◀ ◀ ◀

How can you tell if a barber is famous?
Look at his press clippings.

And then there was the acrobat who wore a hat to the circus and ended up flipping his lid.

▷ ▷ ▷ ▷ ▷ ▷ ▷ ▷ ▷ ▷ ▷ ▷ ▷ ▷ ▷ ▷ ▷ ▷ ▷ ▷

What do you call an out-of-service Barbarian?
Attila Hun-plugged.

◁ ◁ ◁ ◁ ◁ ◁ ◁ ◁ ◁ ◁ ◁ ◁ ◁ ◁ ◁ ◁ ◁ ◁ ◁ ◁

Show me a carpenter who builds a roof on a clock tower ... and I'll show you a guy who works overtime.

▷ ▷ ▷ ▷ ▷ ▷ ▷ ▷ ▷ ▷ ▷ ▷ ▷ ▷ ▷ ▷ ▷ ▷ ▷ ▷

Ben: I take rotten photos because I don't concentrate on what I'm doing.
Jen: If you want to be a professional photographer you've got to learn to focus on your subjects.

◁ ◁ ◁ ◁ ◁ ◁ ◁ ◁ ◁ ◁ ◁ ◁ ◁ ◁ ◁ ◁ ◁ ◁ ◁ ◁

Hal: I'm a movie stuntman. They pay me big money to trip over things and to fall down stairs.
Sal: Really? All these years my clumsy brother has been doing the same stunts for free.

▷ ▷ ▷ ▷ ▷ ▷ ▷ ▷ ▷ ▷ ▷ ▷ ▷ ▷ ▷ ▷ ▷ ▷ ▷ ▷

And then there was the congressman who joined the navy because he wanted to be on a subcommittee.

◁ ◁ ◁ ◁ ◁ ◁ ◁ ◁ ◁ ◁ ◁ ◁ ◁ ◁ ◁ ◁ ◁ ◁ ◁ ◁

Mr. Green: Would you like to buy an inexpensive, custom-made suit?
Mr. Brown: No thanks. My own tailor suits me just fine.

▷ ▷ ▷ ▷ ▷ ▷ ▷ ▷ ▷ ▷ ▷ ▷ ▷ ▷ ▷ ▷ ▷ ▷ ▷ ▷

Why is a baseball catcher like a bouncer in a nightclub?
They both throw out a lot of people.

What did the traffic cop say to the turtleneck sweater?
Hey you, pullover.

Where did the Tin Man go after he retired?
A rust home.

Boss: Do you ever have trouble making decisions?
Job Hunter: Well ... yes and no.

A wife was having lunch with her husband who was the CEO of a big company. "I read in the paper this morning," said the wife, "that a widower in New Jersey with eight children married a widow from New York with seven children. "Her husband grunted in response. "That wasn't a marriage," said he, "it was a merger."

What did the policeman say to the playground equipment?
You can't park here.

Who is the Army's funniest officer?
Major Crackup.

Why did the detectives question the letters of the alphabet?
They were looking for an I witness.

Bobby: My dad used to work at an auto muffler shop, but he quit.
Robbie: Why did he do that?
Bobby: He got too exhausted.

Bob: I used to own a doughnut shop.
Rob: What happened?
Bob: I got tired of the hole business.

Fred: Our company has a special group of individuals who hand out pink slips.
Ed: That sounds like a fire department to me.

Ted: I'm going to clown college.
Ed: That's one way to make a fool of yourself.

Who do you call when a teepee bursts into flames? The fire chief.

SIGN ON SANTA'S HOUSE: Payment expected when service is reindeered.

SIGN ON A TAILOR SHOP: I am a man of the cloth.

Ike: What do you want to be when you grow up?

Mike: This may sound funny, but I want to be a stand-up comic.

Ike: You're kidding, right?

Mike: If I am, the joke is on me.

Ike: I don't mean to laugh at your goal in life, but I can't help smiling when I think about it.

Mike: I'm not just fooling around. This isn't a gag or a prank.

Ike: Well, don't blame me if I can't keep a straight face. Being a comic is a laughing matter.

Mike: I guess I'll have to get used to people treating me like a buffoon. All I ask of you is one thing.

Ike: What's that?

Mike: Don't laugh at me behind my back.

Zack: Are you still in the lawn chair business?

Jack: No. My company folded.

Dom: Did you hear about the big accident at the glue factory? A vat of paste spilled all over the floor.

Tom: Gosh! I'll bet that was a real sticky situation.

Mike: My haberdasher is always losing his temper.

Spike: He sounds like a typical mad hatter to me.

Then there was the cat burglar who committed the purrfect crime.

How does a boss can ten employees fast?

He uses rapid-fire tactics.

What do you call a monk in a submerged submarine?
A deep friar.

New Reporter: Did you attend many senate meetings?
Old Reporter: Yes. And after all is said and done, more is said than done.

NOTICE: A policeman who moonlights as a drummer in a rock band pounds a beat both day and night.

What do you call a person who sells tires for a living?
A wheeler-dealer.

DAFFY DEFINITION:
Garbage man - junk male.

A man holding a big toolbox stood outside of a house and rang the bell. A lady opened the door. "I've come to fix the kitchen sink," said the man. "I'm the plumber." The lady looked confused. "I didn't call a plumber," she replied. "Aren't you Mrs. Jones?" asked the plumber. The lady shook her head. "No. The Jones family moved out a year ago." How do you like that," grumbled the plumber. "They call for a plumber claiming it's an emergency and then they move away."

Why did the president go to the furniture store?
He had to pick out a cabinet.

Why did the lawyer take a clock to court?
He was involved in a time trial.

What do you need to be a successful large-animal veterinarian?
Good horse sense.

Mrs. Morgan: Were you very nervous when you asked your boss for an advance on your salary?
Mr. Morgan: No. I was calm and collected.

What do you get if you cross a fencer and a lumberjack?
A person who uses a saber saw.

An absentminded farmer looked down and noticed he was holding a long length of rope in one hand. He scratched his head with the other hand. "Hmm," he wondered, "did I find a rope or lose a cow?"

What did one farmer shout to the other?
Hay you!

Sara: My uncle is a ventriloquist.
Clara: Does he enjoy talking to himself?

YOU BORE ME!

A minstrel is a strange breed of person. When you ask him what he does for a living, he gives you a song and a dance.

What happened when they burned a judge for witchcraft in Salem?
His honor was at stake.

What does a cowboy put on his salad?
Ranch dressing.

ATTENTION: A barber who always cuts people he shaves has a nick knack.

What do you get if you cross a comedian with a watchmaker?
A person who's a laugh a minute.

Harry: Would you like to drive a taxicab for a living?
Larry: No thanks. I couldn't hack the long hours.

Who is in charge of the vegetable school?
Mr. Lettuce is the headmaster.

Why did the businessman wear a bathing suit to work?
He rode to his office in a carpool.

What do you call two sailors in the brig?
Cell mates.

Boss: You should have been here at eight o'clock.
Employee: Why? What did I miss?

Why did the umbrella manufacturer open a bank account?
He wanted to save some money for a sunny day.

Did you hear about the composer who jumped into a washing machine because he wanted to write soap operas?

What did the tough housekeeper say to her boss?
Don't mess with me.

Fitness Instructor: Business is very slow.
Aerobics Teacher: Don't worry, things will work out.

A kindergarten teacher was teaching her class the alphabet. "Now students," said she. "What comes after T?"
A boy jumped up and shouted "V"!

And then there was the magician who kept falling down because he had a trick knee.

Why did the ghoul take a job in an auto repair place? He wanted to work in a body shop.

YOUR CAR NEEDS A NEW LIVER!

Bob: *I want to be a history teacher some day.*
Rob: *There's not much of a future in a job like that.*

NOTICE: A politician with a broken leg is running for Congress and needs support.

NOTICE: Actors spend their summers in playgroups.

Reporter: How did you learn about raising chickens?
Poultry Farmer: I studied a hencyclopedia.

What is an anti-war plumber an expert at fixing? Peace pipes.

What do you get if you cross a magician with a photographer?
Hocus focus.

Why were the soldiers so tired on April 1st? Because they just finished a 31-day March.

What does a policeman have for dessert? A copcake.

KOOKY QUESTION: Why is the boss always early on the days you're late for work?

What is a lumberjack's favorite state? Arkansaw.

How do musicians fight B.O.?
They use a rock and roll-on deodorant.

What did the lawyer say to the pillow? I'll take your case.

Employee: Boss, can I have Friday off? My wife wants me to paint our house.
Boss: Absolutely not.
Employee: Oh, thank you, boss. Thank you very much.

Where do robbers play tennis? In a criminal court.

What's the difference between a jeweler and a jailer?
A jeweler sells watches and a jailer watches cells.

Construction Boss:
Jones! Why are you only carrying one cinderblock while all of the other workers are carrying two?
Jones: I guess they're too lazy to make two trips like I do.

What's big, happy and raises wheat crops?
The Jolly Grain Giant.

Why did the police arrest the miner?
They thought he was a coal-blooded killer.

Why did the Marines sneak into the mess hall at night?
They were on a mission to raid the refrigerator.

Why did the postman punch the letters?
He wanted to be a mail boxer.

Boy: My uncle has married at least one hundred wives.
Girl: That's awful.
Boy: Nah! It's okay. He's a minister.

Boss: Why are you soaking wet?
Employee: I just came up from the secretarial pool.

Judge: What's your name and occupation?
Prisoner: My name is Sparks and I'm an electrician.
Judge: What's the charge against you?
Prisoner: Battery, your honor.
Judge: I'm positive you're guilty. Take the prisoner to a dry cell.
Prisoner: What a shocking development.

What do you call a mugger
who becomes a friar?
Brother Hood.

Pat: How did you become a copy editor?
Nat: I got the idea back in high school. I never studied for any tests and sat next to a lot of smart kids.

ATTENTION: Garbage men are people with disposable incomes.

Why do tailors make good lawyers?
They're experts when it comes to handling lawsuits.

Jill: Do you like working at a sauna bath?
Bill: No. The place is a real sweatshop.

Joe: Is it hard to be a circus performer?
Moe: The work is in tents.

Show me a blacksmith with a broken cart ... and I'll show you a guy who fixes his own wagon.

Wife: **How was work dear?**
Judge: **It was a very trying day.**

Hobo: I sure wish I were in your shoes.
Businessman: Because I'm successful and have a high paying job?
Hobo: No. Mine have holes in them.

Gil: Did you hear about the man who fell into a machine at the upholstery shop?
Will: Did he get hurt?
Gil: Yes, but he's totally recovered now.

Why did the police arrest the rock musicians?
Because one guy beat on the drums and the other guys picked on guitars.

Who always gets his work done by Friday?
Robinson Crusoe.

What did the tired monk say at the end of his workweek?
Thank god it's friar day.

What did the gangster do to the candle?
He snuffed it out.

▶ ▶ ▶ ▶ ▶ ▶ ▶

Why did the artist go to the bank?
His account was overdrawn.

◀ ◀ ◀ ◀ ◀ ◀ ◀ ◀ ◀ ◀ ◀ ◀ ◀ ◀ ◀

What did the judge say to the petty crook?
You've done some fine work today.

▶ ▶ ▶ ▶ ▶ ▶ ▶ ▶ ▶ ▶ ▶ ▶ ▶ ▶ ▶

Nora walked into Cora's new dress shop. "Hi, Cora," greeted Nora. "How's business?" "Business is awful," complained Cora. "Yesterday I only sold one dress and today business is even worse." Nora was confused. "How could it be worse?" she asked her friend. "Today," explained Cora, "the woman who bought that dress yesterday returned it!"

◀ ◀ ◀ ◀ ◀ ◀ ◀ ◀ ◀ ◀ ◀ ◀ ◀ ◀ ◀

What holiday do corn farmers like best?
New Ear's Day.

▶ ▶ ▶ ▶ ▶ ▶ ▶ ▶ ▶ ▶ ▶ ▶ ▶ ▶ ▶

What kind of party do they hold on an Iowa farm?
A Corn Ball.

◀ ◀ ◀ ◀ ◀ ◀ ◀ ◀ ◀ ◀ ◀ ◀ ◀ ◀ ◀

What do you get if you cross an accountant and an English grammar teacher?
A figure of speech.

Where does a lumberjack put his axe when he goes to the supermarket?
In a chopping cart.

▶ ▶ ▶ ▶ ▶ ▶ ▶ ▶ ▶ ▶ ▶ ▶ ▶ ▶ ▶

What did the lumberjack say to the giant tree?
I'll cut you down to my size.

◀ ◀ ◀ ◀ ◀ ◀ ◀ ◀ ◀ ◀ ◀ ◀ ◀ ◀ ◀

Teddy: What do you make of all this talk about unemployment?
Freddy: I think it's just a lot of gab from people sitting around with nothing to do.

▶ ▶ ▶ ▶ ▶ ▶ ▶ ▶ ▶ ▶ ▶ ▶ ▶ ▶ ▶

Lumberjack: We haven't chopped down a single tree.
Lumberjohn: We haven't chopped down a married one, either.

◀ ◀ ◀ ◀ ◀ ◀ ◀ ◀ ◀ ◀ ◀ ◀ ◀ ◀ ◀

ATTENTION: Rip Van Winkle got fired for falling asleep on the job.

▶ ▶ ▶ ▶ ▶ ▶ ▶ ▶ ▶ ▶ ▶ ▶ ▶ ▶ ▶

Why do corn farmers respect the Bill of Rights?
It's in their Cornstitution.

◀ ◀ ◀ ◀ ◀ ◀ ◀ ◀ ◀ ◀

Tina: Why did you quit your job at the coffee shop?
Gina: Every day it was the same old grind.

▶ ▶ ▶ ▶ ▶ ▶ ▶ ▶ ▶

How do you start a letter to a corn farmer?
To whom it my corncern.

How can you find a noisy lost rock star?
Use a heavy metal detector.

Why did the corn farmer help the old lady across the street?
He was a cornsiderate guy.

Lawyer: I wish I could have done more for you.
Client: Thanks, but ten years in jail is enough.

Kenny: I'm not in favor of a four-day workweek.
Lenny: Why not?
Kenny: It won't give me enough time to rest up for the weekends.

What did the detective say to his neighbor?
Don't move.

Why are writers the strangest creatures on earth?
Their tales come out of their heads.

What did Mr. Spock say to the gold miner?
Live long and prospect.

What did the fencer say to the pizza chef?
I'll take a slice.

Former Crook: I went straight because I was a total failure as a robber. I couldn't even steal a kiss from my steady girlfriend.

Boss: The other night I dreamed I was dead.
Employee: What happened? Did the intense heat wake you up?

Convict: Last year I tried to escape by carving a fake gun out of a bar of soap.
Inmate: Why did the breakout fail?
Convict: I got caught in a cloudburst.

Who takes care of a young English policeman when his parents go out?
The bobby sitter.

What do you get if you cross a loan officer and a song writer?
Bank notes.

What is an oilman's favorite holiday?
April Fuel's Day.

What do pirates like to eat for dessert?
Rum cake.

Where do jail inmates sleep when they go camping?
In con tents.

How do jail inmates keep in touch with their friends?
They use con text.

Where did the prison warden put Dracula?
In a blood cell.

Lawyer: **How did you hurt your back?**
Man: **I slipped getting into the tub.**
Lawyer: **That's a common bathing suit.**

Ted: Girls love a man in uniform.
Fred: Baloney! I've been a bellhop for a year and girls still ignore me.

Why did the writer get a job at the U.S. Mint?
He wanted to coin a phrase.

Why did the pickpocket go into the butcher shop?
He wanted to do some choplifting.

ATTENTION: When crooks play golf, caddies are bagmen for gangsters.

Then there was the crooked tailor who learned to mend his evil ways.

What did the lumberjack say when he found a giant tree?
Now that's a sight for saw eyes.

What do you get when you cross writers and jail inmates?
Prose and cons.

General: What kind of dog do you have, Sergeant?
Sergeant: A West Pointer, Sir.

Where did the governor hang his wet laundry?
On the state line.

Two salesmen were bragging to each other. They worked in competing men's clothing stores. "Yesterday, a man came in to buy socks and I ended up selling him new slacks and a sports coat," boasted one.
"That's nothing," retorted the other. "A lady came in to buy a dark suit to bury her deceased husband in."
"And so?" asked the first. Said the other, "I sold her a suit with two pairs of pants."

Ed: I'm a self-made man.
Fred: Well you do faulty work, pal.

Girl: What do you do for a living?
Artist: I'm a sculptor. I come from a long line of chiselers.

What do you call someone who is always wiring for money?
An electrician.

KOOKY QUESTION: Do celebrity tailors hire press agents?

Why did King Midas start his own business?
He couldn't pass up a golden opportunity.

What do you call a pop-music genius?
A rock-it scientist.

Lady: You should be ashamed of yourself. You're begging for money in the street like a hobo.
Man: Actually, lady, I'm an author. I wrote a book entitled 101 Ways to Make Money Fast."
Lady: If that's the case, why are you begging?
Man: This is one of the ways to make easy money fast.

Does King Midas have a court jester?
No. He has a gold mime.

Who is the strongest policeman in the world?
The traffic cop. He can stop a truck with one hand.

Then there was the private who got in trouble at the military base for shopping at the general store.

Why don't exorcists have many friends?
Because they scare the devil out of a lot of people.

What do you call a ghost maid?
A haunted housekeeper.

What game do retailers like to play with shoppers?
Price tag.

Why did the police arrest the grumpy old man?
He kept making cranky phone calls.

Detective: Can you describe your missing bank teller?
Banker: Yes. He was about six feet tall and fifty thousand dollars short.

ATTENTION: Butler seeks to hire American maid help.

Judge: Don't you know that crime doesn't pay?
Prisoner: Yes, your honor, but you can't beat the hours.

Why did the lumberjack go to the Chinese restaurant?
He wanted some Chop Suey.

Gino: I got a job at the bodybuilders' gym.
Tino: What do you do?
Gino: I work in security. I'm a weight watcher.

What do you get when a zombie becomes a radio disc jockey?
Lots of dead air.

ATTENTION REAL ESTATE AGENTS! You have lots to be thankful for.

ATTENTION: Italian Architects! It's your civic duty to support the Leaning Tower of Pisa.

Lady: How much will it cost for you to change my car tire?
Mechanic: We charge a flat rate.

What happened to the rapper who got arrested for writing bad lyrics?
The judge took away his poetic license.

Show me a deep-sea diver who thinks about his job all day ... and I'll show you a man with water on the brain.

What did the fireman say to the ladder operator?
It's time for me to get a raise.

What do you call a tree cutter who takes yoga classes?
A limberjack.

What did the cashier say after the bank robbery?
There's nothing left to till.

Why did the lawyer go to the beach?
She was looking for some new bathing suits.

What did the security guards say to the gardener?
Stop. Who grows there?

What kind of parties do fishermen have?
Cast parties.

What is a dairy farmer's favorite soap opera?
As the world churns.

The Congressman's wife abruptly sat up in bed late one night. "There's a robber in the house," she stammered as she shook her sleepy husband awake. "A robber in the house?" he snorted wearily. "That's impossible. In the Senate maybe, but in the house—never!"

How did Mr. Snickers become a lawyer?
He passed his candy bar exam.

Customer: These shoes are too narrow and pointed for me. They're uncomfortable.

Salesman: But everyone is wearing narrow pointed shoes this season.

Customer: That's nice, but I'm still wearing last year's feet.

Pickpocket: I just stole this gold watch.
Pawnshop Owner: You couldn't have picked a better time.

How did the sailor break the captain's scale?
He tried to weigh their ship's anchor.

Where does a banker hang his wet laundry?
On a line of credit.

What did the neat farmer do twice a week?
He dusted his crops.

What did the realtor say to the agent as they watched a landslide?
When you said this property would move fast, I thought you were joking.

Where does a friar spy work?
At a secret mission.

Then there was the magician who became a steel worker and pulled rivets out of his hat.

Agent: What do you consider your best work of fiction?
Writer: Last year's income tax return.

Detective: Did you take a circus job with the crooked high-wire act?
Crook: No. They wanted me for their fall guy.

Why did the sergeant fire the lazy fence builder?
He deserted his post.

Boss: **Please don't whistle while you work.**
Employee: **Chill out, boss. I'm not working.**

How did Santa Claus become a lawyer?
He passed the polar bar.

Why did the judge wear earplugs?
She didn't want to hear any more cases.

Circus Clown: **How much do they pay for being shot out of a cannon?**
Human Cannonball: **Twenty dollars a mile plus traveling expenses.**

WHAT'S IT MEAN TO BE FILTHY RICH?

Filthy rich is having wall-to-wall carpeting in your garage.

Filthy rich is hurting your back when you try to lift your wallet.

Filthy rich is hiring a chauffeur to drive your chauffeur to work each day.

Filthy rich is tipping the mugger who robs you.

Filthy rich is having a solid gold ID card.

Filthy rich is not caring if you lose your wallet because you always carry a spare.

Filthy rich is having tickets to a pro football game on the fifty-yard line ... in a hovercraft flying above the field.

Filthy rich is getting numb fingers from counting your weekly pay.

Filthy rich is having escalators installed in your kids' tree house.

Filthy rich is having your own personal ATM machine in the foyer of your home.

Why did the tightrope walker quit the circus?
He finally reached the end of his rope.

When should you answer a circus phone?
After three rings.

Girl: My boyfriend has an odd job.
Father: What do you mean by that?
Girl: If he has a job, it's odd.

Old Employee: You can't help admiring the boss once you start working here.
New Employee: And why is that?
Old Employee: Because if you don't, he fires you.

Harry: I have a leading part at a Broadway theater.
Barry: You're an actor?
Harry: No. I'm an usher.

What does a bad joke writer use to make his sandwiches?
Corny bread.

Judge: The next person who raises his or her voice in my courtroom will be thrown out.
Prisoner: YA-HOO! YIPPEE! HOORAY!!!

How did the nervous carpenter break his teeth?
He bit his nails.

. .

Millie: Did you ever speak in front of an audience?
Billy: Yes. I said, "Not guilty."

. .

Then there was the magician who liked frogs so much he pulled a ribbet out of his hat.

. .

Who shoots people, blows them up, and then lets them go home and hang themselves?
A photographer.

CHAPTER 10

YUMMY YUCKS

What did one tired can of soda say to the other?
I'm too pooped to pop.

Show me a vehicle that runs on potato skins. . .and I'll show you a car that can peel out.

What kind of soda does a wacky person drink?
Kook-a-cola.

What kind of soda does a wacky, calorie-conscious person drink?
Diet Kook-a-cola.

What do you get if you cross a milkshake and a big amusement park in Florida?
Malt Disney World.

What do you call a worried hotdog?
A frankfretter.

Girl: Would you like to drive over a barrel of pickles with a steamroller?
Boy: I'd relish the opportunity.

What did the Gingerbread Boy find on his bed?
A cookie sheet.

· ·

What did Sergeant Jam shout to his jelly troopers?
Spread out, men.

· ·

SIGN IN A GERMAN RESTAURANT—**This is where the in-kraut goes for lunch.**

· ·

What do you call rowboat vegetables?
Oarganic food.

· ·

Boy: Did you like that last pickle joke?
Girl: Yeah! It was really dilly!

· ·

DAFFY DEFINITION:
Barbecued Ribs – a side order.

· ·

ATTENTION: Don't use the butter. It's spoiled. Spread the news.

· ·

What's green and smells bad?
A cucumber with onion breath.

· ·

Chef: Why didn't you boil some water like I told you to?
Dorky Cook: I didn't know the recipe.

What sweet treat does Mr. Scrooge like?
Chocolate-covered mints.

How did Mr. Snickers become a bodybuilder?
He lifted candy barbells every day.

◀ ◀ ◀ ◀ ◀ ◀ ◀ ◀ ◀ ◀ ◀ ◀ ◀ ◀ ◀ ◀ ◀ ◀

What buzzes and is sweet?
A Bee Bee Ruth candy bar.

DAFFY FOOD DEFINITIONS:

Vegetarians – people who don't want to meat.

Box Lunch – **a square meal.**

Mexican Food – a hot meal.

Pizza Pie – **a cheesecake.**

Meatball – ground round.

Cuisine – **any food you can't pronounce.**

What did the corned beef say to the potatoes?
Let's hash out our differences.

Which hand is the best one to eat soup with?
Neither. Use a spoon, you slob.

ATTENTION:
The high price of health food makes me sick!

What's the difference between a mournful song and rotten vegetables?

One is a sad ballad and other is a bad salad.

What do toddlers eat for dessert?

Baby cakes.

Bill: I'll trade you my hotdog for your hamburger.

Will: Okay. We'll have a swap meat.

What do you get if you cross a ground-beef patty and static electricity?

Burger Cling.

What did the pancake say to the flapjack?

This is a stack up.

Where's the best place to buy candied ham?

Go to Hershey Pork.

What do you call a truce between warring vegetables?

A peas treaty.

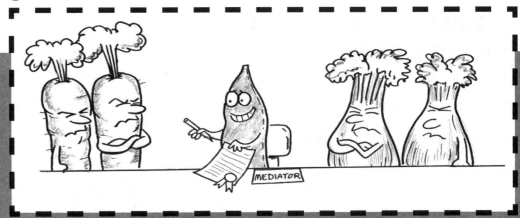

What did the peas drive to the prom?
A limo bean.

What did the bread say to the hot oven?
I'm toast.

What did Ms. Milky Way give Mr. Snickers?
A chocolate kiss.

What kind of candy do school children eat on the playground?
Recess pieces.

Patron: Waiter, there's a hair in my soup!
Waiter: That belongs in the rabbit stew.

What is Attila the Barbarian's favorite fruit?
Huneydew melon.

ATTENTION:
A person who gets too many knuckle sandwiches is a gluten for punishment.

KOOKY QUESTION: Does the Green Giant have an I-pod?

TIME TO DOWNLOAD THE BLACK-EYED PEAS!

What do you get if you cross a pastry chef with root beer?
Baking soda.

Patron: **Waiter, there's a dead bug in my soup.**
Waiter: **We'll hold a funeral after you finish your meal, sir.**

What did the angry custard-maker say?
I'm pudding my foot down.

What do you get if you cross a pastry chef and a baseball hitter?
Cake batter.

What does a meek pastry chef bake?
Humble pie.

What does a pilot eat for dessert?
Pie in the sky.

What did the dairy police do after the milk crime?
They grilled the Big Cheese.

Tillie: **Ralph went on a banana diet. He ate nothing but bananas three times a day for a month.**
Millie: **Did he lose weight?**
Tillie: **No, but you should see him climb trees.**

Why was the bread dough so sad?
It wanted to be kneaded by someone.

Miner #1: I had ham and eggs for breakfast. What did you have?

Miner #2: Coal cereal.

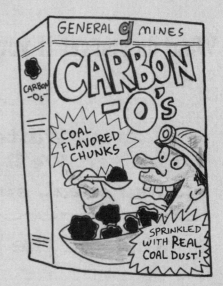

How do you make a Pepsi cake?
Use baking soda.

Hamburger: Can I speak frankly with you?
Hotdog: Sure. Go ahead.
Hamburger: Okay. You're a big wiener.

What is the name of Captain Hook's Italian restaurant?
The Pizza Pirate.

Gino: Where do mummies go for Italian food?
Dino: I don't know.
Gino: To Pizza Tut.

What did the boy potato say to Ms. Spud?
I only have eyes for you.

Who eats dinner faster than a speeding bullet?
Supperman.

Boy: Those first three pancakes you made were great, but this last one on the bottom is awful.

Girl: You're eating the paper plate I put the other three on.

- -

Shopper: Gee, grapes are cheap this week. They're only twenty-five cents.

Manager: That's twenty-five cents per grape, ma'am.

- -

What does the Green Giant eat for a snack?
Peas-a-pie.

- -

What did Dracula say when he saw a zombie making Chinese food?

Dead Man Woking.

- -

How does King Midas like his chicken fried?

Golden brown.

- -

Don: I put shredded cheddar on your taco.
Juan: That's grate news.

- -

Cowboy: I'm so happy I could eat a horse.
Hunter: I'm so happy I could eat a moose.
Trapper: I'm so happy I could eat a bear.
Lady: Gulp! I just lost my appetite.

- -

What does an astronaut use to cook Chinese food in space?
A moon wok.

Girl: Do you eat corn on the cob?
Boy: No. I bite if off and eat it.

Show me an old pastry chef...and I'll show you a former flour child.

What did Ms. Cookie say to Mr. Cookie?
Let's break up.

Girl: Why do you put honey on your peas?
Boy: It makes them stick to my fork.

What kind of cookies does Mr. Scrooge eat?
Fortune cookies.

Waitress: Would you like more alphabet soup, sir?
Customer: N-O.

What is Santa's favorite snack?
Peanut butter and jolly.

Why did the witch go into the kitchen?
To brew some coffee.

What makes the Tower of Pisa lean?
A low-calorie diet.

Teen Girl: I'd like a double-chocolate ice cream sundae with hot fudge topping, nuts, and lots of whipped cream.

Waiter: Do you want a cherry on top?

Teen Girl: Absolutely not! I'm on a strict diet.

STUPID SIGN ON A FRIED CHICKEN RESTAURANT: Employees must wash their hens before they start to cook food.

SILLY SLOGANS:
TOTALLY FAIR PASTRY SHOPPE – The Home of Just Desserts.
ACME BAKERS – We have the dough you knead.

DAFFY DEFINITION:
Pastry Chef – a bake-up artist.

What do you get if you rip a scarf in half?
A bandana split.

What kind of hotdogs does a Sasquatch eat?
Big frank-footers.

Why was the old apple poker player mad?
He had a rotten hand.

▶ ▶ ▶ ▶ ▶ ▶ ▶ ▶ ▶ ▶ ▶ ▶ ▶ ▶ ▶

What do you call a tiny peapod?
A beanie baby.

◀ ◀ ◀ ◀ ◀ ◀ ◀ ◀ ◀ ◀ ◀ ◀ ◀ ◀ ◀

Boy: I had broken cookies for lunch today.
Girl: What a crumby meal.

▷ ▷ ▷ ▷ ▷ ▷ ▷ ▷ ▷ ▷ ▷ ▷ ▷ ▷

What's the best vitamin for making friends?
B-1.

◁ ◁ ◁ ◁ ◁ ◁ ◁ ◁ ◁ ◁ ◁ ◁ ◁ ◁ ◁

What do you get if you cross
a cornfield and a box of candles?
Ear wax.

▶ ▶ ▶ ▶ ▶ ▶ ▶ ▶ ▶ ▶ ▶ ▶

DAFFY DEFINITION:
Belly Fat — what occurs when a person
constantly goes over the feed limit.

◀ ◀ ◀ ◀ ◀ ◀ ◀ ◀ ◀ ◀ ◀ ◀ ◀ ◀

What do you get if you cross chili
peppers and bullets?
Hot shots.

▶ ▶ ▶ ▶ ▶ ▶ ▶ ▶ ▶ ▶ ▶ ▶ ▶ ▶ ▶ ▶

SIGN ON A WORM RESTAURANT: *"Eat dirt cheap."*

◀ ◀ ◀ ◀ ◀ ◀ ◀ ◀ ◀ ◀ ◀ ◀ ◀ ◀ ◀ ◀

What do you get if you cross a radio station with garlic?
A place that broadcasts bad breath.

American Chef: How do our American dishes compare with your French dishes?

French Waiter: They're about the same. If you drop them, they break.

◄ ◄ ◄ ◄ ◄ ◄ ◄ ◄ ◄ ◄ ◄ ◄ ◄ ◄ ◄ ◄

Why didn't the trashcan order anything at the restaurant?

It was full of junk food.

► ► ► ► ► ► ► ► ► ► ► ► ► ► ►

Reporter: What kind of milk do you use to make doughnuts?

Baker: Hole milk.

◄ ◄ ◄ ◄ ◄ ◄ ◄ ◄ ◄ ◄ ◄

Millie: Do they have Swiss Cheese in heaven?
Tillie: I doubt it.
Millie: They should. It's holey enough.

► ► ► ► ► ► ► ► ► ► ►

Jen: Why are those grapes carrying musical instruments?

Len: They're going to a jam session.

◄ ◄ ◄ ◄ ◄ ◄ ◄ ◄ ◄ ◄ ◄ ◄ ◄ ◄ ◄

Ken: Have you ever seen a hotdog stand?
Len: No, but I've seen a hamburger roll.

► ► ► ► ► ► ► ► ► ► ► ► ► ►

Jill: They say you are what you eat.
Bill: Then let's order some rich food.

Polly: *How's the grape juice?*
Dolly: *It's divine nectar.*

What kinds of fights take place at noon?
Lunch boxing matches.

What is the name of the new candy reality show on cable TV?
M & MTV.

Where's the best place to find stewed tomatoes?
Try the salad bar.

What did one graham cracker say to the other?
Wafer me.

SORRY, TEACHER. I ATE MY HOMEWORK!

Jill: **Why did you take a cooking class?**
Bill: **It's a subject I can really sink my teeth into.**

What did the knife say to the artichoke?
I'm going to cut your heart out.

Patron: This duck soup is awful.
Waiter: What's wrong with it?
Patron: It tastes like it's watered down.

What do you get if you put a nuclear reactor in an ice cream factory?
A meltdown.

Where do they make the best corn dogs in the world?
At Corny Island.

What's purple on the inside and silver on the outside?
A grape wrapped in aluminum foil.

What's white on the outside and red, green, brown, orange, and yellow on the inside?
An M & M candy sandwich.

Then there was the rich dairy farmer who kept his money in Swiss Cheese banks.

ATTENTION: Italy is going to sponsor a new global award. It's called the Nobel Pizza Prize.

SIGN ON A PICKLE STORE: Buy now. Don't dilly dally.

What's crisp, salty, and floats?
Potato ships.

What's a buccaneer?
A high price for fresh corn.

◄ ◄

SIGN ON A DINER IN A BAD NEIGHBORHOOD: Try our mugger special and take a bite out of crime.

► ► ► ► ► ► ► ► ► ► ► ► ► ► ► ► ►

Why was the hotdog happy?
He was born a wiener.

◄ ◄

Dora: *This is a new crisp breakfast cereal made in the shape of numbers.*
Flora: *Yum! Let's crunch some numbers together.*

► ► ► ► ► ► ► ► ► ► ► ► ►

What do you get if you cross
a gun and a saucepan?
Something that takes pot
shots at the chef.

What did the
pirate vegetable wear
over one eye?
A cabbage patch.

What's white and runs across the kitchen table?
A glass of spilled milk.

What do you call a long knife that can cut four loaves of bread at one time?
A four-loaf cleaver.

What's the most dangerous vegetable to have in a ship's galley?
A leek.

What do you get if you cross ground beef and sleds?
Hamburger sliders.

What did the grapes say as Santa stepped on them?
We squish you a Merry Christmas.

What is the favorite snack of steam locomotives?
Cheese puff-puff-puffs.

◀ ◀

Why was the lettuce crying?
It banged its head.

Where do you find smart cabbage?
At the head of the class.

What did the ice cream cone say to the scoop?
Will you do me a flavor?

What do you get when lightning strikes a cashew farm?
Nuts and bolts.

Why didn't the eggs go to the rap party?
They were afraid of break-dancers.

What does money say when it sneezes?
Cash-shoo!

What do you call popcorn that's too tired to pop?
Pooped corn.

What do you call a stolen yam?
A hot potato.

What do you get if you cross a cornfield with a shoe repairman?
Corn on the cobbler.

How do you make a garden tool sandwich?
Use hoe wheat bread.

What did the steam locomotive eat for breakfast?
Puffed rice cereal.

How does a field of corn stay in shape?
It does earobics.

What do you get if you cross peanut butter and cabbage?
A thickheaded vegetable.

ATTENTION: Oranges love juicy gossip.

When is the best time to slow cook dinners?
During simmer vacation.

AND YOU WON'T BELIEVE WHO I SAW POMEGRANATE WITH AT THE JUICE MIXER LAST NIGHT!

What do you get when you cross nuts with a desk pad?
Peanut blotter.

SILLY SIGNS

SIGN IN A DENTAL OFFICE – Good oral hygiene is bad for business.

SIGN ON A BAKERY WINDOW – We sell cheesecakes just like the kind your mother used to buy.

SIGN ABOVE A PRISON EXIT – From now on, keep right.

SIGN ON A TAXI CAB COMPANY – We want to drive away our customers.

SIGN ABOVE A PILOTS' LOUNGE – We don't mind if you take off today.

SIGN ABOVE A DETECTIVE'S DESK – Out to hunch.

SIGN IN AN OPTOMETRIST'S SCHOOL – We care about every pupil.

SIGN IN A TAXIDERMIST'S SHOP – We stuff Thanksgiving turkeys.

SIGN BY FLOWERS IN A PARK – Love 'em and leave 'em.

SIGN ON A BEAUTY PARLOR – If your hair isn't becoming to your friends, you should be coming to us.

SIGN ON A HIVE – Our honey is rated bee plus.

SIGN ON A TRASH TRUCK – Satisfaction guaranteed or double your garbage back.

SIGN ON A HENHOUSE – We're proud of being big chickens.

SIGN ON A USED VOLKSWAGEN LOT – We have lots of bugs.

SIGN ON A MATTRESS TESTING COMPANY – We encourage our employees to sleep on the job.

SIGN IN A FLORIDA TRAVEL AGENCY – Don't save your money for a rainy day. Spend it in the sunshine.

SIGN ON A VELCRO FACTORY: Let us stick our product to you.

SIGN ON A FIREWOOD COMPANY: Our Customers Burn Us Up.

SIGN ON A FURNACE COMPANY: We want to

CHAPTER 11

THE DAFFY DICTIONARY

Acorn - an oak in a nutshell.

Acquaintance – a person you know well enough to borrow from but not well enough to lend to.

Actor — a person who works hard at being someone other than himself most of the time.

Adult – a person who has stopped growing at both ends and is now growing in the middle.

Air Force Pilots – **soldiers with their noses up in the air.**

Alarm Clock - a device to wake up people who don't have small children or pets that need to go out.

Antarctic - snowman's land.

I COULD GO FOR PIZZA DELIVERY RIGHT NOW!

Antiques - merchandise sold for old time's sake.

Archaeologist - a professor whose reputation is ruined.

Authorship – a writer's canoe.

Baby Quadruplets – four crying out loud.

Backache — the thing you claim to have when someone asks you to weed the garden.

Bad Driver – the person your car rear-ended.

Balloon – a thing that's full of hot air.

Bandstand - what a band has to do when someone takes away their chairs.

Baseball's Minor Leagues – the hope diamonds.

Basketball - a fancy dance for bugs held in a basket.

Big Belly Laugh - girth quake.

Birth Announcement - a stork quotation.

Blister - a heel's revenge for being stepped on.

Bore - a person who has nothing to say and takes two hours to say it.

Bread - raw toast.

Bully - a person with more muscles and less brains than other kids.

Bus Operator — a person who drives away even his best customers.

Business — what, when you don't have any of it, you go out of it.

Buzz Saw — a honey of a woodcutter.

Camel – *a horse with a speed bump.*

Carp - a musical instrument played by angelfish in heaven.

Caterpillar — an upholstered worm.

Change Purses - old money bags.

Character - a thing few people have and a lot of people are.

Cheap - the sound made by the inexpensive canary you bought.

College - a place where a lot of wise guys hang out; higher than high school.

College Cheer – Rah! Rah! Hi, Mom! Hi, Dad! Send Money!

Computer Crash — dots all folks.

Cookout – a chef on strike.

Cottontail – *a hoppy ending.*

Cowardice - yellow frozen water.

Creditor – a person who has better legal connections than a debtor.

Cricket - a game played by English grasshoppers.

Criminal - a person who managed to overcome his honesty and fear and got caught.

Critic - **a person who loves to hate plays and movies.**

Declaration of Independence – a doctor's excuse that allows you to miss school for a week.

Dentist – a doctor with a lot of pull.

Diamond — a stepping-stone to a walk down the aisle.

Diet – the victory of mind over platter.

Diplomacy – saying nice things to and doing nice things for people you really can't stand.

Duck – a chicken with flat feet.

Dust – mud with the juice squeezed out.

Egotist - an I-for-an-I kind of guy.

Emergency Room - a place where people who are run down wind up.

Encore – an attempt by a live audience to get more for their money at a rock concert.

Eve – **Madam Adam.**

▶ ▶ ▶ ▶ ▶ ▶ ▶ ▶ ▶ ▶ ▶ ▶ ▶ ▶ ▶ ▶ ▶ ▶

Fast Food – quick meals you run out to buy.

◀ ◀ ◀ ◀ ◀ ◀ ◀ ◀ ◀ ◀ ◀ ◀ ◀ ◀ ◀ ◀ ◀ ◀

Fireproof — the boss's relatives who work at his factory.

▶ ▶ ▶ ▶ ▶ ▶ ▶ ▶ ▶ ▶ ▶ ▶ ▶ ▶ ▶ ▶ ▶ ▶

Fish – a creature that goes on vacation the same time most fishermen do.

◀ ◀ ◀ ◀ ◀ ◀ ◀ ◀ ◀ ◀ ◀ ◀ ◀ ◀ ◀ ◀ ◀ ◀

Flagon – a red, white, and blue dragon.

◀ ◀ ◀ ◀ ◀ ◀ ◀ ◀ ◀ ◀ ◀ ◀ ◀ ◀ ◀ ◀ ◀ ◀

Fodder – the guy who married Mudder.

◀ ◀ ◀ ◀ ◀ ◀ ◀ ◀ ◀ ◀ ◀ ◀ ◀ ◀ ◀ ◀ ◀ ◀

Forger – a novel approach to check writing.

▶ ▶ ▶ ▶ ▶ ▶ ▶ ▶ ▶ ▶ ▶ ▶ ▶ ▶ ▶ ▶ ▶ ▶

Fresh Water – you use to get it by turning on a tap, now you get it by twisting off a cap.

◀ ◀ ◀ ◀ ◀ ◀ ◀ ◀ ◀ ◀ ◀ ◀ ◀ ◀ ◀ ◀ ◀ ◀

Friend – a person who dislikes the same people you do and also has the same enemies.

▶ ▶ ▶ ▶ ▶ ▶ ▶ ▶ ▶ ▶ ▶ ▶ ▶ ▶ ▶ ▶ ▶ ▶

Funeral Home – where people are dying to get in.

◀ ◀ ◀ ◀ ◀ ◀ ◀ ◀ ◀ ◀ ◀ ◀ ◀ ◀ ◀ ◀ ◀ ◀

Garlic – exercise food to make your breath strong.

▶ ▶ ▶ ▶ ▶ ▶ ▶ ▶ ▶ ▶ ▶ ▶ ▶ ▶ ▶ ▶ ▶ ▶

Geologist – a graduate of the School of Hard Knocks.

THANK YOU! YOU WERE A GREAT AUDIENCE! I'LL BE HERE ALL WEEK!

THE BEAN STALK

Gigantic — an antic performed by a wise guy giant.

▶ ▶ ▶ ▶ ▶ ▶ ▶ ▶ ▶ ▶ ▶ ▶ ▶

Glove – a sock you wear on your hand.

◀ ◀ ◀ ◀ ◀ ◀ ◀ ◀ ◀ ◀ ◀ ◀

*Good Manners – **the noises you don't make while eating or drinking.***

▶ ▶ ▶ ▶ ▶ ▶ ▶ ▶ ▶ ▶ ▶

Good Sport - a foe that always lets you have the first pick when selecting teams.

◀ ◀ ◀ ◀ ◀ ◀ ◀ ◀ ◀ ◀ ◀ ◀ ◀

Grand Canyon – **America's Hole of Fame.**

▶ ▶ ▶ ▶ ▶ ▶ ▶ ▶ ▶ ▶ ▶ ▶

Granny Knot - what happens when Granny forgets to put her glasses on and ties her shoelaces.

◀ ◀ ◀ ◀ ◀ ◀ ◀ ◀ ◀ ◀ ◀ ◀

Gripe - a ripe grape.

▶ ▶ ▶ ▶ ▶ ▶ ▶ ▶ ▶ ▶ ▶ ▶

Hair - a dome covering.

◀ ◀ ◀ ◀ ◀ ◀ ◀ ◀ ◀ ◀ ◀ ◀ ◀ ◀ ◀ ◀

Halloween - **Pranksgiving time.**

Harmonica — some chin music.

Hibernate — to live on burrowed time.

Hijack — **a tool for changing tires on an airplane.**

Honesty – the terror of being caught.

Horse Sense – stable thinking; what keeps horses from betting on people who run in foot races.

Hospital – you have to be really sick to want to go there.

Huddle – athletes getting together to play some football.

I COULDN'T HAVE DONE IT WITH- OUT YOU!

Hug – people pulling together.

Hula Dance – **a shake in the grass.**

Hypochondriac – a person who worries himself sick if he feels good.

Hypodermic needle – **a stick pin.**

Icicle — an eavesdripper.

Icy Path – **a slidewalk.**

Illiterate – a well-read person who isn't feeling well.

Imitation - **an invite to a party for a bunch of phonies.**

Immediately – the way your grumpy boss want things done.

Jar - a bottle with its mouth open wide.

Jelly - a nervous jam.

Joke - **what some people tell and what other people marry.**

Jump - the last word in airplanes.

WHAT DO YOU GET WHEN YOU CROSS A FUNNY, VIVACIOUS WOMAN WITH A CLUELESS DORK?

I DUNNO...

SPORTS

Jury — twelve people whose job it is to decide which side has the better lawyers.

Kazoo — the sound of a loud sneeze.

Kingdom — **a royal dork.**

Labor Day – *a holiday when people celebrate working by not working.*

Lawsuit – what a cop wears on the job.

Leather – **really dry skin.**

Limerick – a witty ditty.

Locomotive – **an insane reason for doing something.**

Lollipop – **tooth decay on a stick.**

Magician – anyone who can make a weekly paycheck last an entire week.

Magnifying Glass – something that makes mountains out of molehills.

Magpie — a fruit dessert baked by a person named Maggie.

Maternity Ward – **an heirport.**

Mental Institution – *you have to be out of your mind to go to a place like that.*

Menu – a list of food, the best of which the restaurant just ran out of.

Meteorite – **a space chip.**

Middle Class Guy - a man who lives by working himself to death.

Millionaire - a person who never looks at the price listings on a menu before he orders food in a fancy restaurant.

Mist - rain that can't get its act together.

Modern Kitchen - a place to store a microwave oven and frozen and canned foods.

Mother-in-Law — a woman who is never ever outspoken.

Mountain Climber – someone who wants to take a peak.

So THAT'S WHAT THE OTHER SIDE LOOKS LIKE!

Moustache – an eyebrow that slipped down a man's face.

Napkin - a lapkerchief.

Neck – the thing that keeps people from having a head on their shoulders.

One liner - a mini ha ha.

Optimist – a rookie gambler headed for Las Vegas.

Orchestra Pit – the thing you plant in order to grow an orchestra.

Overachiever – what a C-student calls an A-student.

Overeating – something that will make you thick to your stomach.

Parasols — two guys named Sol.

**Parking Meter –
an auto-matic timer.**

*Peanut Butter –
a bread spread.*

Pear – a banana that overeats and never works out.

Pedestrian – a person who should be seen and not hurt.

Penthouse – a tall success story.

Philanthropist – a rich person who gives back to the public a small portion of the wealth he stole from them privately.

Photographer – a person who makes snap decisions.

Piano - a key word in music.

Ping-pong – Munchkin tennis.

Pneumonia — what you get before you get old monia.

Police Station –
a cop shop.

Politician –
a person who is
always ready to
lay down your life
for his country.

Pool Hall - an indoor swimming enclosure open to the public.

Puck – a solid rubber disc hockey players hit when they are not hitting each other.

Quarrel - a nasty squirrel that likes to argue.

Raisin - a grape that didn't age gracefully.

Rubber Trees – stretch plants.

Salute – A military high five.

Sea Sickness – traveling by rail.

Seed — a condensed vegetable. Just plant and add water.

Serious – something children aren't when their parents are.

Ski Jump – a soar spot.

Ski Slope - frost-class traveling.

Snoring – sheet music.

Snow Blower - a way to throw back the weather that winter throws at us.

Socks - gloves for your feet.

Stagnant Pool - water too lazy to run.

Stars - nightlights.

Steam — hotheaded water.

Straw Boss — the man in charge at a scarecrow-making factory.

Stupendous – advanced stupidity.

Sunburn – **getting what you basked for.**

Tarnish – what they spread on asphalt roads to make them shiny.

Teenager – **a human debit card.**

Tennessee – underwater racket sport played by mermaid and mermen athletes.

Theory – **highly educated guesswork.**

Thief – **a person who finds other's belongings before they lose them.**

Thrifty – **what you call a cheap rich guy and a middle-class guy on a tight budget.**

Time — a great healer but an awful makeup man.

Tips — wages we pay other people's hired help.

Toll Booth — a place where you pay as you go.

*Toupee – **top-secret material.***

Traffic Light – something that keeps us from reaching our goals on time.

Trapeze Rigger – A circus guy who knows all the ropes.

Trifle – a rifle with three barrels.

Trouble – a thing most people don't look for, but it finds them anyway.

Ukulele – Tom Thumb's bass fiddle.

University – a mental institution.

Used Car – an automobile that is usually not what it's jacked up to be.

Usher — the leader of the pack in a crowded movie theater.

Vacuum Cleaner — a broom that really sucks.

*Vegetables – **things that would taste better to kids if they didn't know they were good for them.***

Ventriloquist – a performer people pay to see talk to dummies.

Violin - an instrument you fiddle around with.

Waffle - a pancake with potholes.

War Story - a tale of friction.

Wig - ear-to-ear carpeting.

Wigwam - heating a toupee in the microwave to keep your bald head toasty on a frigid day.

Wimbledon Tennis Championship — the Supreme Court.

Window Shopper — a store gazer.

Xylophone – music by the pound.

Yeast – a major cause of inflation in the bakery business.

Zinc - what will happen to you if you jump into deep water and don't know how to swim.

CHAPTER 12

ANIMAL CRACK-UPS

What did one angry snail say to the other?
Don't try to slug me.

Did you hear about the giant ape who invented a bell that would ring whenever a point was made in table tennis? It was called the King Kong Ping Pong Ding Dong.

Why did the hen sit on an axe?
Because she wanted to hatchet.

Why did the rooster file for divorce?
He couldn't stand his hen-laws.

What's black and white and red on the bottom?
A baby zebra with diaper rash.

What do you call the atoms that make up an antelope? Gnutrons.

What kind of coffee does Yogi Bear drink?
Jellystone Perk.

MORE CAFFEINATED THAN YOUR AVERAGE BEAR!

What wears uniforms, gloves, and buzzes?
A beesball team.

What do you get if you cross a parrot and a huge emerald colored being?
A Polly Green Giant.

Owner: My new racehorse just gobbled up five thousand dollar bills.
Stable Hand: Don't worry. Sooner or later he'll make a pile of money.

Farmer: Can I put my pigs in the attic?
Wife: No. Put them in the swine cellar.

Uncle Al: My cellar is so damp that when I put down a mousetrap, I caught a herring.

What did the hen say to the immature rooster?
Why don't you crow up already?

Who delivers baby ears of corn?
The stalk.

Joe: How can Pegasus fly?
Moe: I guess he has horse feathers.

What do you get if you cross a lion with a watchdog?
A very nervous mailman.

Why was Mr. Polar Bear attracted to Ms. Polar Bear?
Animal magnetism.

Mrs. Duck: **What would you like for dinner?**
Little Duck: **Quackeroni and cheese, please.**

Badger: Do you like gnawing down trees?
Beaver: No. It's bark-breaking work.

Mrs. Pig: Did you enjoy the slop?
Mr. Pig: It was a swill meal.

How does a goose find a boyfriend?
She takes a gander.

Why did the robin go to the boxing match?
It was looking for ringworms.

What do teenage geese get if they eat a lot of fried food?
Goose pimples.

What did the duck do in the football game?
It made a first down.

Bill: I know a person who thinks she's an owl.
Jill: Who? Who?
Bill: Now I know two people.

What kind of dog did the chemistry professor have?
A laboratory retriever.

GO FETCH THE BEAKER FROM THE SHELF FOR ME!

What did the boy pig say to the girl pig?
Your slop is showing.

What did King Arthur keep in his birdcage?
A knightingale.

Why did the duck leave the river?
It had more interest in the bank.

What do chickens say when they switch nests?
Let's eggs-change places.

What dessert should you never give to a dog?
Pound cake.

What do you call the emperor of tiny Russian fish?
A Czardine.

What do you get when an antelope tells a funny joke?
Gnu kidding.

What do you get if you cross octopi with soldiers?
Lots of armies.

What do you get if you cross a parrot with a huge, emerald gardener?
The Polly Green Giant.

What do you call an elephant that bats cleanup on his baseball team?
A heavy hitter.

Who is the most famous pig in Boston?
Fenway Pork.

DAFFY DEFINITION:
Scooby Doo – a curtoon character.

What do you get if you cross a runway star with a little cat?
A fashion model kit.

Jack: I've eaten beef all of my life and I'm as strong as an ox.

Zack: Well, I've eaten fish off my life and I can't swim a stroke.

▷ ▷ ▷ ▷ ▷ ▷ ▷ ▷ ▷ ▷ ▷ ▷ ▷ ▷ ▷ ▷ ▷ ▷ ▷

What do you get if you cross a sheep with a jogger and a rabbit's foot?

A baaaad run of luck.

◁ ◁ ◁ ◁ ◁ ◁ ◁ ◁ ◁ ◁ ◁ ◁ ◁ ◁ ◁ ◁ ◁ ◁

What do you get if you cross railroad tracks and monkeys?

Trained chimps.

▷ ▷ ▷ ▷ ▷ ▷ ▷ ▷ ▷ ▷ ▷ ▷ ▷ ▷ ▷ ▷ ▷ ▷ ▷

What do you call a kitten that makes things happen?

A catalyst.

◁ ◁ ◁ ◁ ◁ ◁ ◁ ◁ ◁ ◁ ◁ ◁ ◁ ◁ ◁ ◁ ◁ ◁

ATTENTION: Bambi got a job as a deer-to-deer salesman.

◁ ◁ ◁ ◁ ◁ ◁ ◁ ◁ ◁ ◁ ◁ ◁ ◁ ◁ ◁ ◁ ◁ ◁

And then there was the poor dog that barked and barked for hours because the fleas he had made him itchy. Before the day was done, he was both hoarse and buggy.

◁ ◁ ◁ ◁ ◁ ◁ ◁ ◁ ◁ ◁ ◁ ◁ ◁ ◁ ◁ ◁ ◁ ◁

What's gray, sticky, and weighs two tons?

A sloppy elephant eating honey with its fingers.

▷ ▷ ▷ ▷ ▷ ▷ ▷ ▷ ▷ ▷ ▷

What's big, gray, and delivers letters?

A kangaroo with a mail pouch.

What do you call a cat that doesn't cost anything?
A freeline.

▶ ▶ ▶ ▶ ▶ ▶ ▶ ▶ ▶ ▶ ▶

What do you get if you cross lots of suits and the king of beasts?
A clothes lion.

◀ ◀ ◀ ◀ ◀ ◀ ◀ ◀ ◀ ◀ ◀

What do you call a baby kangaroo that spends all of its time watching TV?
A pouch potato.

▶ ▶ ▶ ▶ ▶ ▶ ▶ ▶ ▶ ▶ ▶ ▶ ▶ ▶ ▶ ▶

What do you get if you cross a boxer and the king of beasts?
A punch lion.

◀ ◀ ◀ ◀ ◀ ◀ ◀ ◀ ◀ ◀ ◀ ◀ ◀ ◀ ◀ ◀ ◀ ◀

What do you get if you cross a frog, a firefly, and a rabbit?
A hoppy-glow-lucky critter.

◀ ◀ ◀ ◀ ◀ ◀ ◀ ◀ ◀ ◀ ◀ ◀ ◀ ◀ ◀ ◀ ◀

What has four legs and is red, white, blue, and black?
A zebra waving an American flag.

◀ ◀ ◀ ◀ ◀ ◀ ◀ ◀ ◀ ◀ ◀ ◀ ◀ ◀ ◀ ◀

Why did the kangaroo start to lift weights?
He wanted to work as a bouncer in a nightclub.

▶ ▶ ▶ ▶ ▶ ▶ ▶ ▶ ▶ ▶ ▶ ▶ ▶ ▶ ▶ ▶

CRAZY QUESTION: Does a horse running for an election take a Gallop Poll?

Why did the squirrel live in the elm tree?
He got evicted from his condominium.

What has five horns, four wheels, and no top?
Five rhinos riding in a convertible with the top down.

Why did the bunch of fish swim so close to the surface of the ocean?
They were in high school.

What do you get if you cross a rabbit and a blood-sucking bug?
A hare-a-tick.

What did the leopard say to the lion before their golf game?
Can you spot me a few strokes?

What kind of toy train does a tiger own?
Lion-el trains.

Perry: Did you hear about the dog that likes to be scrubbed three times a day?
Mary: No. What kind of dog is it?
Perry: The owners aren't sure, but they think it's a shampoodle.

Hunter: do you see that leopard?
Wildlife Artist: Yes. I already spotted him.

What do you get if you cross the king of beasts with sheep?
The Lion's shear.

Why do leopards have so much fun?
They know all of the best nightspots.

Why did the kitten lick the computer?
It was a laptop.

What do you get if you cross leopards and lamps?
Spot lights.

How can you tell if an elephant is a doctor?
Instead of a trunk, he'll have a little black bag.

Why do birds build nests out of twigs and sticks?
Because lumber is too expensive.

What's soft, white, and lumpy?
A baby swan with the mumps.

What do you get when you cross a grocery store and the jungle? You get checkout lions.

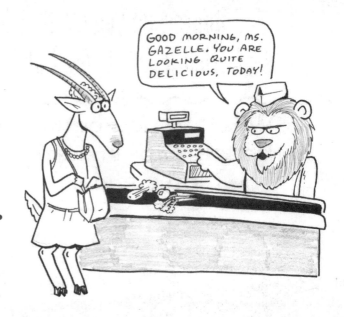

GOOD MORNING, MS. GAZELLE. YOU ARE LOOKING QUITE DELICIOUS, TODAY!

...

Which reptile lives in narrow passages between two buildings? The Alleygator.

...

What's big, bounces, and goes ouch, ouch!! A kangaroo in a cactus patch.

...

What lives in the ocean and never tells a lie? The True Blue Whale.

...

Mom: I had a hard time getting the feathers off of our fresh Thanksgiving turkey.
Boy: Talk about tough pluck.

...

Why did Mr. and Mrs. Turtle take their son to a psychologist? They couldn't get their son to come out of his shell.

...

Then there was the snobby French poodle that was too proud to beg.

...

Boy: My pet dog and I run laps together.
Girl: Big deal. My pet rabbit and I jump rope together.

What's big, gray and goes choo choo choo! An elephant with a head cold.

What's big and black and goes choo, choo choo? A bear with hay fever.

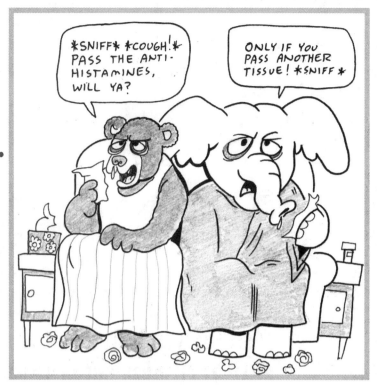

SNIFF *COUGH!* PASS THE ANTI-HISTAMINES, WILL YA?

ONLY IF YOU PASS ANOTHER TISSUE! *SNIFF*

How did Mr. and Mrs. Bat meet? They went out on a blind date.

What do you get if you cross a track hurdler with iguanas? Leaping lizards.

Jim: Did you hear about the two ducks that had a mid-air collision?
Tim: Yeah. They quacked into each other at high speed.

What do you get if you cross a herd of cows with a lemon grove? Lots of sour cream.

What does an aardvark like on its pizza? Ant-chovies.

What do you get if you cross a giant monkey and a big bell? King Bong.

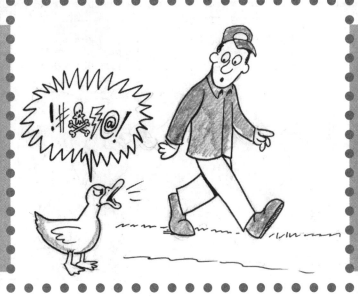

Visitor: Is this really a duck farm?

Farmer: Yes. You're free to walk around, but don't be offended if you hear a lot of fowl language.

Mel: Did you hear about the cross-eyed dog that chased a cat until it climbed out of reach?

Stell: No. What happened?

Mel: The dog ended up barking up the wrong tree.

ATTENTION: Buzzards needed to go on scavenger hunt.

What kind of fish swims right and left and left and right?
A turnpike.

What did the angry shepherd say to his naughty sheep?
Shame on ewe.

STUPID SIGN ON A FISH FACTORY: Many are cod, few are frozen.

SIGN ON A DOG BISCUIT FACTORY: Beware. We bake for animals.

ATTENTION: Athletic beavers play stickball.

DAFFY DEFINITIONS:
Leopard hunter – **a spot remover.**

Dog Catcher – **a Spot remover.**

What's red, white, and blue?
A depressed polar bear with the measles.

◄ ◄ ◄ ◄ ◄ ◄ ◄ ◄ ◄ ◄ ◄ ◄ ◄

Where's the best place to keep hotdogs?
In an air-conditioned kennel.

What's gray, has big ears,
and is ten feet tall?
A mouse on stilts.

What reptile always gets crumbs in its bed?
The crackerdile.

What did the mole outlaw say to the gopher outlaw?
Let's hole up here.

NOTICE: A parrot's idea of a square meal is a cracker.

Where do little skunks take classes?
At a smellementary school.

What vegetable ran in the Kentucky Derby?
The Horse radish.

Why did the beavers devour the wood rowboat?
It was oarganic.

What do you call a mongrel puppy raised at the top of a cliff?
A high-bred cur.

What has four wheels, two horns, and gives milk?
A cow on a skateboard.

What has two heads, six feet, one tail, and four ears?
A man riding a horse.

A circus came to a small town in the mountains. The biggest act under the Big Top was a trained elephant that played the piano without making a single mistake. After the show a farmer went up to the ringmaster. "That elephant is amazing," he said. "How can it play the piano like that?""It's not that big of a deal," replied the ringmaster. "He's been taking lessons for years."

Who is Bambi's favorite comic book hero?
Deer Devil.

· ·

Who was the sardine's favorite relative?
Aunt Chovy.

· ·

What do you get if you cross a camel and a cow?
A lumpy milkshake.

· ·

What do you get if you cross an aerobics class and a skunk?
A fitness scenter.

· ·

What do you get if you cross a window shade and a leopard?
Blind spots.

· ·

Where do you put a turtle with severe mental problems?
In a padded shell.

· ·

Boy: My dog has a sweet tooth.
Girl: How do you know that?
Boy: He only chases bakery trucks.

· ·

What do you get when you cross an elephant and Darth Vader?
An elevader.

· ·

Which musical instruments are great for catching fish?
Castanets.

Who does a considerate cow think of?
Udders.

What do you get if you cross a dog's bark and a street?
A ruff road.

What did the tiger study at the police academy?
Claw enforcement.

Sal: If every dog has its day, what does a dog with a broken tail have?
Cal: A weak end.

What kind of pet dog did the corn farmer have?
A husky.

What were the names of the werewolf's twin brothers?
Whatwolf and Whenwolf.

Chester: Did I ever tell you about the time I came face-to-face with a hungry lion?
Lester: No. What happened?
Chester: There I stood unarmed and defenseless as the snarling beast came closer and closer.
Lester: So what did you do?
Chester: I moved on to the next cage.

Lady: I'm sorry, but my poodle ate my ticket to the dog show.

Doorman: Then I suggest you buy your poodle a second helping, ma'am.

What sheep rides on a magic carpet?
Ali Bahbah.

What's woolly and plays snappy music?
A Dixie Lamb Band.

What do you use to fix a broken chimp?
A monkey wrench.

What do you call Smokey's toupee?
A bear rug.

Why did the homing pigeon fly around and around and around?
The bank foreclosed on his house.

What did the little bird say when she fed her baby a worm?
Swallow.

Why do bulls wear rings in their noses?
Because earrings make them look like pirates.

Why did the farmer put a cow on the scale?
He wanted to see how much the milk weighed.

What do you get when rabbits climb a slippery mountain?
Falling hares.

Why did the woodpecker join a gym?
He wanted to develop his pecks.

What kind of bee is difficult to understand?
A mumble bee.

What do you call a very rich rabbit?
A millionhare.

Why did the bear eat the jogger?
It wanted something healthy to snack on.

Where did Robinson Bunny Rabbit get marooned?
On Easter Island.

Louie: **Was there any money on Noah's Ark?**
Dewey: **Yes. The frog took a greenback, the duck took a bill, and the skunk took a cent.**

Dan: **What would you do if a man-eating tiger were chasing you?**
Ann: **Nothing. I'm a girl.**

What do you call a meeting between pet dogs on an Indian reservation? A bow wow pow wow.

What happens when an elephant does a trapeze act? He brings down the house.

When do cats get out of prison early?
When they get out on purrole.

How deep is a frog pond? Knee Deep! Knee Deep!

How do porcupines hug? Very carefully.

What's has four legs, runs fast, and mugs people? A horse thief.

What do you find on a NASCAR zebra? Racing stripes.

What do you put on a waterfowl window?
A duck blind.

▷ ▷ ▷ ▷ ▷ ▷ ▷ ▷ ▷ ▷ ▷ ▷ ▷ ▷ ▷ ▷ ▷ ▷ ▷

What do you call the father of a mother hen?
A grandfather cluck.

◁ ◁ ◁ ◁ ◁ ◁ ◁ ◁ ◁ ◁ ◁ ◁ ◁ ◁ ◁ ◁ ◁ ◁ ◁

What do you call a tortoise that squeals on his friends?
A turtle tale.

▷ ▷ ▷ ▷ ▷ ▷ ▷ ▷ ▷ ▷ ▷ ▷ ▷ ▷ ▷ ▷ ▷ ▷ ▷

ATTENTION: Beware of crows making crank caws.

◁ ◁ ◁ ◁ ◁ ◁ ◁ ◁ ◁ ◁ ◁ ◁ ◁ ◁ ◁ ◁ ◁ ◁ ◁

Why don't snails become boxers?
Too many slow pokes.

◁ ◁ ◁ ◁ ◁ ◁ ◁ ◁ ◁ ◁ ◁ ◁ ◁ ◁ ◁ ◁ ◁ ◁ ◁

A little girl was crying as she dug a large hole in her backyard. A neighbor saw her and asked what was wrong. "My pet canary died," she explained. The neighbor was confused. "If your canary died, why are you digging such a big hole? He asked."Because," explained the girl, "my canary is in your pet cat and she choked."

◁ ◁ ◁ ◁ ◁ ◁ ◁ ◁ ◁ ◁ ◁ ◁ ◁ ◁ ◁ ◁ ◁ ◁ ◁

Who witnessed the Brontosaurus entering the restaurant?
The diners saw.

▷ ▷ ▷ ▷ ▷ ▷ ▷ ▷

What cute bear writes
creepy stories?
Winnie the Poe.

Why did the ducks dunk their heads in the river?
To liquidate their bills.

What game do members of the K-9 Corps play?
Dog tag.

What do you get when you cross a snail and a pig?
A slowpork.

Where do you find a sty?
In a pig's eye.

What do you get when you cross a turtle and a high stakes card game?
A slow poker.

What do tiny fish like to drink?
Minnow soda.

Why did the news team hire a leopard?
They needed an on-the-spot reporter.

What does a rich parrot say?
Polly wants a cracker...
with caviar on it.

When is it bad luck to have a black cat follow you?
When you're a mouse.

What's ten feet tall, covered with hair, and hops on one big foot?
A Sasquatch with a broken ankle.

Jill: What's the difference between an elephant and a matter baby?
Bill: Huh? What's a matter baby?
Jill: Nothing. What's the matter with you?

What did Mr. Skunk say to Mrs. Skunk when their son started using deodorant?
Please talk some scents into our boy.

What do you call a story about a cat?
Purr fiction.

What kind of weapon does a kangaroo carry?
A pocketknife.

Then there was the little boy whose pet rabbit died young, causing the lad to suffer from premature hare loss.

SIGN ON A PET STORE – Dachshund puppies for sale. Get a long little doggie.

Show me a hare that flunks out of school... and I'll show you a dumb bunny.

Tillie: My canary is one year old today.
Millie: Let's give it a birdy party.

Who can predict a skunk's future?
A fortune smeller.

What snake do you find in the fairytale town of Hamlet?
The Pied Viper.

What do you get if you put a rabbit in an icebox?
A frigid hare.

What did the boy mole say to the girl mole?
I really gopher you.

Joe: **How did the monkey get downstairs?**
Moe: **It slid down the bananaster.**

What's worse than a barrel of monkeys?
A trunk full of elephants.

What shark story did Mark Twain write?
Huckleberry Fin.

Who says Baa Baa Humbug?
Ebenezer Scrooge Sheep.

What giant monster is green, bumpy, and good with sandwiches?
Goddilla.

Mother Rabbit: Did you clean your room?
Boy Rabbit: Not yet.
Mother Rabbit: Well, hop to it.

What did the squirrel say when it found a beautiful acorn?
That's nut nice.

What do you get if you cross an owl and the man who built the Great Ark?
Who Noahs?

Why did Mr. Skeleton get rid of his dog?
His pet kept burying him.

What do you get if you cross a mutt and a skeleton?
A dog and bony show.

Customer: **When I bought this cat in your pet shop you said this feline was good for mice. She won't even go near them.**
Pet Shop Clerk: **Well, isn't that good for mice?**

What did the crow say to the snowman?
Many are cawed, but few are frozen.

ATTENTION: The Year of the Duck is when the sun goes down for good.

Why did the rooster go to the bank?
He wanted to open a chicken account.

What's white and white and white and white?
Three polar bears in a snowstorm.

What do kids have for breakfast on the farm?
Goatmeal.

What do you get if you cross Smokey and a Sasquatch?
A big bear foot.

What do you get if you cross a toad and a rhino?
A frog horn.

ATTENTION: Baby alligators at sale prices. Get one now before they're all snapped up.

Hunter: I want you to catch a giraffe for my zoo.
Guide: Now that's a tall order to fill.

What did Mickey say to the talkative rodent?
Shut your mousetrap.

What do you get if you cross cops with an octopus?
The long arms of the law.

What did Mr. Spock say to the giraffe?
Live long and prosper.

How do you repair a torn waterfowl?
Use duck tape.

What does a zebra wear to bed?
Striped pajamas.

What does Bambi wear to bed?
Nothing. He sleeps buck naked.

How do you pet a porcupine?
Very carefully.

How do you pet a giraffe?
First climb up the ladder.

How do you pet a turtle?
Use slow strokes.

What do you get if you cross a watch with two kangaroos?
A clock that keeps its hands in its pockets.

What do chicken villains do?
They hatch sinister plots.

ATTENTION: Turtles who play golf drive slow.

What do you get if you cross a spaniel and a beagle?
A spangle.

Why was Ms. Duck so shocked when she kissed Mr. Duck?
He had an electric bill.

Where do old dogs like to spend their free time?
At a Day Cur Center.

SIGN ON A DOG BISCUIT DELIVERY TRUCK:
We Bake For Animals.

Why should you never name a cat Alfred?
Because his friends might call him a Freddie Cat.

What did the greyhound with fleas say
at the starting gate?
You'd better scratch me from the race.

Who wears a robe, fights with
Robin Hood, and quacks?
Friar Duck.

Why didn't Bugs and Porky let
Daffy play hide and seek?
Because Daffy was a peeking duck.

What do you call a fight between baby rhinos?
The Battle of the Little Big Horns.

A young lady returned to the stable after her first horseback-riding lesson. "So what did you think of that?" asked the riding instructor. The girl rubbed her sore backside and replied, "How can anything filled with hay feel so hard?

Why are packs of lions great hunters?
They take pride in their work.

Who keeps the cow barn tidy?
The milk maid.

ATTENTION: Leopards do not keep their homes spotless.

Boy: **Do you have a pet dog?**
Girl: **No. Our house is Spotless.**

What do elephants do when they go swimming?
They hold their trunks up.

Why did the dog buy his mom a gift?
It was Mutter's Day.

What do you get if you cross a chef and a rooster?
A bird that says "Cook-a-doodle doo!"

ATTENTION: **Mr. Porker works as a loan officer at a piggy bank.**

Patron: *What is this fly doing in my ice cream?*
Waiter: *He got tired of swimming in our soup so he took a ski trip.*

What kind of bone can't a dog eat?
A trombone.

Then there was the good-looking retriever who was a fetching beauty.

What kinds of trucks do Alaskan
Huskies chase?
Ice cream trucks.

What kind of hawk has no wings?
A tomahawk.

**What do you get if you cross the
Wolf man and a show dog?
A werewolf with a pedigree.**

Which chicken only costs one cent?
Henny Penny.

Why didn't they hang giraffe outlaws in the Old West?
They couldn't find any trees tall enough.

What did the bear say to the gabby mountain men?
Why don't you all close your traps?

Joe: **Yesterday my dog started to chew up my new
comic book before I'd read it.**
Moe: **What did you do?**
Joe: **I took the words right out of his mouth.**

What did the hungry shark eat before its swordfish steak?
A tuna salad.

Which King of England was friends with Tarzan?
King Henry the Ape.

Where did the little fish swim?
In a pre-school.

What did Captain Ahab send to Moby Dick?
A get whale quick card.

Where do you put a dirty horse?
In the stable's shower stall.

Hunter: I shot a goose as it flew over the garbage heap.
Man: Oh no! It's another case of down in the dumps again.

Gambler: How fast is that racehorse?
Jockey: Not too fast. The last time he ran they timed him with a calendar.

Did the little fish and his friends swim to kindergarten?
No. They took a school bus.

Chester: Your dog can't read.

Lester: Oh yes he can. Yesterday he saw a sign on a park bench that read, wet paint, and that's just what he did.

Why don't snakes use spoons?
They already have forked tongues.

What did the best man do at the cow's wedding?
He made a milk toast.

Cow: That new horse the farmer bought is a real hick.
Goat: Why do you say that?
Cow: He sleeps with his shoes on.

Why can't hippos be cowboys?
They don't make saddles big enough.

What has two wheels and a horn?
A rhino on a bicycle.

Boy: My parents always treated me like a dog.
Girl: I don't believe that's true.
Boy: Oh no? Then why did they name me Fido?

Jenny: Does your poodle do the doggie stroke in the pool?
Penny: No. She does the bark stroke.

Which Sasquatch lives in Jellystone National Park?
Yogi Bearfoot.

What do you get if you cross a shelled nut and a goat?
A peanut butter.

What happened to Santa Walrus?
He got jumped by a bunch of Christmas Seals.

What was the name of the walrus that conducted the symphony orchestra?
Tuskanini.

Why did the Romans close down the arena?
The lions ate up all the prophets.

SIGN IN A PET SHOP: Buy a chimp. We have a monkey back guarantee.

How do you kill a vampire shark?
Drive a swordfish stake through its heart.

What do you get when cows swallow stones?
Rock-moo-sick

▶ ▶ ▶ ▶ ▶ ▶ ▶ ▶ ▶ ▶ ▶ ▶ ▶ ▶ ▶ ▶ ▶ ▶ ▶

Why did the crow join the Navy?
It wanted to visit exotic ports of caw.

◀ ◀ ◀ ◀ ◀ ◀ ◀ ◀ ◀ ◀ ◀ ◀ ◀ ◀ ◀ ◀ ◀ ◀ ◀

What famous story did Ernest Hemingway Octopus write?
A Farewell to Arms.

▶ ▶ ▶ ▶ ▶ ▶ ▶ ▶ ▶ ▶ ▶ ▶ ▶ ▶ ▶ ▶ ▶ ▶ ▶

Why did the shark join the Army?
It wanted to be in a fish tank.

◀ ◀ ◀ ◀ ◀ ◀ ◀ ◀ ◀ ◀ ◀ ◀ ◀ ◀ ◀ ◀ ◀ ◀ ◀

How do you start a frog fairy tale?
You say, once a pond a time...

◀ ◀ ◀ ◀ ◀ ◀ ◀ ◀ ◀ ◀ ◀ ◀ ◀ ◀ ◀ ◀ ◀ ◀ ◀

What's big, swims in the ocean, and quacks?
Moby Duck.

◀ ◀ ◀ ◀ ◀ ◀ ◀ ◀ ◀ ◀ ◀ ◀ ◀ ◀ ◀ ◀ ◀ ◀ ◀

What kind of race did the lady horse run?
A mareathon.

▶ ▶ ▶ ▶ ▶ ▶ ▶ ▶ ▶ ▶ ▶ ▶ ▶ ▶ ▶ ▶ ▶ ▶ ▶

How does an old alligator get on the Internet?
It uses crocodile up.

◀ ◀ ◀ ◀ ◀ ◀ ◀ ◀ ◀ ◀ ◀ ◀ ◀ ◀ ◀ ◀ ◀ ◀ ◀

What did the poker player say to the fishmonger?
I'll take two cods please.

▶ ▶ ▶ ▶ ▶ ▶ ▶ ▶ ▶ ▶ ▶ ▶ ▶ ▶ ▶ ▶ ▶ ▶ ▶

How do hens buy things in a bad economy?
On the layaway plan.

What do you call an Antarctic flamingo?
A pinkguin.

◄ ◄ ◄ ◄ ◄ ◄ ◄ ◄ ◄ ◄ ◄ ◄ ◄ ◄ ◄ ◄ ◄ ◄ ◄

What's the best thing to get in a skunk restaurant?
Odors to go.

◄ ◄ ◄ ◄ ◄ ◄ ◄ ◄ ◄ ◄ ◄ ◄ ◄ ◄ ◄ ◄

Who do you get if you cross a cuddly bear and a church bench?
Winnie the Pew.

► ► ► ► ► ► ► ► ► ► ► ► ► ► ► ► ►

What do ducks exchange when they get married?
Webbing rings.

◄ ◄ ◄ ◄ ◄ ◄ ◄ ◄ ◄ ◄ ◄ ◄ ◄ ◄ ◄ ◄ ◄

Why didn't the dolphin invite the swordfish to her party?
He was too dull.

IT'S GOING TO BE A COLD WINTER IF...

...you see bears buying electric blankets they can use during hibernation.

...penguins start to show up in Florida.

...squirrels start to install insulation and aluminum siding on the trunks of trees they live in.

...you see snowshoe rabbits wearing skis.

On which side do chickens have the most feathers?
On the outside.

◄ ◄

Camper: **What was that?**
Ranger: **Just an owl.**
Camper: **I know that, but what was doing the owling?**

What do you get if you cross a wild
African dog and a pumpkin?
A Jackal lantern.

Why did the school of fish listen very carefully?
They were having a herring test.

► ►

What does the littlest of four octopus brothers wear?
Hand-hand-hand-hand-me-down clothes.

Why did the Wolf man get glasses?
He was fur sighted.

Fran: Did you hear about the squirrel
that lived in a bad neighborhood?
Ann: No.
Fran: His house was filled with nuts
and bolts.

Who is the slowest bird?
The turtledove.

Who do you get if you cross a shipwrecked sailor with a turtle?
Robinson Cruise Slow.

What did the rooster have before his main course?
Chicken soup.

What did Old MacDonald see on the chart when he took his eye test?
E - I - E - I - O.

Mule: That new horse always says the wrong things at the wrong times.
Pony: Maybe he has hoof-in-mouth disease.

Tillie: Your cat was making an awful noise last night.
Willie: Ever since she ate our canary she thinks she can sing.

Girl: Did I ever tell you the story of my forebears?
Boy: No, but I know the story of the Three Bears.

Gopher: What qualities do you look for in a friend?
Mole: I like someone who is down to earth.

What do you call a stupid rodent?
An ignoramouse.

What did Mickey's girlfriend wear to the mouse party?
A Minnie skirt.

How did the frog get to Oz's Emerald City?
He followed the yellow brick toad.

What do you get if you cross geese and a herd of buffalo?
Animals that honk before they run you over.

What does a bully whale do?
He picks on shrimps.

A leopard went to see an optometrist. "Every time I look at my wife I see spots before my eyes," the big cat complained. "That makes sense," said the optometrist. "After all, you are a leopard." "It's makes no sense," corrected the leopard. "My wife is a lioness."

What did the boy octopus say to the girl octopus?
Can I hold your hand, hand, hand, hand?

What do nervous elephants do when they go to the beach?
They wet their trunks.

Why do hens get so discouraged?
Because they never find things where they lay them.

What gopher was a famous cartoon detective?
Dig Tracy.

Hank: Wow! Your dog plays chess. He must be super smart.
Frank: Nah. I always beat him.

Why did Rapunzel throw a rabbit out of her tower window?
Someone shouted, Rapunzel, Rapunzel, let down your hare!

Fred: Did you finally coax your new parrot into talking to you?
Ed: Yeah. Yesterday it said, "Shut up, stupid!"

What do you call a dozen whales packed in a tin can?
Godzilla sardines.

Why should you never bunk next to a fish?
Fish always wet the bed.

Why did the sardine quit his job as a judge?
He was tired of herring cases.

What do you call a chicken that plays center for the Pittsburgh Penguins?
A hockey cluck.

Why did the bat go to a psychologist?
It had a lot of hang-ups.

Which ocean fish is very boring?
The dull-fin.

What did Bambi make for breakfast?
Hart boiled eggs.

Lara: **Did you hear the story about the peacock?**
Sara: **No.**
Lara: **It's a beautiful tale.**

Why did the bear go over the mountain?
He didn't want to pay the toll at the tunnel.

Why did the president order the government to buy a million horses?
He was trying to stabilize the economy.

Why didn't Smokey the Bear go to college?
He bearly passed high school.

Rat: I finally got our research scientist trained.
Mouse: What do you mean?
Rat: Now every time I complete the maze I've trained him to give me a piece of cheese.

What is Yogi's favorite candy?
Gummy bears.

Why doesn't Smokey were sneakers?
He liked walking around in his bear feet.

What do you get if you cross a football offensive lineman with Smokey the Bear?
A block bear.

Mr. Moose: Bambi isn't afraid of anything.
Mr. Elk: I know. He's a real deer devil.

Moose: Bambi never strays far from home.
Elk: Why not?
Moose: A buck just doesn't go as far today.

In which state do the deer and antelope roam?
In Gnu York.

What do you find between an elephant's toes?
Slow animals.

The Vampire Doll...you wind it up and it bites a Barbie doll on the neck.

The Werewolf Doll...you wind it up and a Ken doll turns into the Wolf man.

The New Puppy Doll...you wind it up and it wets the carpet.

The New Kitten Doll...you wind it up and it climbs the drapes.

The Pro-Wrestler Doll...you wind it up and it body-slams Ken.

The Karate Kid Doll. . . you wind it up and it kicks a G.I. Joe in the head.

The NASCAR Doll...you wind it up and it hops into a toy car and speeds away.

. .

The American Idol Doll...you wind it up and it sings off-key.

. .

The Super Doll...you wind it up and it flies through the nearest wall faster than a speeding bullet.

. .

The Deliveryman Doll...you wind it up and it drops a tiny package labeled, "Fragile. Handle with Care."

. .

The CIA Doll...you wind it up and it keeps you under surveillance.

CHAPTER 13

BUGGIN' OUT

What did the fleas do after they robbed the bank?
They hopped in a getaway cur.

ATTENTION: Invest in beehives. It's a honey of a deal.

What did General Insect say after Plan A failed?
It's time for plan Bee.

Where does Noah keep his bees?
In the ark hives.

How do you make a horsefly go faster?
Use a buggy whip.

How do bees get to school?
They ride the school buzz.

Which bee was a barbarian?
Attila the Honey.

What did the bee scientist say when he solved the insect housing crisis?
Hive got it!

What did the bee say when music started to play?
Hive got rhythm.

When is a mother flea sad?
When she sees her children going to the dogs.

What's black, yellow, orange, and buzzes?
Bees and carrots.

Why was the firefly actor so proud?
His performance got glowing reviews.

Doctor: You've got to stop thinking that you're a spider.
Boy: But, Doc, how do I do that?
Doctor: First of all, climb down from the ceiling.

Which insect starred in a Broadway play?
Little Orphan Anty.

What did the robber say to the Queen Bee?
Your honey or your life.

How do you start a firefly race?
Shout: On your mark! Get set! Glow!

What did the termite say when it went into the tavern?
Hi. Is the bar tender in here?

Which insect was a famous
old movie director?
Cecil Bee DeMille.

What is a spider's favorite
day of the week?
Flyday.

What kind of music do hip bees like?
Bee Bop.

**What kind of bug makes a mess while
drinking things?**
A spilling bee.

Bug Employee: **Do you want me to hire some flies?**
Boss Bug: **Yes, but first screen the applicants.**

Why are ticks annoying?
Because they get under your skin.

Two ants at a picnic were running across the top of a box of cookies. Suddenly, one ant stopped and said, "Hey! Why are we going so fast?" The other ant stared and shook his head. "Can't you read? The instructions say to tear across the dotted line."

What's green and buzzes and hops around like crazy?
A frog with a bee in its mouth.

ATTENTION: Bug broadcasters needed to work on Gnatwork TV.

Ben: What are the most loyal insects?
Len: Ticks. When they find someone they like, they really stick to him.

Why did Mr. Firefly wake his family up at dusk?
It was time for them to glow.

Why did the moth eat a hole in the carpet?
Because it wanted to see the floor show.

What did the referee shout when Boxer Bug knocked out a buzzing insect?
Your fly is down!

What does the ruler of a hive sleep on?
A queen-size mattress.

◄ ◄ ◄ ◄ ◄ ◄ ◄ ◄ ◄ ◄ ◄ ◄ ◄ ◄ ◄ ◄ ◄ ◄ ◄ ◄

Why did the butterfly go to the library?
It wanted to join the book-of-the-moth club.

What insect starred on the Andy Griffith TV show?
Aunt Bee.

What bug do you find in an alley?
The bowl weevil.

► ► ► ► ► ► ► ► ► ► ► ► ► ► ► ► ► ► ►

What did the keeper say to the angry swarm?
Beehive yourselves.

◄ ◄ ◄ ◄ ◄ ◄ ◄ ◄ ◄ ◄ ◄ ◄ ◄ ◄ ◄ ◄ ◄ ◄ ◄ ◄

Where do you find acrobat bugs and clown insects?
In a flea circus.

NOTICE: Fireflies are not dumb bugs. They are very bright insects.

What do you get if you cross insects and hares?
Bugs Bunnies.

► ► ► ► ► ► ► ► ► ► ► ► ► ► ► ► ► ► ►

What do you get if you cross a spider and a tornado?
Something that spins really big webs.

Which bugs work in the construction business?
Carpenter ants.

What insect has four wheels and lives at the beach? The dune buggy.

Harry: **What do you get if you cross a centipede with a cheetah?**
Barry: **I don't know, what?**
Harry: **I don't know either. It runs so fast it's just a blur.**

What do you call a cocoon that hates to have fun?
A party pupa.

What does a clumsy centipede do?
He trips over his own feet at least one hundred times a day.

What do you get if you cross a cobbler and a bug?
Shoe fly!

**How can you learn all about Mr. Spider?
Check his web page.**

What do you call a cowardly hornet?
A yellow jacket.

What did Mr. Firefly say to his wife?
You light up my life.

What kind of insects like photography?
Shutterbugs.

What did one female firefly say to the other?
You glow, girl.

NOTICE: Pegasus is the original horsefly.

What line did Buggy Shakespeare write?
To bee or gnat to bee.

KOOKY QUESTION: Do flies have zip codes?

What flies at night and goes blink, blink, blink?
A firefly with a short circuit.

HOW'S YOUR LIFE, MR. BUG?

MR. FIREFLY - "Not so hot."

MR. FLEA - "I scratch out a living."

MR. GRASSHOPPER - "It has its ups and downs."

Which insect do you find in
a butcher shop?
The grub steak.

▶ ▶ ▶ ▶ ▶ ▶ ▶ ▶ ▶

**Which bug was a
famous artist?
Rembr-ant.**

◀ ◀ ◀ ◀ ◀ ◀ ◀ ◀ ◀

What goes boing, boing, squish?
A grasshopper crossing a busy road.

▶ ▶ ▶ ▶ ▶ ▶ ▶ ▶ ▶ ▶ ▶ ▶ ▶ ▶ ▶ ▶ ▶

Why didn't the new invention work right?
It still had some bugs in it that needed to be ironed out.

◀ ◀ ◀ ◀ ◀ ◀ ◀ ◀ ◀ ◀ ◀ ◀ ◀ ◀ ◀ ◀ ◀ ◀ ◀

Why did the damsel fly scream?
She saw a dragonfly.

◀ ◀ ◀ ◀ ◀ ◀ ◀ ◀ ◀ ◀ ◀ ◀ ◀ ◀ ◀ ◀

**What did the wooden plank say to the termite?
You bore me.**

◀ ◀ ◀ ◀ ◀ ◀ ◀ ◀ ◀ ◀ ◀ ◀ ◀ ◀ ◀ ◀ ◀

Why did the spider like to eat at the cheap diner?
Because he always found a fly in his soup.

▶ ▶ ▶ ▶ ▶ ▶ ▶ ▶ ▶ ▶ ▶ ▶ ▶ ▶ ▶ ▶ ▶ ▶

What do you get if you cross a hornet and a giant gorilla?
Sting Kong.

What do student fleas scribble notes on?
Scratch pads.

▶ ▶ ▶ ▶ ▶ ▶ ▶ ▶ ▶ ▶ ▶ ▶ ▶ ▶ ▶ ▶ ▶ ▶

What do you get if you cross an insect with a secret agent?
A spyder.

◀ ◀ ◀ ◀ ◀ ◀ ◀ ◀ ◀ ◀

What do you call two spiders that just got married?
Newlywebs.

▶ ▶ ▶ ▶ ▶ ▶ ▶ ▶ ▶ ▶

*What kind of insects
are well rested?*
Bed bugs.

◀ ◀ ◀ ◀ ◀ ◀ ◀ ◀ ◀ ◀ ◀

Why was Mother Fly so tired?
Her baby was sick and she had to walk the ceiling with him all night.

▶ ▶ ▶ ▶ ▶ ▶ ▶ ▶ ▶ ▶ ▶ ▶ ▶ ▶ ▶ ▶ ▶ ▶ ▶

Which bug can tell your fortune?
The gypsy moth.

◀ ◀

What do you get if you leave a bag of Hershey Kisses on an anthill while the sun is hot?
Chocolate-covered ants.

▶ ▶ ▶ ▶ ▶ ▶ ▶ ▶ ▶ ▶ ▶ ▶ ▶ ▶ ▶ ▶ ▶ ▶ ▶

What does an aardvark drink when it has an upset stomach?
Antacid.

Why did the man plant bugs in his garden?
He wanted an ant farm.

What has four wheels and two wings?
A Volkswagen beetle.

What flies funny and goes blit! Bizt! Bizet!
A bee with a broken buzzer.

What comic book hero would make a great bug exterminator?
The Shadow. He knows what weevil lurks in the hearts of men.

What do you get if you cross a skunk and an insect?
A stinkbug.

Why do termites like computers?
They get to log on.

Which spider is a little crazy?
The dotty long legs.

What happened to the blood-sucking insect when the dog got a bath?
It got ticked off.

What do you get if you cross a ghoul
with an insect?
A creepy crawly.

What did father centipede say to his son?
It's time for you to stand on your own hundred legs.

Boy: Did you hear the joke about the giant bee?
Girl: No. Tell it to me.
Boy: Just forget it. It's over your head.

*What do you get if you cross gunpowder
with a tiny insect?*
Dyna-mite.

What did one tough bug say to the other?
Hey pal, what rock did you
crawl out from under?

**What did the spider
order at McDonald's?**
A burger and flies.

Which insect likes potato skins?
The catipeeler.

What game do little fireflies play in school?
Glow and tell.

What kind of stories do boll weevils tell?
Cotton tales.

Who brings colored eggs and candy to little insects?
The Easter Buggy.

Where did Jack Bug and Jill Insect go to fetch water?
Up an anthill.

Why did Mr. Spider shop in the men's department?
He was looking for pants with flies.

What does a getaway driver do when he sees a bug on the sidewalk?
He steps on it.

What do you find at the end of a buzzing bug's feet?
Mosqui-toes.

What did the soldier on guard duty shout to the firefly?
Halt! Who glows there?

How many worms make a foot?
Twelve inchworms.

What did the tiny sign on the itchy dog's back say?
Flea parking.

SIGN ON A HONEY FARM – Going out of buzzness sale.

What did the honey farmer say to the hungry bear?
Keep your nose out of my bee's wax.

A snail was climbing up a cherry tree when he passed a caterpillar. "Where are you going?" asked the caterpillar. "It's only early spring. There are no cherries at the top of this tree yet." The snail smiled. "There will be by the time I get to the top."

Why was Miss Termite happy?
She was invited to a lumber party.

NOTICE: Dragonflies are fly-by-knight insects.

Why did the cop give Spiderman a ticket?
He was a litterbug.

ATTENTION: Termites like to chew, chew on wooden railroad ties.

What do you call a ghostly insect?
A bugaboo.

What old dance do hip insects do?
The jitterbug.

What do you find at the top of flea shirts?
Flea collars.

What do you call buzzing insects dressed in traditional Scottish attire?
Kilter bees.

What did Mrs. Cricket name her twin sons?
Jim 'n' Lee Cricket.

What happened to the boy bee that fell in love?
He got stuck on his honey.

How did Mr. Centipede go broke?
He had to buy new sneakers for his five kids.

Which spider wrote a dictionary?
Webster.

Chef: **What topping do you want on your pizza?**
Aardvark: **Ant-chovies.**

What did the flea shout when he saw two dogs about to crash into each other?
Jump for your lives!

What flies, has fins, and buzzes?
A fish gnat.

What do you get if you cross a tailor and a bunch of buzzing insects?
Pants with button-down flies.

What pass route did the football insect run?
A fly pattern.

What bug do you find in a church steeple?
A praying mantis.

What bug is totally wacky?
The cuckoo roach.

When does a moth get lovesick?
When she sees her old flame.

What is a bee's favorite horror story?
Dr. Jekyll and Mr. Hive.

What do you call a bug with laryngitis?
A hoarse fly.

What kind of sports car does a hornet drive?
A Stingray.

What sports do English insects play?
Cricket and Rugbee.

Boy Bug: Are you going on vacation with your parents?
Girl Bug: No. I'm staying with my favorite ant.

Do insects like to play baseball?
No. They'd rather play bee ball.

How do you get rid of criminal insects?
Call a S.W.A.T. team.

What does a centipede do when it's his turn at bat?
He steps up, up, up, up, up, up to the plate.

Why was the gardener so upset?
He had ants in his plants.

What bug jumps over drinking cups?
The glasshopper.

What do you call an insect brawl?
A flea for all.

What's the best way to get rid of unwanted insects?
Tell them to buzz off.

Why did the firefly quit his job?
He was a victim of burnout.

How do insects fight a sore throat?
They gargle with ant-i-septic.

Who rules the
insect kingdom?
The monarch butterfly.

Who helps rule the
insect kingdom?
The viceroy butterfly.

Which insect got married early in the summer?
The June bug bride.

What kind of cap did the college bug wear?
A bee-nie.

What happens when a cricket loses his temper?
He gets hopping mad.

Why did the little bug get sent to his room?
He was being very gnatty.

What do lumberjack bees use?
Buzz saws.

Mr. Tick: How is this neighborhood?
Mrs. Flea: It's going to the dogs.

Why did the insect go to the psychologist?
The problem was a nervous tick.

How many ants can live in a motel?
Ten ants.

Which insect is full of energy?
Vitamin Bee.

What do you get if you cross insects and clocks?
Ticks.

What did the Queen Bee say when she saw the honeycomb?
Home sweet home.

What did the girl bee say to her boyfriend?
I'll give you a buzz later.

Why did the spider eat the firefly?
He was in the mood for a light snack.

What do corn spiders spin?
Cobwebs.

What do termites eat
for a snack?
Wood chips.

What swims in the ocean
and buzzes?
Bumble Bee tuna.

What kind of bug has stripes on it?
An army ant sergeant.

What do you use to light a firefly?
A cricket match.

What has a roof, a chimney, a front door and wings?
A housefly.

What did the buzzing insects do on the carpet?
They played a rug-bee game.

What do you get if you cross a firefly with a snail?
Something that glows slow.

Then there was the young firefly that went to the doctor because he had glowing pains.

CHAPTER 14

TALL TALES

A boy in Rhode Island had a fever so high his little sister popped corn on his forehead!

A lady in London liked walking in the rain so much she cut holes in all of her umbrellas!

A football player for a team in Denver, Colorado, was so unpopular that during games his teammates refused to let him in their huddle.

A comedian in New York City has been banned from telling his best joke because it's so funny some people have died laughing.

The soil in parts of Massachusetts is so rocky local worms have to carry tiny jackhammers.

There are trees in Washington state that grow so high birds wear oxygen masks to build their nests in the top branches.

There was a fish in the North Atlantic who was so smart the school he swam in was made up of Harvard and Yale graduates.

There's a catfish in the Mississippi River that is so big the only way to hook it is to use a python for bait!

The F.B.I. just captured a gangster so notorious that instead of deporting him to his native country, they blasted him into space to live in a space station.

Then there was the circus snake that tried to tie itself into a bow and ended up with a knot in its stomach.

A woman in New York waxes the floors in her home so often her house has slide rules.

A sheriff in a quiet Western town got so bored he finally held up the bank in his own town, tracked himself down, and locked himself in jail.

There's a hotel in Canada that's located in such a remote region that its doorman is a Sasquatch and its greeter is Smokey the Bear.

There's an intersection in Rome that has so many cars merging at the same place they hired an octopus to direct traffic.

Bugs grow so big in Alaska that people have to swat them with tennis rackets.

Either Africa has the biggest mice in the world or the local elephants have developed a passion for cheese.

In a city in Italy they make macaroni so big and long that if it goes stale they use it as drainpipes.

In Alaska the lightning bugs are so big that if you catch them in your bare hands you get a shock.

A Texas oilman owns a limo so long that when he drives it cross-country, the front end and rear end are in different zip codes.

Gophers in Alaska are so big construction companies hire them to dig train tunnels.

Trees in Montana grow so tall that when their leaves fall in October, they don't hit the ground until December.

A young girl in Alabama is so thin, when she stands sideways at her desk in the morning her teacher marks her absent.

▶ ▶ ▶ ▶ ▶ ▶ ▶ ▶ ▶ ▶ ▶ ▶ ▶ ▶ ▶ ▶ ▶

Squirrels in New Hampshire are so forgetful they have to draw tiny maps in order to find the nuts they bury in the fall.

◀ ◀ ◀ ◀ ◀ ◀ ◀ ◀ ◀ ◀ ◀ ◀ ◀ ◀ ◀ ◀

There's a farmer in Russia who is so big he makes the Green Giant look like a leprechaun.

▶ ▶ ▶ ▶ ▶ ▶ ▶ ▶ ▶ ▶ ▶ ▶ ▶ ▶ ▶ ▶ ▶

A New Yorker on a plane was boasting to the Texan seated next to him. "In New York City they start putting up a fifty story building one month and have it finished by the next month." "Humph! That's nothing," replied the Texan. "In Dallas, I've seen them lay the foundation for an apartment building in the morning and when I drive by the same spot that night they're already evicting tenants for non payment of back rent."

◀ ◀ ◀ ◀ ◀ ◀ ◀ ◀ ◀ ◀ ◀ ◀ ◀ ◀ ◀ ◀

A star in Hollywood got so much fan mail, the postal authorities let her open her own branch office.

▶ ▶ ▶ ▶ ▶ ▶ ▶ ▶ ▶ ▶ ▶ ▶ ▶ ▶ ▶ ▶ ▶

There is a performer who does such good impressions of Hollywood stars his wife has no idea who she's married to.

◀ ◀ ◀ ◀ ◀ ◀ ◀ ◀ ◀ ◀ ◀ ◀ ◀ ◀ ◀ ◀

There's a new hairspray so strong people who use it have to have their hair cut with a chain saw.

Lobsters in Maine grow so big lumberjacks put them on leashes and let them snip down tree trunks with their claws.

A farm in Oklahoma is so big that when a young couple goes out to milk the cows their grandchildren bring back the milk.

A rich couple in California has so many credit cards that they use them to play Canasta.

Horseflies are so big in Texas that cowboys don't swat them, they rope them, saddle them, and ride them in air rodeos.

There's an Arab oil baron who is so rich he keeps a small sports car in the trunk of his huge limo just in case he gets a flat tire.

Mosquitoes are so big in some parts of the Amazon that people who get bit need immediate blood transfusions to stay alive.

There's a Mexican chili pepper so hot only fire-breathing dragons are allowed to eat them.

There's a sultan so rich, when he plays golf, he hires a millionaire as his caddy.

A dog in New Jersey is so talented instead of rolling over he does magic tricks.

And then there was a guy in Vermont who was so unlucky that black cats wouldn't cross his path.

There's a dog in Hollywood who is so smart that he auditions for speaking parts in movies.

A baby born in Wisconsin was so big, his wealthy parents fed him with a silver shovel.

There's a place at the North Pole that gets so cold at night that people who live there huddle around their refrigerators to keep warm.

There's a Hollywood mansion so huge the owner travels from his bedroom to the kitchen in a golf cart.

There was a high school football player in Maryland so dumb that when his coach told him to run a naked reverse, he stripped off his uniform.

There was a comedian from Pennsylvania whose material was so bad he made a laughing hyena frown.

There's a Texas billionaire so rich he lines the bottom of his birdcages with hundred dollar bills.

A guy in Nevada is so lazy he traded in his Dachshund for a Great Dane so he wouldn't have to bend over to pet his dog.

The soil in Iowa is so rich farmers plant toothpicks in the spring and harvest fence posts in the fall.

In Texas they make water beds so big the owners keep pet dolphins in them.

Bullfrogs grow so big in Florida that farmers put rings through their noses.

Hailstones are so big in Buffalo, New York, that three of them piled together make a snowman.

There's a new supersonic jet so fast that you get in one end of the plane and by the time you walk to the other end, you're already landing at the place you wanted to go.

The mail delivery in one state is so slow people mail their Christmas cards on the 4th of July in order to have them delivered by December 24th.

A couple of Arctic explorers were swapping stories. "One night it was so cold where we were the flame on our candles froze and we couldn't blow them out until the sun came up." "That's not cold," countered the other explorer. "It was so frigid where we were, when we tried to talk our words instantly froze into ice cubes. We had to fry the ice cubes in a hot pan to hear what we were saying.

A teenager in Nebraska is growing so fast his shadow can't keep up with him.

Then there was the school librarian who was so strict she taped students' mouths shut.

There was a Texas oilman so rich he bought a university so his dumb son could attend college.

Then there was the absentminded daredevil who went over Niagara Falls in a special barrel and left the barrel on shore.

There is a park in New York City that is so dangerous the muggers demanded police protection.

◄ ◄ ◄ ◄ ◄ ◄ ◄ ◄ ◄ ◄ ◄ ◄ ◄ ◄ ◄ ◄

A bus driver in New Jersey was so snobby he wouldn't allow passengers to get on his bus without an engraved invitation.

▶ ▶ ▶ ▶ ▶ ▶ ▶ ▶ ▶ ▶

A grandfather sneezed so hard he launched his teeth into outer space.

◄ ◄ ◄ ◄ ◄ ◄ ◄ ◄ ◄ ◄ ◄

Then there was the elevator operator who was so dumb he didn't know which way was up.

▶ ▶ ▶ ▶ ▶ ▶ ▶ ▶ ▶ ▶ ▶

There's a new jumbo jet so big it has a taxi service between first and second-class.

There's a Texas oil baron so rich he hires the Pope to say grace over his Thanksgiving dinner.

Scientists in Egypt have developed a new camel that has a bucket seat on its back instead of humps.

◄ ◄ ◄ ◄ ◄ ◄ ◄ ◄ ◄ ◄ ◄ ◄ ◄

Pearls are so big in the waters off a secret island in the South Seas that natives use them as baseballs.

There's a gambler who is so lucky that when he walks into a casino they automatically hand him a fistful of money.

There is an earthworm bodybuilder so strong it challenges birds to a tug of war and always wins.

There is an army general who is so respected that when he goes to a restaurant, everyone stands at attention while he gives his order.

There is a schoolteacher so smart computers ask her to check their spelling.

There's an Ivy League football team that is so smart it never has to huddle up because every player always knows the right play to run on every down.

In some parts of Australia the fleas grow so big kangaroos hitch rides on them.

Scientists have developed a new advanced watermelon that spits out its own pits when you buy it.

My neighbor's poodle is so neat she buries her bones in plastic bags to keep them clean.

There is a lumberjack who is so tall that when he trips and falls his friends all shout, "Timber!"

There's a new breed of super squirrel so strong its jaws are powerful enough to crack nuts and bolts.

There's a special rhino that lives in London, England and has a foghorn.

A boy in Miami had a fever so high anyone who sat close to him got sunburn.

An early pioneer was talking about the famous echo mountain. "Once I camped there for a night," said he. "I crawled in my tent and before I sacked out I stuck out my head and yelled, 'Time to wake up you old buffalo!' Then I went to bed and fell asleep. Eight hours later the echo came back loud as ever and woke me up."

There was a private school so wealthy it had tollbooths at the ends of its hallways.

I once had a cat that was so finicky she'd only eat her food if she saw me taste it first.

There was once a watchdog that was so ferocious he wouldn't let his owner into the house after dark.

And then there was the woman who was such a messy housekeeper she had to hire a detective and a bloodhound to track down where her kids were.

I went to a restaurant where the food was so bad the waiters tipped the customers if they stayed for the entire meal.

The other day I went to a Broadway play that was so bad the author's mother and father walked out after the first act.

Global warming is so bad that last winter the Abominable Snowman came down with a case of heat stroke.

There was an oil baron in Texas who was so rich the bank used to call him to borrow money.

A COUPLE OF BILLION SHOULD HOLD US OVER!

Some luxury cars get such bad mileage it takes a full tank of gas to warm up the engine on a cold day.

WHILE YOU'RE UP, WOULD YOU MIND FETCHING ME SOME MORE KIBBLE?

My pet dog is so spoiled that when I tell him to sit he jumps in my recliner and puts up his feet.

I knew a Polish guy whose name was so long he had it tattooed on his arm so he could remember how to spell it.

Then there was the cowboy who took boxing lessons because he wanted to punch cattle.

Wee Willie Winkie ran through the town in his nightgown and got arrested for indecent exposure.

Jack be nimble. Jack be quick. He jumped over the candlestick and they rushed him to the hospital because he had second-degree burns on his backside.

The Old Woman who lives the shoe couldn't pay her rent so her landlord booted her out.

Mary stole the Golden Fleece and now she's on the lamb.

Little Jack Horner sat in a corner, and with the help of a slick lawyer, sued his parents for child abuse.

Humpty Dumpty had a great fall, but a lousy winter. He went skiing and cracked his skull.

Jack and Jill didn't go up the hill. They just bought bottled water instead.

Hey Diddle Diddle, the cow jumped over the moon but her landing on the surface of Luna was faked by NASA.

Bobby Shafto's gone to sea. He joined the navy because he heard girls love a man in uniform.

The Three Little Kittens lost their mittens and didn't get any pie. Who cares? Their mom can't bake.

Little Miss Muffet sat on a tuffet until her new living-room furniture was delivered.

Along came a spider and sat down beside Miss Muffet, so she called an exterminator who whacked the pesky bug.

Jack and Jill went up the hill. Jack fell down and broke his crown. He sued Mother Goose and settled for a million bucks.

The Three Blind Mice had laser surgery and now they see fine.

Little Tommy Tucker sings for his supper on the American Idol TV show.

There was a crooked man,
who walked a crooked mile, campaigning for a seat in Congress, and he got elected.

Rub a dub dub. Three men in a sauna bath.

To market, to market, to look at all the food we can't afford to eat and to buy a can of cheap tuna.

Baa Baa Black Sheep. We told you to stay away from that oil spill.

Old King Cole was a merry old soul until he went on a strict diet and became a cranky old guy.

Then there was the Western marshal whose draw was so lightning fast that every time he pulled a gun there was a crack of thunder.

Old Mother Hubbard went to the cupboard to see what she could pop into the microwave.

Maybe you heard about the tiny quarter horse that was only worth a plug nickel.

In Arizona there was an outlaw so strong he used to hold up banks and shake the money out of them.

There was an Indian medicine man who was so good at performing the rain dance he could make it drizzle just by tapping his foot.

In Nevada there was an unlucky cowboy who lost his shirt playing poker and had to ride his horse bareback.

Then there was the frontier circus that didn't circle their wagons when attacked. Instead they formed into three rings.

BIZARRE BOOKS

"Our Ship is Sinking" by Mandy Lifeboats.

"The World of Dorks" by Boyer Dumb.

"What's that Awful Smell" by Claire de Room.

"Stand Straight and Tall" by Eileen Dover.

"Be Punctual" by Kit Going.

"Cruise Ship Safety" by Ty Tanic.

"Help with Your Homework" by Al Dewit.

"I Swam the English Channel" by Frances Near.

"How to Control your Temper" by Bea Nicenow.

"How to Iron Clothing" by Manny Wrinkles.

"The Joy of Living" by Emma Everhappy.

"Get Restful Sleep" by Lotta Zees.

"Be a Proofreader" by Ty Poe.

"How to Behave in Church" by Neil Down.

"Pirate Adventures on the High Seas" by Peg Legg.

"How to Get Rich Quick" by Mike Money.

"The Complete Pasta Cookbook" by Liz Onya.

"101 Excuses Why I was Late" by Misty Bus.

"How to Top a Cracker" by Chad R. Cheese.

"Let's Do Homework Together" by Dewey Hafta.

"How to Get an Allowance" by M.T. Wallet.

"Skydiving Made Easy" by Hugo Furst.

"Hygiene During the Middle Ages" by Anita Bath

"Eat Your Veggies" by Brock O. Lee.

"Monkey Business" by Bob Boone.

CHAPTER 15

SCREEN GRABBERS

Why didn't the movie director hire real criminals to work in his gangster film?
He was afraid they'd steal the show.

Two grandfathers were walking out of a movie theater after the show. "It's really amazing how movies have advanced over the years," said one. "In what way?" asked the other. "Well," said the first grandfather, "First we had silent flicks. Then came talking movies. Now we have films that really stink."

◄ ◄ ◄ ◄ ◄ ◄ ◄ ◄ ◄ ◄

Why is Frodo's cell phone so cool?
It's the Lord of the Ring Tones.

What do you get if you cross a rabbit and a famous young wizard.
Hare E. Potter.

What do you get if you cross cable fans with paste?
Viewers who are glued to their TV screens.

Dolly: Did you star in that movie about the romantic joggers?
Molly: No. I only had a walk-on part.

Girl: Don't you hate people who talk behind your back?
Boy: Yeah, especially at the movies.

When do you see a tornado on TV?
When it makes a gust appearance.

Does SpongeBob use a towel?
No. He's a drip-dry cartoon character.

A young actor named Morgan was looking for a job. He went to the third-floor office of a famous movie producer. "I do bird imitations," Morgan said to the producer. The producer frowned. "Today we make hit movies about vampires and zombies," replied the producer. "No one is interested in bird imitations." "Okay," replied the young actor sadly. Morgan then jumped out of the window and flew away.

Why did the big game hunter move to Hollywood?
He wanted to shoot some movies.

◀ ◀ ◀ ◀ ◀ ◀ ◀ ◀ ◀ ◀ ◀ ◀ ◀ ◀ ◀ ◀ ◀ ◀ ◀ ◀

Knock! Knock!
Who's there?
Empty.
Empty who?
Empty-V is my favorite channel.

What do you find in the Land of Oz bakery?
The Wicked Witch of the Yeast.

What do you get if you cross Dorothy's red shoes and bananas?
Ruby slippers.

What creature lives in the ocean and stars in motion pictures?
The actor-pus.

What did the director tell the reality star who arrived late?
Get with the program already.

Is it easy to get a role in a zombie movie?
No. There is still competition for all parts.

Don: Sir Lancelot and Sir Galahad are starring in a TV reality program.
Lon: What's it called?
Don: The Two Knight Show.

What TV channel do conductors and locomotive engineers watch?
The Train Station.

What is the name of Boo Boo Bear's brother?
Boo Hoo Bear.

What do you get if you cross Scooby and Yogi?
A cur bear.

Ken: Television will never totally replace newspapers.

Len: What makes you so sure of that?

Ken: Have you ever tried to swat a fly with a rolled-up television?

MISSED ME!

What kind of TV show is very soothing to watch?
A sit calm.

SILLY TV SLOGANS:

THE MEDICAL CHANNEL ... "You'll never get sick of watching us."

THE COMEDY CHANNEL ... "We like it when people laugh at our programming."

THE CARTOON CHANNEL ... "Draw up a chair and enjoy our funny sketches."

THE HISTORY CHANNEL ... "Our past reruns are up to date."

THE FOOD CHANNEL ... "If you're hungry for good TV, tune us in to see what's cooking."

THE MILITARY CHANNEL ... "Pay attention to our shows. That's an order."

Who do you get if you cross a Western action movie star and a baker?
Clint Yeastwood.

THE COURT CHANNEL ... "There are no objections to our programs."

Len: How can I learn to send printed messages on my cell phone?
Jen: Study a textbook.

Ed: There are a lot of silly mistakes on your internet profile.
Ned: Gee, I guess I have egg on my Facebook.

Knock! Knock!
Who's there?
Peas.
Peas who?
Peas stop playing that video game.

What happens when you drop a TV commercial?
Commercial breaks.

What do you call two identical televisions?
A TV set.

What does a Munchkin use to surf TV channels?
A wee-mote control.

How does a computer geek start a fire?
He looks on match.com.

Knock! Knock!
Who's there?
Avery.
Avery who?
Avery body loves Raymond.

What do you get if you cross a computer geek with a parakeet?
A nerdy birdie.

What do you get if you cross a computer and a lifeguard?
A screen saver.

Which TV show stars crows as detectives and district attorneys?
Caw and Order.

Which TV show did Mr. Skunk own?
Sports Scenter.

How do you check out a baby on the internet?
Goo-Goo him.

What do Larry and Curly do when they run out of cash?
They borrow Moe money.

What's goofy and grows in the forest?
Tree Stooges.

Where does Attila play video war games?
Hun line.

Larry has a perm.
Curly has a buzz cut.
What does their new partner have?
A Moe-hawk.

What did Larry and Curly shout
when they finished their ice cream?
We want Moe.

Who is the partner of Moe and Larry Rabbit?
Curly Hare.

Why did the man cross a clock with a television set?
He wanted to watch TV.

Where do you find free-range video games?
On a video game preserve.

Which late night TV comic played varsity sports?
David Letterman.

ATTENTION: In the story of computer creation, did Eve take a byte out of an Apple computer?

Why do cats like computers?
They get to push a mouse around.

What did Larry and Curly name their bird of prey?
Moe-hawk.

What do you get if you cross a Western movie star with a thundercloud?
John Rain.

Why did the lumberjack take a computer class?
He wanted to learn how to log on.

What do you get if you cross a computer and a lifeguard?
A screen saver.

How do you check out a tornado on the internet?
Go to the whirl wide web.

Knock! Knock!
Who's there?
Hash Lee.
Hash Lee who?
Hash Lee Simpson.

▶ ▶

How did the baby know who was creeping over to visit him?
He checked his crawler I.D.

◀ ◀ ◀ ◀ ◀ ◀ ◀ ◀ ◀ ◀ ◀ ◀ ◀ ◀ ◀ ◀ ◀ ◀ ◀

Where did the internet pirates anchor their ship?
On e-Bay.

▶ ▶ ▶ ▶ ▶ ▶ ▶ ▶ ▶ ▶ ▶ ▶ ▶ ▶ ▶ ▶ ▶ ▶ ▶ ▶

What do you get if you cross a computer hack with Spiderman?
Someone who spends endless hours looking at websites.

◀ ◀ ◀ ◀ ◀ ◀ ◀ ◀ ◀ ◀ ◀ ◀ ◀ ◀ ◀ ◀ ◀ ◀ ◀

Do spider guy wannabees use web cams?

▶ ▶ ▶ ▶ ▶ ▶ ▶ ▶ ▶ ▶ ▶ ▶ ▶ ▶ ▶ ▶ ▶ ▶ ▶

Why did the Tin Man walk away from the Scarecrow and the Cowardly Lion?
He needed to use the rust room.

◀ ◀ ◀ ◀ ◀ ◀ ◀ ◀ ◀

What do lumberjacks watch on cable TV?
The Home Chopping Network.

▶ ▶ ▶ ▶ ▶ ▶ ▶ ▶ ▶

Where do you keep a cartoon crook?
In an animation cell.

What tumbling move did Luigi do?
A Mario cartwheel.

What video game do crows play?
Caw of Duty.

What do prizefighters watch on cable TV?
Home Box Office.

What do you get if you cross a boxing movie with ice cream?
Rocky Road.

What famous comedian invested in milk cows?
Dairy Seinfeld.

Which bird hosts the Tonight Show?
Bluejay Leno.

Gary: Do you want to watch this show about the Boston Marathon?
Barry: Nah. It's a rerun.

What do you get if you cross candy made from boiled molasses with a water fowl?
Taffy Duck.

How do you find a crazy movie on TV?
Check your loco schedule.

What is a geek's favorite fairy tale?
Snow White and the Seven Dorks.

What does the Tin Man wear when he plays cowboy in the Land of Oz?
A tin-gallon cowboy hat.

What show did the geek watch on TV?
It was a dorkumentary.

Mother: What happened to that exercise show?
Father: I was tired of watching it.

Why was the Cowardly Lion in the Land of Oz a total phony?
The Lion was really a chicken.

Why is watching movies on TV with the Abominable Teenager no fun?
Every few minutes he hits the freeze frame.

Tina: Do you want to watch this ongoing cooking show about making broth?
Gina: No thanks. I don't care for soup operas.

What do you get when you cross a Cinemaplex with a quarterback?
Movie passes.

Knock! Knock!
Who's there?
Oscar.
Oscar who?
Oscar if she'll go
to the movies with me.

How do you view Attila the Barbarian TV?
Go to Hun Demand.

DAFFY DEFINTIONS:
CHURCH TV – *pray per view.*
UNEMPLOYED TV – *a no-pay channel.*

What does a pet computer mouse wear around its neck?
A tech collar.

Where's the best place to shop for a pet computer mouse?
Try eek-Bay.

What does SpongeBob use to call his cartoon pals?
An animation cell phone.

What do you get if you cross a golfer and a video game warrior with a mohawk?
Mr. Tee.

Did SpongeBob play first team on the Ocean Football Squad?
No. He was a scrub player.

What made SpongeBob overweight?
Saturated fat.

JUST A LITTLE WATER RETENTION!

Why don't some people like SpongeBob?
They think he's too self absorbed.

Does SpongeBob like showers?
No. He always takes a sponge bath.

Who do you get if you cross a famous TV dog with a hippo?
Rin Tin Ton.

What do you get if you cross a herd of cattle with space explorers?
Steer Trek.

What do you get if you cross a T-Rex with a hog?
Jurassic Pork.

Which pig is a space hero?
Ham Solo.

THIS WAY, CHEWBACON!

CRAZY QUOTE:
"I'll be bark." -The Dog
Terminator.
◄ ◄ ◄ ◄ ◄ ◄ ◄ ◄ ◄

Where can you find an owl video on the internet?
Look on Who-tube.

Where can you find a skunk video on the internet?
On Pee-yew-tube.

What do you get if you cross an ape with a person
who makes ceramics?
Hairy Potter.

What would Minnie be if she married Mickey?
A mousewife.

NOTICE: Computer cats post material on MewTube.
◄ ◄ ◄ ◄ ◄ ◄ ◄ ◄ ◄ ◄ ◄ ◄ ◄ ◄ ◄ ◄

Astronomer: What is a star with a tail called?
Student: Mickey Mouse.

What do you call a baby kangaroo that watches too much TV?
A pouch potato.

What is a playing card's favorite TV game show?
Deal or No Deal.

How do horses relax at night?
They watch stable TV.

Mother: What happened to the baby program I was watching on TV?
Daughter: I decided to change it.

What do you get if you cross a steamroller with an old television set?
A flat screen.

What did the TV reporter say after she dropped her coffee mug?
I have breaking news.

What did the old movie film say to the projector?
I'm not in the loop anymore.

Why did the TV news reporter go to the ice cream store?
She needed a scoop.

Knock! Knock!
Who's there?
C.D.
C.D. who?
C.D. remote over there? Go get it.

What video game do crying babies play?
Wah Craft.

What's the difference between a computer geek and a fish?
A computer geek wants to get online and a fish doesn't.

Knock! Knock!
Who's there?
Peas.
Peas who?
Peas stop playing that video game.

What game show do NASCAR drivers play?
Wheel of Fortune.

What do dogs eat when they go to the movies?
Pupcorn.

What do you call a television signal received at the top of the Empire State Building?
High-definition TV.

What do you call a TV preacher who records his sermons?
A DVD prayer.

Larry and Curly ride motorcycles. What does their pal ride?
A Moe-ped.

What does the director of a Western movie need to know?
The shooting schedule.

Where do computer experts keep their money?
In a data bank.

What kind of underwear do TV reporters wear?
News briefs.

What is a sailor's favorite TV crime show?
C.S.Aye-Aye.

Was Sponge Bob on a navy ship?
No. He was in the scrubmarine service.

What do you get if you cross a TV program with a hen?
A show that lays an egg.

Molly: What did you think of that new movie about jockeys and horses?
Dolly: It was kind of racy.

There's a new TV program about a guy who is both a lawyer and a doctor. In the premiere show, the star defends himself in a malpractice suit.

Why did the robber become a movie actor?
He wanted to steal some scenes.

How do you preserve a criminal case?
Seal it in a Perry Mason jar.

A young boy walked into a movie house to view the early showing of an action flick. "Hey," said an usher as the boy walked by. "Aren't you supposed to be in school?" The boy looked back and grinned. "Nope," he said, "I have the chickenpox."

What TV comedy show did the funny zombies star in?
Saturday Night Dead.

▶ ▶ ▶ ▶ ▶ ▶ ▶ ▶ ▶ ▶ ▶ ▶ ▶

What is King Midas's favorite
James Bond movie?
Goldfinger.

◀ ◀ ◀ ◀ ◀ ◀ ◀ ◀ ◀ ◀ ◀

Millie: Did you have your
TV set on last night?
Tillie: Yes.
Millie: How did it fit?

▶ ▶ ▶ ▶ ▶ ▶ ▶ ▶ ▶ ▶ ▶

How do you make a James Bond movie?
Use a spy cam.

◀ ◀ ◀ ◀ ◀ ◀ ◀ ◀ ◀ ◀ ◀ ◀ ◀ ◀ ◀ ◀

What is James Santa Bond's Number?
Double Ho Seven.

◀ ◀ ◀ ◀ ◀ ◀ ◀ ◀ ◀ ◀ ◀ ◀ ◀ ◀

Where can you watch movies based on books by Samuel Clemens?
On the Mark Twain Station.

◀ ◀ ◀ ◀ ◀ ◀ ◀ ◀ ◀ ◀ ◀ ◀ ◀ ◀ ◀

What do little dogs watch on TV?
Curtoon shows.

▶ ▶ ▶ ▶ ▶ ▶ ▶ ▶ ▶ ▶ ▶ ▶ ▶ ▶

Why did James Bond call an exterminator?
His room was full of bugs.

◀ ◀ ◀ ◀ ◀ ◀ ◀ ◀ ◀ ◀ ◀ ◀ ◀ ◀ ◀

What do you call an electronic message from
Dallas to Houston?
A Tex message.

What's the most exciting way to make a movie about forests?
Film it in Tree-D.

▶ ▶ ▶ ▶ ▶ ▶ ▶ ▶ ▶ ▶ ▶ ▶ ▶ ▶ ▶ ▶ ▶ ▶ ▶

How does a TV addict lose weight?
He eats a steady diet of couch potato salad.

◀ ◀ ◀ ◀ ◀ ◀ ◀ ◀ ◀ ◀ ◀ ◀ ◀ ◀ ◀ ◀ ◀ ◀ ◀ ◀

Mr. Scrooge stormed up to the ticket window outside of the local movie theater. "Humph!" he grunted. "Your ad in the newspaper stated that you show first-run films at popular prices. Do you call ten dollars a ticket a popular price? "The theater manager looked through the opening in the ticket window and grinned at Mr. Scrooge. "Well, sir," he replied, "we like it."

◀ ◀ ◀ ◀ ◀ ◀ ◀ ◀ ◀ ◀ ◀ ◀ ◀ ◀ ◀ ◀ ◀ ◀ ◀ ◀

Who stars in Law and Order Garden Division?
Berry Mason and Celery Queen.

◀ ◀ ◀ ◀ ◀ ◀ ◀ ◀ ◀ ◀ ◀ ◀ ◀ ◀ ◀ ◀ ◀ ◀ ◀ ◀

Tina: My brother and I finally stopped fighting over which cable TV shows to watch.
Gina: Did you compromise?
Tina: No. My mom forgot to pay the bill and they shut off the cable.

▶ ▶ ▶ ▶ ▶ ▶ ▶ ▶ ▶ ▶

How can you make your computer safe?
Buy it a crash helmet.

NEWS BLOOPERS

A SPORTS ANNOUNCEMENT IN A PROVIDENCE, RHODE ISLAND PAPER STATED: **The teams will play a single game tonight. Burke Suter will stitch for Pawtucket.**

IN PAYSON, ARIZONA: The Pine Chamber of Congress announced it will hose a barbecue on Saturday.

IN A CALIFORNIA NEWSPAPER: Beautiful kittens free. They are willing to do a little mouse work.

IN A KANSAS PAPER: Mrs. Marth Carthey entertained the members of the Friday Sueing Circle.

A SPORTS REPORT IN A DENVER, COLORADO PAPER: He was tickled in the end zone.

FROM A TOLEDO, OHIO PAPER: The yacht will be anchoring nearby in a deep harbor where Lord Nelson once kept his feet.

IN A TEXAS NEWSPAPER: Many antiques at a city citizen's meeting.

IN A MILWAUKEE, WISCONSIN PAPER: City officials to talk garbage.

A CALIFORNIA CHURCH BULLETIN: Because of the secretary's vacation, the church office schedule will be somewhat erotic.

AN AD FOR A NEWS SHOW IN EL PASO, TEXAS: Tonight be sure to hear weatherman Hal Smathers! The complete dope on the weather.

IN A BOSTON, MASSACHUSETTS NEWSPAPER: For sale. Cheap. New love seat. Divorced.

IN A MINNEAPOLIS, MINNESOTA NEWSPAPER: April babies flood local hospital.

IN A TEXAS NEWSPAPER: When any industry contemplates moving to Ohio, it has only to place an order for skilled workers it will need and they will be brained, ready, and waiting.

IN A TAMPA, FLORIDA NEWSPAPER: Wedding wows renewed.

AT THEIR WEDDING: Judy Snyder announced to all present she would take husband-to-be Michael J. Pellowski for bitter or verse.

IN A BOSTON, MASSACHUSETTS NEWSPAPER: Mr. and Mrs. Harry McKenny are happy to announce that their daughter Martha will carry David Henderson next Sunday.

IN A UTAH NEWSPAPER: Mr. and Mrs. Gregg Honsdale were married today. The couple plans to spend their honeymoon in sunny Paine.

IN AN OPELOUSAS, LOUISIANA. PAPER: The yard at the home of Mr. and Mrs. D. was awarded the Garden of the Weed by the Garden Club.

A NEW YORK PAPER REPORTED: Police discovered a full case of gin in a parked car on a street in Greenwich Village last night. A police captain said, "We have no clues who owns the gin, but I have two men working on the case right now."

IN A NEW JERSEY NEWPAPER: Great buy! Nine room house with two paths.

CHAPTER 16

THE OUTRAGEOUS OUTDOORS

How does Mother Nature get into sporting events?
She has season tickets.

Why should you never play hide and seek with mountains?
Because mountains usually peak.

Why were the lazy flower bulbs upset?
They had to get out of their bed early.

Mother: I'm glad you're home from your campout, son. Did you fish with flies? Son: I sure did, Mom. And I hiked with them. Slept with them. I even ate with them, too.

What did the waterfall say to the water pistol?
Scram, you little squirt.

What did the boy leaf say to the girl leaf in autumn?
I think I'm starting to fall for you.

What creepy tree haunts the forest?
The Frankenpine Monster.

Camper: I don't like all the flies in my cabin. Can you do something about it?

Counselor: Sure. You point out the ones you like and I'll swat the others.

What did one campfire say to the other?
Aren't you one of my old flames?

Hunter: What are you doing in that oak tree?

Rip Van Winkle: I must have fallen asleep on an acorn.

What did the lifeguard say to the boy walking in the surf?
See ya, wader.

Why did the plant go to the dentist?
It needed a root canal.

IT HURTS RIGHT THERE!

Girl: How do you locate lost pieces of a daisy?

Boy: Use a petal detector.

◄ ◄ ◄ ◄ ◄ ◄ ◄ ◄ ◄ ◄ ◄ ◄ ◄ ◄ ◄ ◄ ◄ ◄

NOTICE: Topsoil delivered to your home. We sell dirt cheap.

Why was Mr. Wildfire proud?
His son went out in a blaze of glory.

What do you get if you cross a clothesline and a campfire?
Rope burn.

Tim: **How did you tear your bathing suit?**
Jim: **I got caught in a riptide.**

WACKY WEATHER REPORTS

FOR PREGNANT LADIES- Showers expected.

FOR RAPPERS - Very cool.

FOR STREET CROOKS - Muggy.

FOR CARNIVAL OPERATORS - Fair conditions.

FOR QUARTERBACKS - Passing clouds.

FOR DOCTORS - Higher temperatures than normal.

FOR NERVOUS PEOPLE - High pressure.

Who invented the tulip bulb?
Thomas Edison's gardener.

Eartha: Is your husband a good gardener?
Bertha: Let me put it this way. Last summer his artificial flowers died.

What did the gardener say to the librarian?
I weed more than you do.

How did the mountain climber break his legs?
After he climbed the cliff, he stepped back to admire his work.

What do you call a smart piece of land?
A wise acre.

Mrs. Compost: Do you love me a lot?
Mr. Compost: Yes. I love you very mulch.

What kind of paper does a tree use?
Loose leaf.

What did the floodwater say to the river?
Don't talk with your mouth full.

What did the angry creek say to the talkative brook?
Stop babbling already.

What did the iceberg say to the hot sun?
Are you trying to make a pool out of me?

What did Mr. Fungus say to Ms. Fungus?
Let's grow mold together.

Why did the NASCAR driver go into the cornfield?
To tune up some engine ears.

Ranger: Mister, you've been silently watching me fish for two hours. Why don't you get a rod and a reel and do some fishing on your own?
Man: Thanks. But no, I don't have the patience for fishing.

What did the tornado say as it picked up the house?
You're finally going up in the whirl.

What did the wheelbarrow say to the gardener?
Who do you think you're pushing around?

Sunday School Teacher:
Only God can make a tree.
Student: Then he should help rake up the leaves in the fall.

Bob: How did you find the weather while you were on vacation?
Rob: I just went outside and there it was.

Why did Mr. and Mrs. Boulder go to a counselor?
Their marriage was on the rocks.

What did the creek say to the noisy river?
Don't you ever close your mouth?

What do you call a tiny ripple on the ocean?
A micro wave.

What do you get if you cross coffee beans with fir trees?
Perky pines.

What do you get if you cross a thundercloud and a dumb dork?
A rain dunce.

Zack: What's it like to own apple orchards?
Mack: There are times when it's a rotten business to be in.

DAFFY DEFINITION:
Fruit Orchard — a place where a
farmer's money grows on trees.

Why was Mr. Topsoil depressed?
People treated him just like ordinary dirt.

What did the girl mushroom say to the boy mushroom after their date?
Gee, you're a fungi.

THE LAST GUY I DATED WAS A COLOSSAL SPORE!

What kind of tree keeps floors clean?
The sweeping willow tree.

Minnie: Holly is a very important plant.
Linny: What makes you say that?
Minnie: Where would we be with no holly days to celebrate?

What do you get if you cross a big rock with a track sprinter?
Boulderdash!

Brad: Did you hear about the two men who went ice fishing?
Chad: What did they catch?
Brad: They caught a 200-pound block of ice. And when they cooked it, they drowned.

What do you call it when the earth goes backwards?
Revearth.

Bill: Did you hear the joke about the mountain?
Jill: Yes. It was hill-arious.

What do you get if you cross a deep fryer and thunderclouds?
Greased lightning.

An old Russian man named Rudolph looked out his kitchen window one morning and announced to his spouse, "It's raining." Rudolph's wife looked out the same window and said, "You're wrong, it's sleeting."
"It's raining," insisted the old Russian angrily. "Rudolph the Red knows rain, dear."

Did you hear about the cowboy who leaned over to look at a cactus and ended up with a sight for sore eyes?

How does a weather expert name hurricanes?
She makes a gust list.

How do corn plants walk around?
In their stalking feet.

How can you learn all about tornadoes?
Watch Whirl News Tonight.

What is a lawn lover's
theme song?
Sod Bless America.

How did the river
hurt itself?
It had a water fall.

What do trees do before a big race?
They limber up.

Where do you find a successful compost maker?
At the top of the heap.

Who is green and discovered America?
Christofern Columbus.

Man: What kind of lawn mower is that?
Father: It's one that's good for the environment.
Man: How does it work?
Father: It's a son-powered push mower. It conserves my energy.

Why are cows and sheep
better for the environment than cars?
Cows and sheep are grass powered instead of
being gas powered.

What do you get if you cross a long, slender vegetable with polluted air?
Asparagasp!

▶ ▶ ▶ ▶ ▶ ▶ ▶ ▶ ▶ ▶ ▶ ▶ ▶ ▶ ▶ ▶ ▶ ▶

How do fresh vegetables travel while in the city?
They take taxi cabbages.

◀ ◀ ◀ ◀ ◀ ◀ ◀ ◀ ◀ ◀

What tree is always grumpy?
The crabapple tree.

▶ ▶ ▶ ▶ ▶ ▶ ▶ ▶ ▶ ▶

What did the gardener say to his plants?
I'll cheer for you if you'll root for me.

◀ ◀ ◀ ◀ ◀ ◀ ◀ ◀ ◀ ◀

How did the ecologist feel when the conservationist told her his house was solar powered?
She was green with envy.

YOU SQUIRRELS GET OUT OF MY HEAD!

▶ ▶ ▶ ▶ ▶ ▶ ▶ ▶ ▶ ▶ ▶ ▶ ▶ ▶ ▶ ▶ ▶

Boy: Why won't you hug that tree?
Girl: Because it's a dogwood and its bark scares me.

◀ ◀ ◀ ◀ ◀ ◀ ◀ ◀ ◀ ◀ ◀ ◀ ◀ ◀ ◀ ◀ ◀ ◀

What do you get if you cross a poultry farmer with a conservationist?
A henvironmental expert.

▶ ▶ ▶ ▶ ▶ ▶ ▶ ▶ ▶ ▶ ▶ ▶ ▶ ▶ ▶ ▶ ▶

What do you call a ghost who is green conscious?
An eekologist.

What did one compost pile say to the other compost pile?
I think I'm having a breakdown.

◄ ◄

What is big, grows vegetables, and is concerned about the environment?
The green Green Giant.

► ►

What do you get if you cross a sapling with a disposable diaper?
A tree huggie.

◄ ◄

A camper got up early and went outside to make breakfast for his sleeping friend. In the distance he spotted a hungry grizzly lumbering toward the camp. He raced into the tent and woke up his pal. "Get up!" he shouted. "A bear is coming. We've got to make a run for it." "Are you nuts?" said the friend. "You can't outrun a hungry bear." The friend started for the exit. "I don't have to outrun the bear," he called back. "I only have to outrun you!"

► ►

Why did the tornado go to a psychologist?
It was spinning out of control.

◄ ◄

How are rain and snow alike?
Rain comes in sheets and snow comes in blankets.

► ►

Why did the hiker jump feet first into the brook?
He wanted to put some spring in his step.

What do you get if you cross a mountaintop and a flawless beauty?
The peak of perfection.

What do you get if you cross a tornado with a Harley?
A spin cycle.

Why did the boulder have stripes?
It was a jailhouse rock.

Why were the flowers restless?
They had rocks in their bed.

What did Mr. Boulder use to season his steak?
Rock salt.

◄ ◄ ◄ ◄ ◄ ◄ ◄ ◄ ◄ ◄ ◄ ◄ ◄ ◄ ◄ ◄ ◄ ◄ ◄ ◄

What did the wind say to the tornado?
Let's blow this town.

What happens when you pollute the ocean?
You make the sea sick.

When did rocks rule the earth?
In the Stone Age.

What kind of music do volcanoes play?
Soft rock that's hot stuff.

ATTENTION: A cactus is a plant that appreciates dry humor.

What corn grows on a tree?
A-corns.

What kind of cheese do you find in a tree?
Limburger.

What makes a fisherman sad?
Days when there's no school.

Man: What did you do when the tornado blew past your house?
Farmer: I sat back and watched the whirl go by.

Where was Mr. Boulder's son born?
In Little Rock, Arkansas.

Why did Mr. Boulder's son play music in a boat?
He wanted to join the Rowing Stones band.

Why was Mr. Boulder so proud?
His son was a rock legend.

Why did the river run so slow?
It was a lazy river.

What do you call small streams that run into the Nile River?
Juveniles.

What makes a great decoration for Sherwood Forest?
Ribbon Hood.

Why is a canoe inexpensive to operate?
Because it runs on water.

Why did the gardener go crazy?
He had beetle mania.

What did one river say to the other?
Let's pool our resources.

What do you get if you cross a plant that eats bugs and a hobo?
A Venus Fly Tramp.

Who is the smartest tree in the forest?
Albert Pinestein.

How do you show your appreciation for lightning?
Give it a thunderous ovation.

What did the creek say to the brook and the stream?
Let's all pool together.

Why didn't the rain cloud pay for lunch?
It was a pour guy.

What did the thunderclouds say to the rain clouds?
Let's get together and do some brainstorming.

Hiker: **Why are you so upset?**
Ranger: **Today I saw an endangered animal eating an endangered plant.**

What did Mother Whirlpool name her boy?
Little Eddy.

What happens when an orange gets too much sunshine?
It peels.

What did the gardener say to the lawn grass?
Stop being so crabby.

Neighbor: **What do you grow in your garden?**
Man: **Tired.**

What is a tornado's favorite old soap opera?
As the Whirl Turns.

Why did the cod fisherman go to the hospital?
He was involved in a fluke accident.

Why did the beautician go to the shore?
She wanted beach blond hair.

What did Father Plant say to his seedlings?
Why don't you guys grow up already?

How do you make a naughty canoe move?
Give it a good paddling.

Why didn't the
mountain make it to
the big leagues?
It peaked too early.

**What do you get
if you cross a
desert and a pier?**
A dry dock.

Why is summer a clumsy month?
It's heading for a fall.

What did the brick wall say to the ivy plant?
Stop crawling all over me.

When is the best weather for street crime?
When it's muggy out.

What do you get if you cross a stream and a brook?
Wet feet.

What did the Irish farmer say to his son Dan when they went into the garden?
Hoe Danny boy.

Jack: Why did that tornado hit my house and not yours?
Mack: I guess it was a twist of fate.

What does a tornado like in its tea?
A twist of lemon.

How did Mr. Sleet get home?
He hailed a cab.

How did the storm cloud applaud the lightning bolt?
With a clap of thunder.

Where can you find the world's best lawn?
In Soddy Arabia.

Show me a gardener who doesn't spray his flowers ... and I'll show you a guy with ants in his plants.

What do you get if you cross a tornado and a Latin choreographer?
A Spinish dancer.

How do you stop a bitter green vegetable from attacking you?
Use pepper spray.

When's the best time to go duck hunting?
In fowl weather.

What did the hippie say when the farmer asked him to make a garden?
I can dig it.

What did the morning mist say to the farmer?
What can I dew for you?

Joe: Did you hear about the stupid snowman that went to a tanning salon?
Moe: Yeah. What a drip he turned out to be.

When is a Dogwood tree silent?
When it has no bark.

MOTHER NATURE HATES YOU IF...

Fluke lightning strikes your metal bat just as you step up to the plate.

You go out to sunbathe and it starts to hail.

You live in the desert and your cellar get flooded.

You finish putting a new roof on your house the day before a tornado strikes.

There's a rare heat wave the week you planned to go skiing.

There's a thunderstorm on the only morning you can sleep late.

A sudden gust of strong wind blows away your winning lottery ticket.

There's a sudden downpour in the middle of your giant yard sale.

Your hockey career is ruined because you slip on a patch of ice on the sidewalk and injure your back.

You get snowed in the day before you're scheduled to leave for your winter vacation in Florida.

A hurricane strikes the day after you rent an expensive beach house.

The wind blows all the dead leaves off the neighbor's trees into your yard.

Your Fourth of July picnic is snowed out.

Where do math teachers like to camp?
Along the Continental Divide.

Deak: **Why are you eating dirt?**
Zeke: **The Park Ranger told us to live off the land while camping out.**

What spins around and around in the Rockies?
Mountain-tops.

How did the lifeguard tear his suit?
He swam in the rip tide.

What did the sailor say when he saw Bambi?
Ahoy deer!

Where do boulders go to relax?
To rock concerts.

Why did the dog go camping?
He wanted to ruff it.

What's the first question you should ask a riverbank?
What's your current rate of interest?

Why should you never let a punk band use your canoe?
They'll rock the boat.

What does a kitty take camping?
A cat knapsack.

What does a baseball hurler do when he goes camping?
He pitches a tent.

Why did the river go to the hospital?
It had a rapid heartbeat.

What do you get if you cross a sheep with a mountain?
Shear cliffs.

Where do you find a sea horse?
At the captain's stable.

What happened to the attorney who went to the beach?
He got sand in his lawsuit.

Knock! Knock!
Who's there?
Sandy.
Sandy who?
Sandy bill to my parents.

Knock! Knock!
Who's there?
Dizzy.
Dizzy who?
Dizzy think there are any sharks out there?

Why did the sailor throw the cards in the bathtub?
The captain told him to wash the deck.

Who leads stretching exercises in Jellystone National Park?
Yoga Bear.

What's the biggest problem rangers have at Jellystone National Park?
Traffic jams.

Why did the fish eagle fly over the lake?
It was looking for a nice perch.

Ranger Bill: Did you hear about the big fish who lived in an elm?
Ranger Will: No. What kind of fish was it?
Ranger Bill: A tree sturgeon.

Why do salmon swim upstream?
It's easier than walking on their tail fins.

▶ ▶

Ranger Al: What happened in Echo Cave?
Ranger Val: It made so much noise we had to close its mouth.

◀ ◀

What do you get if you cross a mink with a pine tree?
A mink fir.

▶ ▶

How does a groundhog transport heavy logs?
He uses a woodchuck wagon.

◀ ◀

How does a pickle catch fish?
It uses a dill spear.

◀ ◀

SIGN ON A SQUIRREL'S NEST: Out to crunch!

◀ ◀

What do you get if you cross a creek and a computer?
Something that streams live on the internet.

▶ ▶

What did the football center say to the campers?
Who wants to take some hikes?

◀ ◀

Knock! Knock!
Who's there?
Redwood.
Redwood who?
Redwood be a good color for these walls.

What do you get when you cross a man with a couple of teepees?
A guy who is two tents.

▶ ▶ ▶ ▶ ▶ ▶ ▶ ▶

Which monk likes to
sleep outdoors?
The camp friar.

◀ ◀ ◀ ◀ ◀ ◀ ◀ ◀ ◀ ◀ ◀ ◀ ◀ ◀ ◀ ◀ ◀

Zack: It's hot in this log building.
Jack: That's just cabin fever.

▶ ▶ ▶ ▶ ▶ ▶ ▶ ▶ ▶ ▶ ▶ ▶ ▶ ▶ ▶ ▶

Knock! Knock!
Who's there?
Achoo!
Achoo who?
"Achoo on trees," said the beaver.

◀ ◀ ◀ ◀ ◀ ◀ ◀ ◀ ◀ ◀ ◀ ◀ ◀ ◀ ◀ ◀ ◀

When does Old Man River limp?
When he has water on the knee.

▶ ▶ ▶ ▶ ▶ ▶ ▶ ▶ ▶ ▶ ▶ ▶ ▶ ▶ ▶ ▶

Where do you find a river zombie?
In a watery grave.

◀ ◀ ◀ ◀ ◀ ◀ ◀ ◀ ◀ ◀ ◀ ◀ ◀ ◀ ◀ ◀ ◀

Do people who live on islands mind having visitors?
Not atoll.

▶ ▶ ▶ ▶ ▶ ▶ ▶ ▶ ▶ ▶ ▶ ▶ ▶ ▶ ▶ ▶

What did one rock say to the other?
I'm your boulder brother.

What is a little boulder's favorite rhyme?
Rock-a-bye Baby.

Where do rocks play golf?
At Pebble Beach.

Why did the fisherman go to Burger King?
He promised his wife he'd bring home a whopper.

What does a pooch do when he goes hiking?
He dogs the trail.

What's the best way to see the Rockies?
Take a peek.

What do you get if you cross an angry lion and white water?
Roaring rapids.

What determines who gets to ride the best waves?
First come, first surfed.

Why did the ice cream cone jump into the ocean?
It felt like having a cool dip.

What happened to the businessman who went to the shore?
He got sand in his suit.

Knock! Knock!
Who's there?
Wirey.
Wirey who?
Wirey wasting time? Let's surf!

Where do sailors go for sweet treats?
To a dessert island.

◀ ◀ ◀ ◀ ◀ ◀ ◀ ◀ ◀ ◀ ◀ ◀ ◀ ◀ ◀ ◀ ◀

What did the
jockey like to catch
at the shore?
Horseshoe crabs.

**Which fish is
very musical?**
The piano tuna.

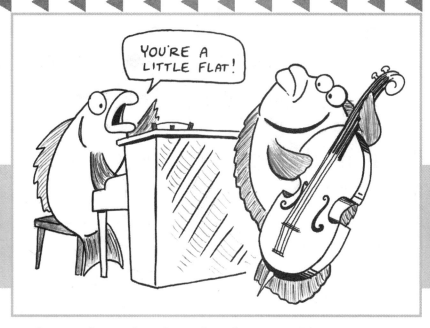

YOU'RE A LITTLE FLAT!

Explorer: I'd love to go swimming in that river. Are you
sure there is no danger of me being attacked by crocodiles?
Guide: Yes, sir. It's perfectly safe. The piranhas ate all of
the crocodiles.

Why didn't the beautician like the ocean?
It had too many waves.

What do you get if you cross a navy frogman and a NASCAR racer?
A deep-sea driver.

How do you play water polo?
First learn how to
ride a sea horse.

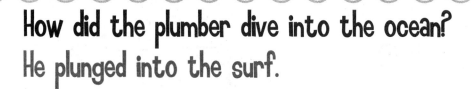

What is Santa's favorite fish?
The jollyfish.

How did the plumber dive into the ocean?
He plunged into the surf.

What did the pebble want to be when she grew up?
A rock singer.

Why did the boxer jump feet first into the ocean?
He refused to take a dive.

Boy: Is that the coastline ahead?
Girl: Shore enough.

Why shouldn't we pollute the ocean?
Because it'll make the sea sick.

Why were all the ships docked in a straight line?
Because they were rowboats.

What swims in the ocean holding a billiard cue?
A pool shark.

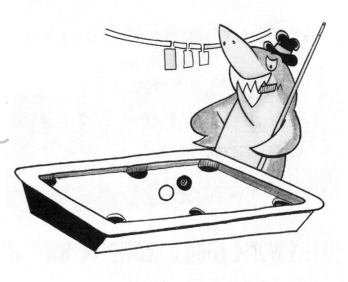

What did the English Santa say when he saw the ship's kitchen?
Gally Ho!

What did the octopus spend his entire paycheck on?
Underarm deodorant.

Where does Attila the Barbarian Fish live?
Hunder the Sea.

Where do fish go on vacation?
To Finland.

Where did the surfer beautician ride?
In the curl of a wave.

Knock! Knock!
Who's there?
Woody.
Woody who?
Woody loan me his new surfboard?

What did the pool shark say to the movie director?
Cue me.

Why didn't the little fish have any classmates?
He was home schooled.

What's worse than a centipede with athlete's foot?
An octopus with tennis elbow.

What's worse than an elephant on water skis?
A porcupine in a rubber raft.

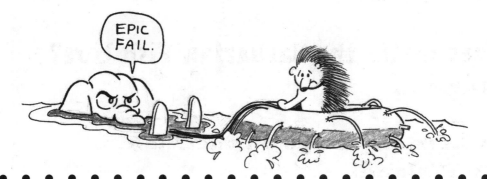

How do you catch rabbit fish?
Use hare nets.

How do you catch kangaroo fish?
Just let them jump into your boat.

What did the NASCAR clam drive?
A mussel car.

What do you get if you cross a zebra and a fish?
A striped bass.

What lives on the beach and has four wheels?
Taxi crabs.

What did the ocean say to the muddy river?
Close your dirty mouth.

What did one angry tree say to the other angry tree?
Apologize or I'll tear you limb from limb.

Sean: What do you call a fake boulder?
Patrick: A sham rock.

Benny: Did you hear a big noise this morning?
Lenny: Yes. Was it the crack of dawn?
Benny: No. It was daybreak.

Knock! Knock!
Who's there?
It's dandelion.
It's dandelion who?
It's dandelion around and doing nothing.

What do you get if you cross a tree and cheese?
Limb-burger.

SIGN ON A HIP ICEBERG: I go with the flow!

What kind of seafood does the Abominable Snowman like to eat?
Snow crab.

Knock! Knock!
Who's there?
Clam.
Clam who?
Clam up already, big mouth!

DAFFY DEFINITIONS:
Surfers – board members.
Surfboards – shore things.

Why did the baseball player go to the beach?
To catch some rays.

Where does a shellfish sue for damages?
In a small clams court.

Knock! Knock!
Who's there?
I'm tide.
I'm tide who?
I'm tide and I want to come in.

Randy: Is it true lightning never strikes twice in the same place?

Andy: Absolutely. After lightning strikes once, the same place isn't there anymore.

What did Mother Nature say to her teenage son?
Pull up your plants.

What did the valley say to the mountain peak?
Greetings, your highness.

Knock! Knock!
Who's there?
Flora.
Flora who?
Flora kid you're pretty smart.

Boy: Hey Pop! Why does it rain?

Father: Because when it rains on plants it makes things like fruits and vegetables grow.

Boy: Then why does it rain on sidewalks and roads?

Teacher: What's the difference between the moon and the sun?

Boy: They're as different as night and day.

What's the best thing to save for a rainy day?
An umbrella.

If April showers bring May flowers, what do May flowers bring?
Pilgrims.

SIGN ON A DEER TURNPIKE: No passing the bucks.

What did the lightning say when it ran for Congress?
Volt for me.

Where does a thorny plant get the best deals?
At a briar's market.

Why doesn't a river need a dentist?
It has a mouth but no teeth.

Show me a fisherman who has no tackle ... and I'll show you an angler who is out of line.

What do you get if you mix the Alps with stoves?
Mountain ranges.

What do you get if you cross a giraffe with a lawnmower?
A tall hedge clipper.

What do termites do when they get tired of working on wood walls?
They take a coffee table break.

What do you get if you cross severe windy and wet weather with rabbits?
Hare-canes.

Mother: Why are you running outside?
Boy: The man on TV said there's going to be some change in the weather and I could use some extra cash.

What do you get if you cross a praying mantis and termites?
Bugs that say grace before eating your house.

Knock! Knock!
Who's there?
Tampa.
Tampa who?
Tampa outta forest fires in Italy.

Why does the ocean roar?
You'd roar too if you had that much sand in your bed.

Dork: I'm going to water my flowers.
Mork: But there's no water in your watering can.
Dork: That's okay. I have artificial flowers in my flower box.

What do you use to dust a flower garden?
Ragweed.

Which flower is known as the Kissing Flower?
Tulips.

▶ ▶ ▶ ▶ ▶ ▶ ▶ ▶ ▶ ▶

Boy: I can't cut the grass because the lawn mower won't work.
Mother: Maybe your father can fix it so it'll start.
Boy: I hope not. I just fixed it so it won't.

▶ ▶ ▶ ▶ ▶ ▶ ▶ ▶ ▶ ▶ ▶ ▶ ▶ ▶ ▶ ▶ ▶

What do you get if you cross poison ivy with a notebook?
A scratch pad.

◀ ◀ ◀ ◀ ◀ ◀ ◀ ◀ ◀ ◀ ◀ ◀ ◀ ◀ ◀ ◀ ◀ ◀

Boy camping in forest: Hey, Dad, where's our bathroom?
Father: I told you son. Out here our bathroom is behind that tree.
Boy: Right. But how do you flush it?

▶ ▶ ▶ ▶ ▶ ▶ ▶ ▶ ▶ ▶ ▶ ▶ ▶ ▶ ▶ ▶

What do you call people who like to barbecue on campouts?
Grill Scouts.

◀ ◀ ◀ ◀ ◀ ◀ ◀ ◀ ◀ ◀ ◀ ◀ ◀ ◀ ◀ ◀

What's the easiest way to start a fire while camping?
Rub two sticks together and make sure one of them is a match.

▶ ▶ ▶ ▶ ▶ ▶ ▶ ▶ ▶ ▶ ▶ ▶ ▶ ▶ ▶ ▶

Why won't canoes talk about the hats they wear?
They don't want anyone to know about their cap sizes.

What did the match say to the kindling?
It's my job to fire you.

▷ ▷ ▷ ▷ ▷ ▷ ▷ ▷ ▷ ▷ ▷ ▷ ▷ ▷ ▷ ▷ ▷ ▷ ▷ ▷

Sara: I don't feel so good. I just came back from a long ride on a horse.
Lara: Do you have a headache?
Sara: No. Just the opposite.

◁ ◁ ◁ ◁ ◁ ◁ ◁ ◁ ◁ ◁ ◁ ◁ ◁ ◁ ◁ ◁ ◁ ◁ ◁ ◁

A lady checked into a lodge in a national park. She walked up to the front desk where she was greeted by a friendly clerk. "Can you give me a room and a bath?" asked the lady. "I can give you a room," the clerk replied, "but you'll have to take a bath by yourself."

◁ ◁ ◁ ◁ ◁ ◁ ◁ ◁ ◁

Jack: Stumbling into poison ivy is like escaping from prison.
Mack: In what way?
Jack: Once you're in it, it's not long before you have to break out.

◁ ◁ ◁ ◁ ◁ ◁ ◁ ◁ ◁ ◁ ◁ ◁ ◁ ◁ ◁ ◁ ◁ ◁

Counselor: What would you do if an angry bear charged you?
City Girl: I'd pay whatever the charges were.

CHAPTER 17

THE FINAL FRONTIER

What is the favorite
board game of
space aliens?
Moonopoly.

What's red and green and
flies a U.F.O.?
An airsick Martian.

What do you say when a blob from space rings your bell?
Ooze at the door?

What do you usually find on a flying saucer?
A flying coffee cup.

What do you need to operate a flying saucer?
A flying saucer pilot's license.

Man from Mars: I flew to earth seeking intelligent life forms.
Girl from Venus: Boy! Have you come to the wrong place.

Man from Mars: My flying saucer is made out of wood.
Man from Saturn: Does it go fast?
Man from Mars: Yesterday I flew through a meteor shower at warp speed.

What do you get if you cross Captain Kirk's mission with a magician?
Star Trick.

What did Captain Kirk use to wipe his nose?
Mr. Scott Tissues.

Where does Doctor McCoy get this medical supplies?
From sick-e-bay.

Captain Kirk: Mr. Spock, is the check switch on?
Mr. Spock: No, sir. It's check off.

What did Captain Kettle say to Mr. Scott?
Steam me up, Scotty!

What radio channel do space aliens listen to?
The space station.

How do you find a lost star?
Follow its star tracks.

What does a Martian do after dinner is over?
He washes the satellite dishes.

What do you find in a lunar playground?
The dark slide of the moon.

What do spacemen eat off of?
Satellite dishes.

What did Superman say to Mr. Scott?
Beam me up, up, and away, Scotty.

Does an actor play the doctor on the original Star Trek?
No, he's the real McCoy.

What did Mr. Spock use on the space clown who refused to talk?
The Vulcan mime meld.

Why did Captain Kirk call for a dentist?
He needed some bridge work.

What do you call a magician from space?
An unidentified flying sorcerer.

What heavenly body has a big ego?
The Hollywood star.

What has less calories than a full moon?
Moon lite.

What did the alien couple do after their wedding?
They spent time on a honeymoon.

How did Mars become the red planet?
It stayed out in the sun too long.

What did the police chief say to Luke Skywalker?
The force is with you.

Who puts worms on the hooks when Imperial Storm Troopers go fishing?
Darth Baiter.

Knock! Knock!
Who's there?
Wookie.
Wookie who?
Wookie! Wookie! Here comes Cookie Monster!

What floats in space and goes pow, ka-pow?
A shooting star.

What kind of vegetables grow in space?
Alien beans.

What sound does a moon alarm clock make?
Luna ticks.

Why did the Martian squirrel come to earth?
He was looking for astronuts.

Why did the plump astronaut go into space?
Just once in his life he wanted to be weightless.

What do you get if you cross Han Solo's pal with a beaver?
Chew-bark-a.

What do you get if you cross Yogi Bear's pal with a Star Wars mercenary?
Boo-Boo Fett.

Who sells Italian food in a universe far, far away?
Jabba the Pizza Hut.

How do you cheer up a depressed rocket?
Give it a boost of confidence.

Why did the aliens abduct an earth maid?
They needed someone to star dust.

What did earth say to the moon?
I'm going for a spin around the sun. Want to come along?

What do you call a Martian skunk?
A space scenter.

What happened when an extraterrestrial crow was marooned on earth?
E.T. cawed home.

What do you get if you cross a Star Wars hero and a fairytale?
Han Solo and Gretel.

What does Luke Skywalker listen to music on?
His Jed-i-Pod.

What do you get if you cross a being from space and a golfer?
E-Tee.

Why is traveling into space so much fun?
Right from the start, it's a real blast.

What fish do you find in deep space?
The Neptuna.

What did Saturn say to Mars?
I'll give you a ring when I'm not busy.

Why can't R2D2 play the guitar well?
He has a tin ear.

What's greasy and comes
from outer space?
A frying saucer.

What kind of music do
alien robots like?
Heavy metal.

Who is the comic book hero of Neptune?
Splash Gordon.

What is Mickey Mouse's favorite planet?
Pluto.

What did the meteor say to the earth's atmosphere?
You really burn me up.

What does a space farmer use?
A tractor beam.

Why was the alien actor unhappy with his
movie role?
He didn't get star billing.

What do you call amateur alien artists?
Space crafters.

What do you get if you cross a firefly and a sword?
A light saber.

What do alien football players wear?
Space helmets.

What heavenly body only costs twenty-five cents?
The quarter moon.

How do you cool off Captain Kirk and Mr. Spock? Turn on a Star Trek fan.

How do you make a Star Trek car run better?
Change the Spock plugs regularly.

Who do you get if you cross a sci-fi hero and a guy who grows flowers?
Flash Garden.

Why was the astronaut's daughter so sad?
She had no space in her closet.

A UFO landed in a Manhattan alley and a man from Mars stepped out. Instantly a panhandler walked up to him. "Stranger, can you spare a quarter?" said the panhandler. "What's a quarter?" replied the man from Mars. "You're right," answered the panhandler. "Make it a dollar."

I'M AFRAID I ONLY HAVE A GOOGOL KLORKZA BILL!

◄ ◄ ◄ ◄ ◄ ◄ ◄ ◄ ◄ ◄ ◄ ◄ ◄ ◄ ◄ ◄ ◄ ◄

Who takes orders in the Star Wars Restaurant?
Darth Waiter.

◄ ◄ ◄ ◄ ◄ ◄ ◄ ◄ ◄ ◄ ◄ ◄ ◄ ◄ ◄ ◄ ◄

Where's the best place to put a scoop of space ice cream?
In a nose cone.

◄ ◄ ◄ ◄ ◄ ◄ ◄ ◄ ◄ ◄ ◄ ◄ ◄ ◄ ◄ ◄ ◄

When do actors like to blast into space?
When their rocket has three stages.

► ► ► ► ► ► ► ► ► ► ► ► ► ► ► ► ►

Who do you get if you cross a Star Wars villain with a football quarterback?
Jabba the Hut! Hut! Hut!

◄ ◄ ◄ ◄ ◄ ◄ ◄ ◄ ◄ ◄ ◄ ◄ ◄ ◄ ◄ ◄ ◄

What do you call a space taxi that can't find a job?
An unemployed flying object.

Knock! Knock!
Who's there?
Hy.
Hy who?
Hyper space.

▶ ▶ ▶ ▶ ▶ ▶ ▶ ▶ ▶ ▶ ▶ ▶ ▶ ▶ ▶ ▶ ▶ ▶

Which planet has a laundry problem?
Saturn. It has ring around the collar.

◀ ◀ ◀ ◀ ◀ ◀ ◀ ◀ ◀ ◀ ◀ ◀ ◀ ◀ ◀ ◀

Knock! Knock!
Who's there?
Ewoks.
Ewoks who?
Ewoks the baby in his cradle every night.

◀ ◀ ◀ ◀ ◀ ◀ ◀ ◀ ◀ ◀ ◀ ◀ ◀ ◀ ◀ ◀ ◀

What did the space invader name his gun?
Ray.

◀ ◀ ◀ ◀ ◀ ◀ ◀ ◀ ◀ ◀ ◀ ◀ ◀ ◀ ◀ ◀ ◀

How do you catch a starfish?
Use a pla-net.

▶ ▶ ▶ ▶ ▶ ▶ ▶ ▶ ▶ ▶ ▶

What did the Martian say
to the poodle?
Take me to your breeder.

◀ ◀ ◀ ◀ ◀ ◀ ◀ ◀ ◀ ◀ ◀

Why did the space alien
go to an earth tailor?
He wanted to have
a clothes encounter.

Why did the moon skip dinner?
Because it was full.

What does an alien spaceman use to hold up his pants?
An asteroid belt.

When does a little green man from space turn red?
When you tell him the zipper of his spacesuit is down.

How can you tell if a Martian is healthy?
If he's healthy, he'll be well red.

What does an astronaut write notes on while waiting for blast-off?
His launching pad.

What do earthmen use to play golf on the moon?
An Apollo Nine iron.

BOY, I HATE THE BUNKERS ON THIS COURSE!

What do you get if you cross a famous movie android with a skunk?
R2-PU!

Why did the nuclear-powered android report to sick bay?
He had atomic ache.

Why did the Martian lawyer go to court?
He had a space suit to settle.

What did Spock say when Kirk called him?
I'm all ears, Captain.

What's the opposite of meteorite?
Meteorleft.

What space creature has fangs and claws?
A Mercury Cougar.

Why was Saturn so happy?
It just got an engagement ring.

◄ ◄ ◄ ◄ ◄ ◄ ◄ ◄ ◄ ◄ ◄ ◄ ◄ ◄ ◄ ◄ ◄ ◄ ◄ ◄

How do you make an astronomy talk show a success?
Make sure you have a lot of guest stars.

What do you need to construct a universe?

Sun beams.

COMICAL CLOSE ENCOUNTERS:

A close encounter of the 4th kind is when an alien from Mars knocks on your door and asks to borrow a cup of uranium.

A close encounter of the 5th kind is when an alien movie producer offers you the starring role of a space monster in his next sci-fi flick.

A close encounter of the 6th kind is when an alien garbage saucer dumps a load of space trash in your backyard.

A close encounter of the 7th kind is when a mugger from Mercury jumps out of a dark alley and steals your i-Pod.

A close encounter of the 8th kind is when an alien volunteer from Jupiter asks for a contribution to send underprivileged space invaders to camp on Earth next summer.

A close encounter of the 9th kind is when an alien real estate agent sells you a worthless lot on the moon.

A close encounter of the 10th kind is when an alien asks you to help jumpstart his saucer.

A close encounter of the 11th kind is when an alien Little Leaguer or band member asks you to buy a bar of space candy made in the Milky Way.

A close encounter of the 12th kind is when a alien with six arms asks you to direct her to the nearest nail salon.

A close encounter of the 13th kind is when an alien from deep space stops to walk his pet klog on your front lawn.

Why do all the other planets respect the sun?
It always sets a shining example.

- -

football player: I have athlete's foot.
Astronaut: Well, I have missile toe.

- -

ATTENTION: Being an astronaut is the only job in the world where you get fired before you go to work.

- -

NOTICE: A rooster who lives on the dark side of the moon has nothing to crow about.

- -

Why was the alien lonely?
All of his friends were down to earth.

- -

What do spacemen roast over campfires?
Martianmellows.

- -

Why was the space
rocket upset?
It was going through
a difficult stage.

- - - - - - - - - - - - - - - -

Then there was the Martian
beauty queen whose looks
were out of this world.

A bank teller named Cash.

A crook named Rob.

A drummer named Tom-Tom.

A florist named Rose.

A gardener named Daisy.

A pop star named Rock.

A boat named Dory.

A beach lifeguard named Sandy.

A coin collector named Penny.

A dairy farmer named Barn-ey.

A collection agent named Bill.

A wig maker named Harry.

A hotdog vendor named Frank.

A pro bowler name Ali.

A parrot owner named Polly.

A house cleaner named Dusty.

An attorney named Sue.

A legal document expert named Will.

A sound expert named Mike.

A honey farmer named Bea.

A steak expert named Chuck.

An English policeman named Bobby.

A tree expert named Woody.

An arbitrator named Cher.

CHAPTER 18

LAST LAUGHS

What do you get if you cross Sir Lancelot and a corn plant?
A knight stalker.

What do you get if you cross a checking account with glue?
A bank stickup.

◀ ◀ ◀ ◀ ◀ ◀ ◀ ◀ ◀ ◀ ◀

Why is skiing like life?
Getting to the top is an uphill struggle.

What was the first great ape video game?
King Pong.

Barley Field: Do you want to hear a farm joke?
Corn Field: Sure, I'm all ears.

What did baby pebbles say to mama boulder?
Rock me to sleep.

What did the circus clown say when he climbed into the cannon by mistake?
Ah, shoot!

What do you get if you cross daisies and sheets of music?
Floral arrangements.

Crook: *The guy you're looking for is buried in cement.*
Detective: *We need concrete proof of that.*

What do you get if you cross the Green Giant with acorns?
Peanuts.

Two kids were fishing on a steep riverbank. "I bet you five bucks that I catch a fish before you do," said the first kid. "It's a bet," agreed the second kid. A short time later the second kid got a nibble on his line. He got so excited he jumped up and accidentally tumbled into the river. "Hey," yelled the first kid when his friend surfaced. "If you're going to dive for fish, the bet is off!"

Why did Mr. Snickers think he was so cool?
He was a candy rapper.

Mr. Line: Are you in good shape?
Mr. Rope: Yes. I'm fit to be tied.

Why are great boxers like artists?
They're experts at putting people on canvas.

What do you get if you cross a hobo with a hip song?
A bum rap.

HIC GOT NO TIME TO MAKE A RHYME! BROTHER, CAN YOU SPARE A DIME?

Cheerleader #1: Why won't you go out with that new basketball player?
Cheerleader #2: Because he's a little forward.

Mother: When your sister gets married a lot of men will be miserable.
Son: Why? How many men is she going to marry?

How do you fix a torn pumpkin?
Use a pumpkin patch.

What did one racehorse say to the other?
I don't remember your mane, but your pace if familiar.

Clerk: There are thousands of ways to make big money, but only one honest way.
C.E.O.: What's that?
Clerk: Humph! It figures you wouldn't know.

What did the best man shout after the two slices of bread got married?
Let's toast the happy couple.

What do you call a brawl between baseball hurlers? A pitched battle.

Show me a burned up post office...and I'll show you a case of blackmail.

Cook: How's your new breakfast cookbook doing?
Chef: It's selling like hotcakes.

What did the racehorse say to the stable keeper?
Quit stalling me. I want my food now.

Lady: You-hoo! Is your taxi engaged?

Cab Driver: No lady. We're both single.

Boss: If Mr. Jones comes in tell him I'm out.
Assistant: Yes sir Mr. Smith.
Boss: And don't let him see you doing any work or he'll know you're fibbing.

Boy: Yahoo! I won a thirty-day supply of free ice cream, whipped cream, and chocolate sauce.
Girl: Gosh! Talk about a month of sundaes.

Boss: *My new assistant is from Hamburg, Germany.*
Clerk: *Oh. She's a hamburger helper.*

What happens when lions play basketball?
They use a mane-to-mane defense.

Nell: Do you work hard at the prune plant?
Dell: I sure do. Every night I come home plum tuckered out.

What do you get if you cross a bad cook with a doorknob?
A meal that turns your stomach.

Where did the rich Martians go for dinner?
To a four-star restaurant.

What are the first words of a pickle wedding ceremony?
Dilly beloved.

Boy: Is it true today's humans evolved from monkeys?
Father: A lot of people believe that.
Boy: What will happen to today's monkeys?
Father: If they're smart, they'll stay monkeys.

Knock! Knock!
Who's there?
Allison.
Allison who?
Allison Wonderland.

Mr. Apple: Tell me the truth. Am I going to die young?
Gypsy: No. You'll live to a ripe old age.

How do you plant a forest in a car?
Tree in the back. Tree in the front.

Boy: Did you hear the joke about the fabulous present?
Girl: No. Tell me. Please!
Boy: No way. You won't get it.

Are lions very religious?
Yes. They'll prey on almost anything.

What do you get if you cross crooks and chickens?
Robbers that hatch criminal plots.

Minister: You always pray before eating dinner?
Boy: Only when my sister cooks. It's better to be safe than sorry.

Girl: Why are you feeding birdseed to your cat?
Boy: Because that's where my canary is.

Girl: What is the use of reindeer?
Boy: It makes the flowers grow, sweetheart.

Which sailor is the best poker player?
The deck hand.

▶ ▶ ▶ ▶ ▶ ▶ ▶ ▶ ▶ ▶ ▶ ▶ ▶ ▶ ▶ ▶ ▶ ▶ ▶

Chef: I bought this fish at half price.
Cook: Why? What's wrong with it?
Chef: Nothing. It's a sale fish.

◀ ◀ ◀ ◀ ◀ ◀ ◀ ◀ ◀ ◀ ◀ ◀ ◀ ◀ ◀ ◀ ◀ ◀

Girl: What's a fad?
Mom: It's something that goes in one era
and out the other era.

▶ ▶ ▶ ▶ ▶ ▶ ▶ ▶ ▶ ▶ ▶ ▶ ▶ ▶ ▶ ▶ ▶ ▶

What do you get if you cross an evil space villain with a spud?
Darth Tater.

◀ ◀ ◀ ◀ ◀ ◀ ◀ ◀ ◀ ◀ ◀ ◀ ◀ ◀ ◀ ◀ ◀ ◀

Judy: I dropped my cell phone in the toilet.
Melanie: Well now it's ringing wet.

I COULD USE A LITTLE MORE WATER OVER HERE!

▶ ▶ ▶ ▶ ▶ ▶ ▶ ▶

Patron: Waiter do you serve crabs here?
Waiter: Yes, sir, but you'll get better service if you're nice.

◀ ◀ ◀ ◀ ◀ ◀ ◀

Where do witches stop for gas?
At a Hexon station.

What position did the elephant
play on the football team?
Wide, wide receiver.

**What did the rattlesnake
say to the cottonmouth?
Can we have a poison-to-
poison conversation?**

*What did the
skeleton say when he answered the phone?*
Sorry. There is no body home.

How does a Sasquatch hunter keep track of his clues?
He uses footnotes.

What do you get if you cross a lumberjack and a
poker player?
A person who always cuts the cards.

What was the only mistake Noah made?
He didn't swat those pesky two flies when he had
the chance.

Girl: EEK! Lightning scares me.
Boy: Relax. It'll be over in a flash.

Ms. Pebbles: **Did you hear the joke about the crushed
rock?**
Mr. Boulder: **Yes. It cracked me up.**

Why was Mother Nature bored?
After morning passed, she had nothing to dew.

What became of the rock hunter?
It found its quarry.

Hobo: I'd like an order to go.
Waiter: Fine! Get out of here right now.

How can you tell if an apple is a Green Beret?
Check to see if it has a Marine core.

What does the Little Mermaid eat for dessert?
Sponge cake.

Detective: Is that hot chocolate?
Boy: No. I paid for it.

What does Blackbeard
the Pirate eat with?
Long John Silverware.

What do you call a funny chicken?
A comedi-hen.

What do you get if you cross a well-kept lawn with a rhino.
A greenhorn.

Why couldn't anyone play poker on the Ark?
Because Noah sat on the deck.

Why couldn't the elephant wear a ten-dollar bill?
Money is tight these days.

Billy: Why does your Granny read the bible all the time?
Willy: I think she's cramming for her finals.

What did Bambi say to the other racers when he became a NASCAR driver?
Never pass the buck.

What's the difference between land and the ocean?
Land is dirty. The ocean is tidey.

How did the fireman become a fire chief?
He climbed the ladder of success.

What do steer invest in?
Mootual funds.

Cop: How many people will our new police cars hold?
Chief: About four in a pinch.

What do you get if you cross an expert jeweler and a circus announcer?
A ringmaster.

Girl: Have you ever heard of Sherlock Holmes.

Boy: Of course I have. It's a housing development, right?

..

Santa: What do you get if you cross a chicken with a cow?

Elf: I don't know. What?

Santa: Eggnog.

..

What do you call several coins in the pocket of Louis's pants?

Lou's change.

..

Which vegetable is also a fruit?

A carrot because it's orange.

..

Ted: What do you do at the candle factory?

Fred: I work on wick ends.

..

Bob: I ate cookies in bed last night.

Rob: How did you feel in the morning?

Bob: Crumby.

What kind of money do chicks spend?

Peeper money.

..

Mrs. Jones: Ms. Johnson says she's thirty-five. Do you believe that?

Mrs. Smith: She must be telling the truth. She stuck to that same story for five years now.

..

What job did Frodo Baggins get with the circus?

He became the ringmaster.

..

Billy: Why is your sister so unpopular with all the girls in school?

Willy: Because all of the boys voted her the most popular girl in school.

..

What happened to the saintly gopher that died?

He became a holy moley.

When does Little Boy Blue blow his horn?
When his car is stuck in traffic.

Why did Mr. Scrooge take two twenty-five cent pieces to bed with him?
They were his sleeping quarters.

And then there was the good-natured boxer who knocked himself out helping his friends.

Edward: **English money comes in pounds.**
George: **Really? I wish I had a ton of it.**

What did one car bumper say to the other?
Let's keep out of touch.

What did Ms. Rivers wear in her hair?
A water fall.

What happened to the Thanksgiving turkey that became a boxer?
He got the stuffing knocked out of him.

What do you get if you cross a parrot and a cornfield?
Something that will talk your ears off.

WADDYA MEAN THERE'S ONLY CORN HERE? OUT OF THIS WHOLE GARDEN YOU CAN'T FIND ME A SINGLE CRACKER? OF ALL THE....

What do you get if you cross a comedian with a cabbage patch?
Someone who makes you laugh your heads off.

Who is the most famous buzzing insect?
The glory bee.

Cara: I can never think of anything to say.
Sara: Me neither. But it doesn't stop me from talking.

How does the Air force announce a garage sale?
They send out flyers.

What did the camper say to the lopsided tent?
Sorry, I had you pegged all wrong.

John: *I was so mad I could have punched Joey in the nose.*
Sean: *What stopped you?*
John: *Joey. He's bigger than I am.*

Camper: I can't sleep. What should I do?
Counselor: Lie near the edge of your bunk bed. Sooner or later you'll drop off.

What do you call a scared matador?
A bull frighter.

Tillie: Did you hear about the chest that turned into a new wardrobe?
Millie: Yes. It became a really sharp dresser.

Why did the king's men put Humpty Dumpty together again?
They were afraid of a malpractice suit.

Waitress: Don't I know you from somewhere? You look familiar.
Bit Actor: You may have seen me in the movies.
Waitress: Could be. Where do you usually sit.

Why was the gold digger acting crazy?
He lost his mine.

What did number two say to number four?
You don't owe me a thing. We're even.

How does a dairy farmer relocate a herd of cows?
He hires a mooving van.

Waiter: Is there anything else I can bring you to make this a really memorable dining experience?
Patron: Yes. A small check.

Why did the snowman become a hobo?
He wanted to drift around the country.

NORTH POLE

WACKY RHYME:

When I cook I cannot look
Into a potato's eyes.
For if I do I cannot bear
to chop it into fries.

Tex: Why do they call you Dollar Bill, pardner?
Bill: Because I own four quarter-horses.

Girl: I've been ice-skating for hours on end.
Boy: I guess your backside is pretty sore by now.

Boy: Yuk! My dollar bill is soaking wet.
Girl: Put it in a change machine.

ATTENTION: Singers who become demolition derby drivers end up having smash hits!

Fred: You're a dork.
Ed: Say that again and I'll punch you.
Fred: Consider it said.
Ed: Consider yourself punched.

Woman: How do you tell the difference between a flower sprout and a weed sprout?
Gardener: Pull them all. The ones that grow back are weeds.

Boy: I don't like what you said about me. I'll give you five minutes to take it back.
Bully: And if I don't?
Boy: Then I'll give you a little longer to reconsider.

OR MAYBE YOU COULD SLEEP ON IT?

Where does a horse go when it needs food money fast?
To a Hay-T-M.

DAFFY DEFINITION
Crust — the margins on a slice of bread.

Zack: *What do you call a tiger with no ears?*
Mack: *I don't know.*
Zack: *Anything you want. He can't hear you.*

What did the boy say to the Japanese banker?
I have a yen to open an account.

Caddy: How's your game?
Golfer: I shoot in the 70s. If it gets any colder I go home.

Writer: No one will publish my short stories.
Agent: Well, write something longer.
Writer: Now that's a novel idea.

WACKY RHYME:
I think windows are
very handy.
They always keep out
the rain.
But when it comes to
washing them.
Windows will always
be a pain.

Why did the Abominable Snowman refuse to get married?
He got cold feet.

What did Mother Goose give Jack Be Nimble before he jumped over the candlestick?
Fireproof pants.

What kind of money does a cow spend?
Moola.

**Man: I love golf. I could play like this forever.
Caddy: Gosh! Don't you ever want to improve your game?**

Two little fish in the ocean were talking about places they'd like to visit. "I'd like to visit a sardine canning factory just to see what goes on in there," said one fish. "How about you?" The other little fish was shocked. "Not me," he said. "I wouldn't be caught dead in a place like that."

What do disco dancers order at a restaurant?
Food to go-go.

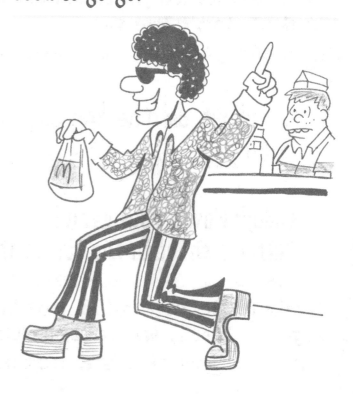

Show me a guy who spends lots of cash at the bowling alley...and I'll show you a man who has plenty of spare change.

Why did the dish run away with the spoon?
Because the fork was too picky.

Why did Humpty Dumpty have a great fall?
To make up for his lousy summer.

Mr. Hamilton: I created the words, "In God We Trust."
Mr. Franklin: Gosh. You really know how to coin a phrase.

Banker: **Why did you invest in goose feathers?**
Client: **I heard the stock market was going down.**

DAFFY DEFINITIONS
Behead – what you find at the end of a bee's neck.
Behold – what a bee wrestler uses to pin another insect.

Why did Scrooge keep his loose change in a freezer?
He liked the feel of cold hard cash.

Ann: Does Jenny really spread happiness wherever she goes?
Fran: No. I said whenever she goes.

What do you call an angler from Warsaw?
A fishing Pole.

What do you call a gift you can walk into?
An enter-prize.

Why did the girls cry when Georgie Porgie kissed them?
He had onion breath.

Joe: Hey! Why did you throw a handful of dollar bills into the river?
Moe: I'm floating a loan to a pal on the other side.

Boy: Have you ever heard the saying, money talks?
Girl: Sure. And every time I go to the mall, my money says goodbye.

Zack: How do you like being a traffic cop?
Mack: I'm so busy I don't know which way to turn.

Caddy: Why do you play golf with Mr. Jones? He's always a bad loser.
Mr. Smith: I'd rather play with someone who is always a bad loser than someone who is always a good winner.

DAFFY DEFINITIONS

Applause – two hands slapping each other in the face.

Appeal – what a banana comes in.

Stucco – what you get when you sit on gummo.

What do you call a bunny that wins the lottery?
A millionhare.

DAFFY DEFINITION:
Inkling – a baby ballpoint pen.

Who wears a crown and is covered with soot?
Old King Coal Dust.

Which turtle superhero
is a real geek?
Leonerdo.

Woman: I'd like to buy a chicken.

Butcher: Do you want a pullet?

Woman: No. I'll carry it home.

Harry: Are you still working as a carpet installer?

Larry: Nah! The boss pulled the rug out from under me.

ATTENTION: Computer surfers use keyboards.

How did the mosquito become a Hollywood star?

She passed a screen test.

What did the Italian explorer wear to the Chinese picnic?
His Marco Polo Shirt.

WACKY RHYME:

My sister uses sweet perfume
And thinks she's really neat.
But she'll need much more than that
To hide her stinky feet!

What do you call goofy insects that live on a dog?
The Flea Stooges.

Flora: Boys make me sick and tired.

Dora: Well stop chasing them.

Nan: A week ago I was crazy about Robert.
Ann: Isn't it amazing how changeable guys are?

..

DAFFY DEFINITIONS

Dining Car #1 – a chew, chew train.

Dining Car #2 – meals on wheels.

Dining Car #3 – fast-track food.

..

What do you get if you cross a dairy farm and a prison?
Milk and crookies.

..

What happened to the robber who fell into a vat of cement?
He turned into a hardened criminal.

..

DAFFY DEFINITION:
Shin - a human's built-in device for finding low objects hidden in a dark room.

..

Connie: I wonder if my boyfriend will love me when my hair is gray.
Bonnie: Why wouldn't he? He's loved you when it was brown, silver, blonde, and red.

..

Joe: **What do you do at the candle factory?**
Moe: **I wax the floors.**

What's green and bores hole?
A drill pickle.

Phil: What do you call a person who draws a circus trapeze?
Jill: A trapeze artist.

What did the hamburger
get after he graduated
from college?
350 degrees.

What sport do insect parasites play?
Lice hockey.

WACKY RHYME:
Joey had a pet turtle
It always moved very slow.
If Joey took it for a little walk,
the turtle took two hours to go.

Did you hear about the wacky hamster that climbed into an exercise wheel and gave himself the run around?

What did Mr. Boulder and Mr. Rock say to Mr. Oak?
Beat it. Trees a crowd.

Why was Mrs. Owl so proud of Mr. Owl?
He was just listed in Who's Whooo.

DAFFY DEFINITIONS:
Florist – a person in business for the green stuff.
Screens – a device that keeps insects in your house.

What did Mr. Gold say when he was in debt to Mr. Silver?
I.O. Silver!

Where do you find duck biscuits?
In a quacker barrel.

Where did Bambi go before his wedding took place?
To a stag party.

WACKY RHYME:
If you don't get any big ideas, my friend,
It's not that you are crazy.
Your mental state is great my friend,
It's just your brain that's lazy.

Where does a smart pro basketball player keep his money?
In a swish bank account.

Cook: How do I make fettuccini?
Chef: Use your noodle to figure it out.

Why did the cow jump over the moon?
It aimed for Mars, but missed.

Why couldn't Number Three play baseball with Numbers Two and Four?
He was the odd man out.

Kelly: How was the guy you went out with last night?
Nellie: He was a wonder date.
Kelly: Really. Tell me more.
Nellie: Well, I wonder why I dated him in the first place.

Nurse: **What does it take to be a good neurologist?**
Doctor: **A lot of nerve.**

Where did Cinderella Golfer go?
To the golf ball.

Which toilet was a space hero?
Flush Gordon.

NOTICE: Overweight men suffer from industrial waist.

What did Mars say to Venus?
Gee, what a heavenly body.

Who do you get if you cross
a famous Western marshal
with fizzy soda pop?
Wyatt Burp.

▷ ▷ ▷ ▷ ▷ ▷ ▷ ▷ ▷ ▷ ▷ ▷

What's the best thing to do before buying new golf clubs?
Test drive them.

◁ ◁ ◁ ◁ ◁ ◁ ◁ ◁ ◁ ◁ ◁ ◁ ◁

Hal: I built my own ship.
Cal: You must be a very
 crafty fellow.

◁ ◁ ◁ ◁ ◁ ◁ ◁ ◁ ◁ ◁ ◁ ◁ ◁ ◁ ◁ ◁

What does Neurologist Superman have?
Nerves of steel.

◁ ◁ ◁ ◁ ◁ ◁ ◁ ◁ ◁ ◁ ◁ ◁ ◁ ◁ ◁ ◁ ◁ ◁ ◁

How does a golfer crawl?
On all fores.

▷ ▷ ▷ ▷ ▷ ▷ ▷ ▷ ▷ ▷ ▷ ▷ ▷ ▷ ▷ ▷ ▷ ▷ ▷

NOTICE: An ice cream cone always gets a licking, especially if it's good.

◁ ◁ ◁ ◁ ◁ ◁ ◁ ◁ ◁ ◁ ◁ ◁ ◁ ◁ ◁ ◁ ◁ ◁ ◁

NOTICE: Come out for the weightlifting team. Join the firm.

▷ ▷ ▷ ▷ ▷ ▷ ▷ ▷ ▷ ▷ ▷ ▷ ▷ ▷ ▷ ▷

Man: Yahoo! I played golf today and shot several birdies!
Lady: Humph! I'm reporting you for hunting out of season.

What was Detective Miner working on?
A coal case.

▶ ▶ ▶ ▶ ▶ ▶ ▶ ▶ ▶ ▶ ▶ ▶ ▶ ▶ ▶ ▶ ▶ ▶ ▶

WANTED: Cabbage farmer wants to go into business with a lettuce farmer. Let's put our heads together to make more money.

◀ ◀ ◀ ◀ ◀ ◀ ◀ ◀ ◀ ◀ ◀ ◀ ◀ ◀ ◀ ◀ ◀ ◀ ◀

WANTED: Pop-top can company seeks someone to install video cameras. We want to keep tabs on our employees.

◀ ◀ ◀ ◀ ◀ ◀ ◀ ◀ ◀ ◀ ◀ ◀ ◀ ◀ ◀ ◀ ◀

Hally: I want to change the color of my hair, but I don't know how to do it.
Sally: I'll help you with a dye-it plan.

◀ ◀ ◀ ◀ ◀ ◀ ◀ ◀ ◀ ◀ ◀ ◀ ◀ ◀ ◀ ◀ ◀ ◀

An executive submitted his expense account for conferences he'd attended across the country. His boss looked over the items and pointed out a large expense. "What's this?" the boss asked. "Those are my hotel bills," explained the executive." Humph!" grunted the boss. "In the future don't buy any more hotels!"

▶ ▶ ▶ ▶ ▶ ▶ ▶ ▶ ▶ ▶ ▶ ▶ ▶ ▶ ▶ ▶ ▶ ▶ ▶

This is the story of two young fireflies that got married because they were a perfect match. As soon as they kissed, sparks began to fly. It was love at first light.

DAFFY DEFINITIONS:
Photograph of a baseball hurler – a pitcher in a picture.

Space Mission Control - a launch room.

Rick: I'm going to get rich selling duck eggs.
Nick: You're cracked. You'll go broke for sure.

Mr. Bean: An ear of corn just had a fight with a pea.
Mr. Carrot: What happened?
Mr. Bean: After the corn got creamed, the pea split.

Knock! Knock!
Who's there?
Wina.
Wina who?
Wina prize. Buy one of my lottery tickets.

Katrina: Did you hear about the clock that went on a strict crash diet?
Serena: No. What happened?
Katrina: After a while, everyone said time was wasting away.

Seed: I'm going to be hay when I sprout up.
Bud: That's a lofty ambition.

Why did the ghost get arrested for scaring people on Thanksgiving?
It was haunting out of season.

Who do you get if you cross a famous Western hunter and a guy who sets up the stage for rock concerts?
Buffalo Bill Roadie.

ATTENTION: Old quarterbacks never die...they just pass away.

Show me an aging, slow-flying blackbird...and I'll show you an old cot.

Wizard: I lost my new staff in a bog.
Harry: Well don't be an old stick in the mud about it.

ATTENTION: A flashflood hit the local bank and officials now report a cash-flow problem.

A store manager overheard a salesman speaking to a new customer. "No Ma'am," said the salesman, "we haven't had any for a while and it doesn't look like we'll be getting any soon." After the woman walked away, the angry manager rushed up to the salesman. "Never, I repeat never, tell a customer we're out of anything and that we don't expect to have that item again soon," snapped the manager. "It's bad for business. Do that again, and you're fired. Always say the item is on order and will be in the store soon," the store manager stated. "Now what item was the customer talking about?" Answered the salesman with a smirk on his face. "Rain."

Chester: That sanitation worker looks really depressed.
Lester: Don't worry about that guy. He's always down in the dumps.

Who sits at the Round Table to write plays?
King Author.

What did medieval rulers yell in the morning to wake up their workers?
Serfs up.

What did the boss pier say to the worker pier?
I'm going to have to dock your pay.

ATTENTION: A tough boxer is a good athlete you just can't keep down.

ATTENTION: America is the only country in the world where people jog ten miles a day for exercise and then taken an elevator up to an office on the tenth floor.

Then there was the wealthy Gingerbread Man who was so rich he was rolling in dough.

Chester: Is it true you jumped off a cliff and didn't get hurt?
Lester: Nah. It was only a bluff.

Narly: What does it take to ride a wave all the way into the beach?
Surfer: You have to be shore footed, dude.

What do you say when a clock bounces on a trampoline?
Time's up.

Boy: I charge people to clean up leaves in the fall.
Girl: Wow. I bet you rake in the money.

Moe: I heard a steamroller ran over Curly.
Larry: That's a flat out lie.

What did the wildlife expert say to the forest ranger?
This is a no-park zone.

What do you get if you cross a drum major with an octopus?
Something that can lead eight bands at once.

What's the antelope capital of the world?
Gnu York.

ABOUT APPLESAUCE PRESS

What kid doesn't love Applesauce?

Applesauce Press was created to press out the best children's books found anywhere. Like our parent company, Cider Mill Press Book Publishers, we strive to bring fine reading, information, and entertainment to kids of all ages. Between the covers of our creatively crafted books, you'll find beautiful designs, creative formats, and most of all, kid-friendly information on a variety of topics. Our Cider Mill bears fruit twice a year, publishing a new crop of titles each spring and fall.

"Where Good Books Are Ready for Press"

Visit us on the web at
www.cidermillpress.com
or write to us at
12 Port Farm Road
Kennebunkport, Maine 04046